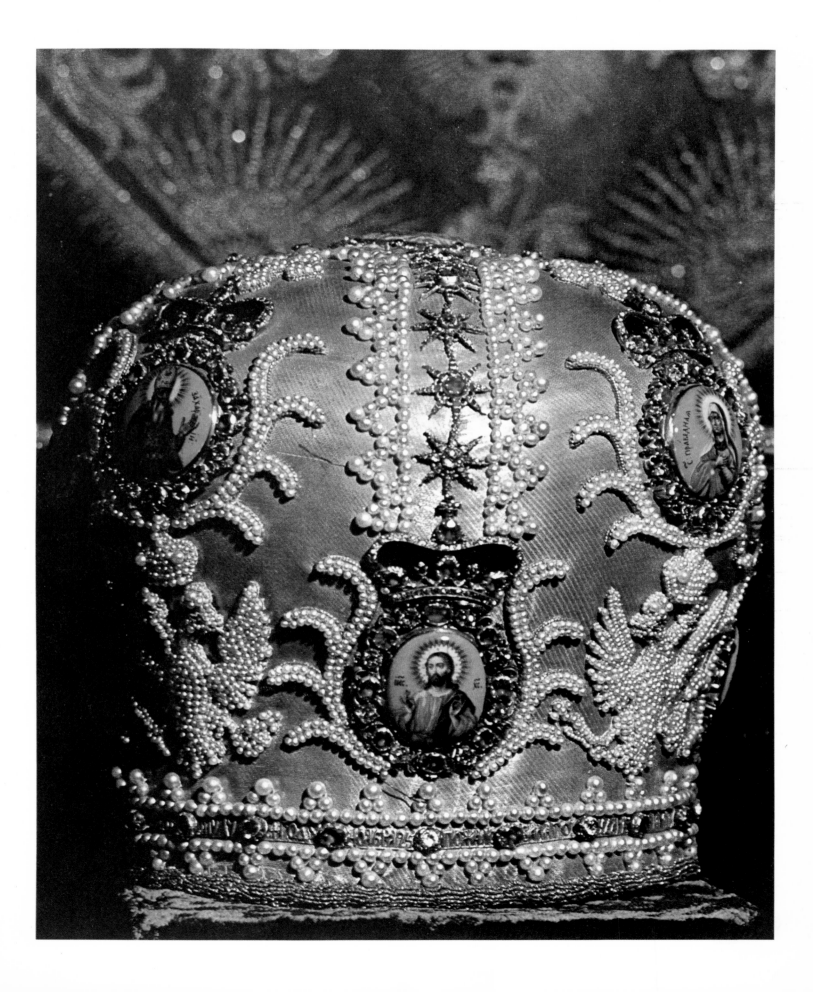

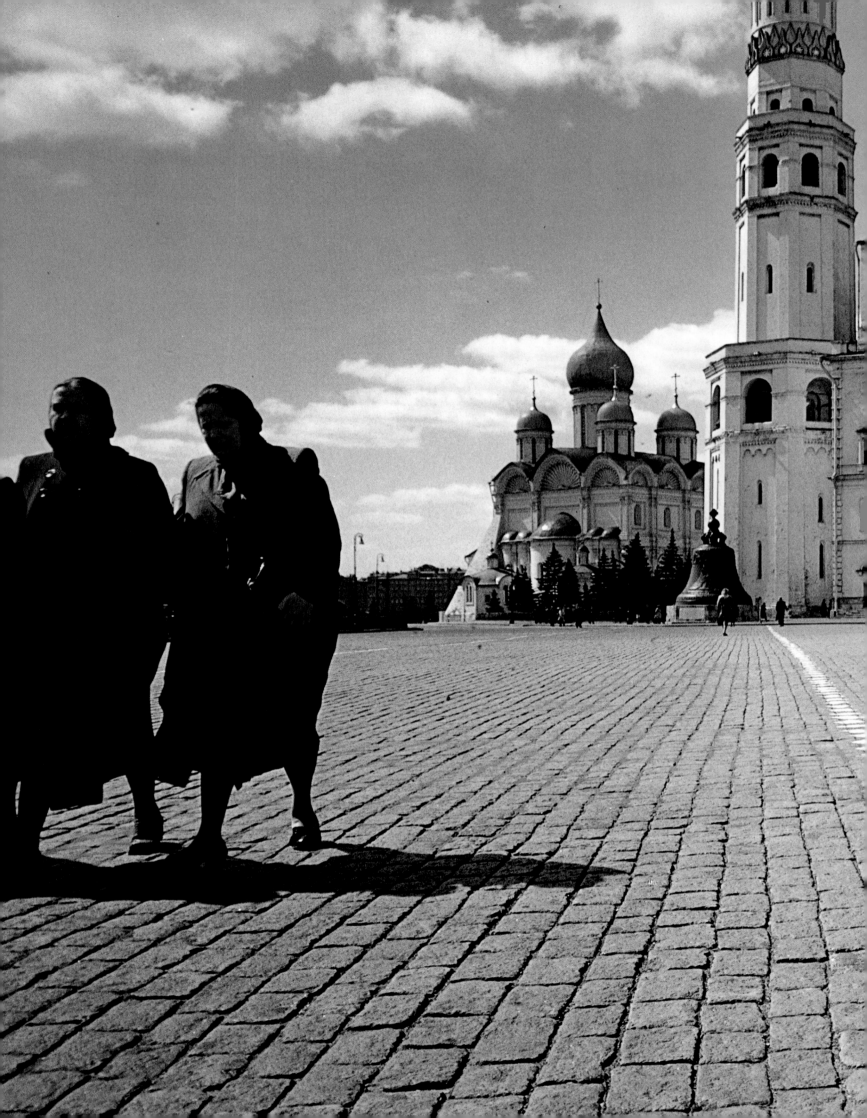

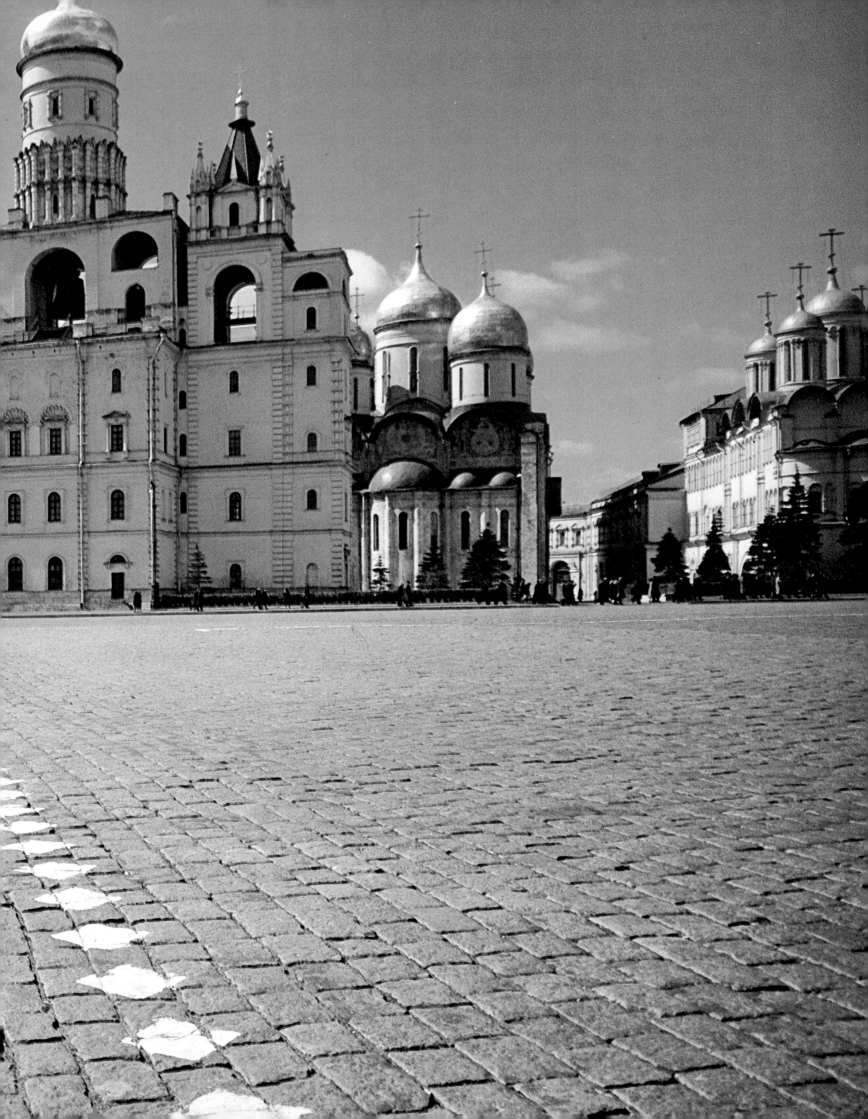

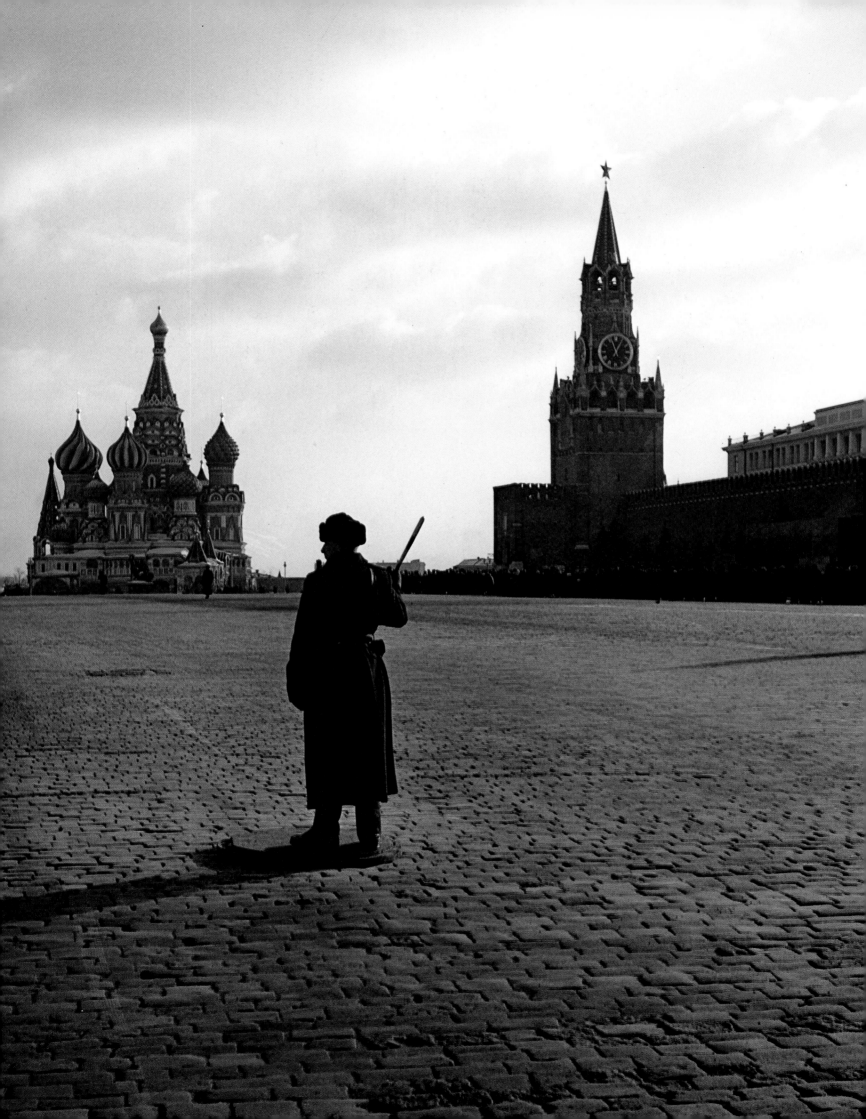

GREAT TREASURES OF
THE KREMLIN

WITH TEXT AND PHOTOGRAPHS BY

DAVID DOUGLAS DUNCAN

ABBEVILLE PRESS • PUBLISHERS • NEW YORK

Library of Congress Catalog Card Number 79-66575
ISBN 0-89659-074-7

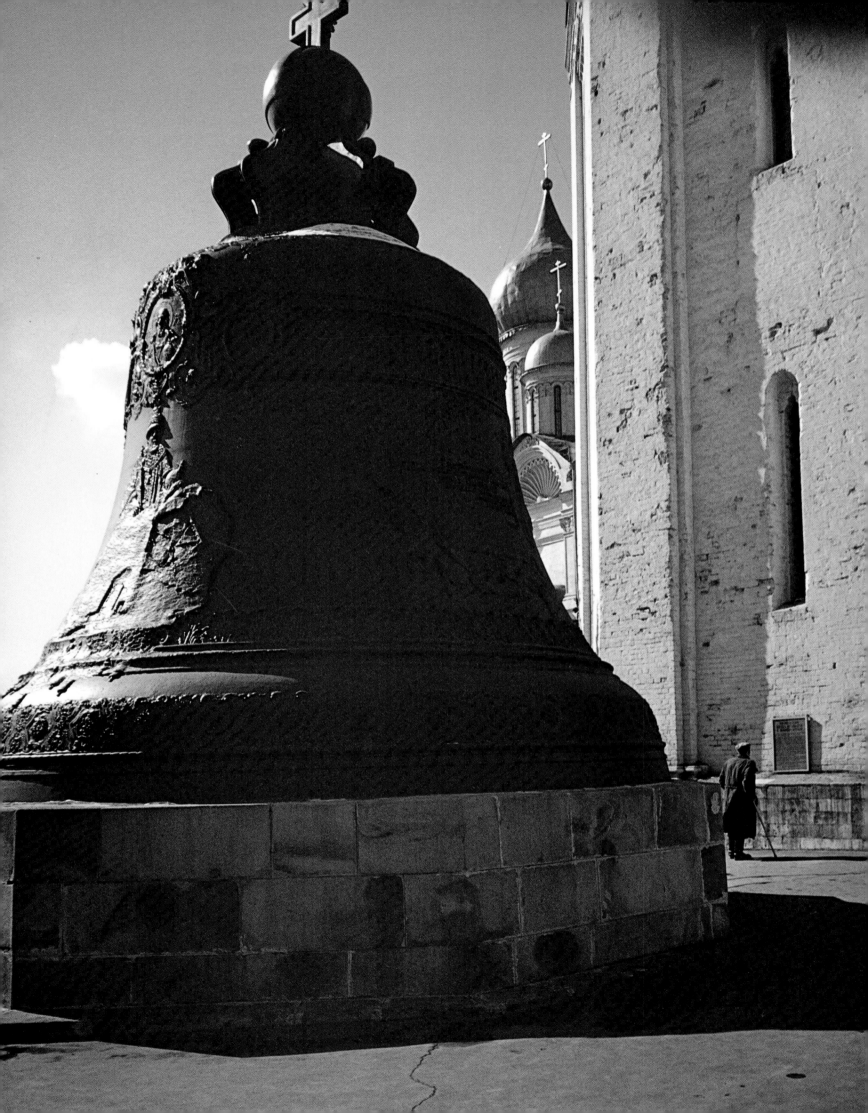

THREE DAYS HAD PASSED. Three days lost and I hadn't even started making pictures. Twenty-seven more and I would be thrown out—my visa expired. It was Moscow in late autumn of 1956, the autumn of Budapest and Suez. After two long years of futile waiting for replies to my requests for a journalist's visa I was finally in the Soviet Union as a tourist. It was that easy. The visa had been granted in a couple of weeks. I'd been sent to the USSR to shoot a color essay on the Volga, working in partnership with two other tourist-visaed gypsies, Jane and John Gunther, while he finished researching his encyclopaedic "Inside Russia Today." Cameras, typewriters, electronic flash equipment and John's endless notebooks—some tourists! The Soviet authorities looked at the visas and then us, and passed us without comment or inspection.

The evening of that third day, hoping that I might see old friends known from earlier stories while with their army, I dropped by the Turkish Embassy to help celebrate their Independence Day. I had no invitation but knew they wouldn't care and that the food would be great. Gunther must have felt the same patriotism. He already was there. I repeated the answer to the question he had asked at lunch—no, there still was no reply to my request for the Volga. "Well then," Gunther casually glanced over my shoulder, "why don't you ask him!" Nikita Khrushchev and the entire Central Committee of the Supreme Soviet had just walked into the reception.

My opportunity came later in the evening. Chairman Khrushchev stood visiting with the Indian, Egyptian and Sudanese ambassadors. An English-speaking interpreter was at his shoulder. During a momentary lull I stepped forward, introduced myself as an American photographer making my first visit to his country and explained that I had come hoping to shoot a color story on the Volga. I wanted to make pictures showing life along its banks, its farms and festivals, the places that had inspired some of the great lines in Russian literature, the scenes where historic battles had been fought; in short, the story of the river known as Mother Russia to the rest of the world. Khrushchev said nothing until I had finished.

Then he replied, seriously, reflectively, almost wistfully. "Yes. We Russians are very sentimental about the Volga. It is the mother of our country! It would make a very beautiful story. Unfortunately, it's impossible." The three ambassadors stood silently giving me my chance; so I explained further. "But I don't want any part of the river that's restricted. I haven't the slightest interest in military areas. I'll need an interpreter anyway, so give me a guide who will tell me when I can't use the camera. I've been here for three full days. My visa is good only until the end of the month. I've sent letters, telegrams, personal notes and made phone calls to the press secretary of

the Foreign Ministry, the Cultural Ministry and to Intourist. I haven't had one reply. Look, you run things here—fix it up for me." Khrushchev poked a finger at my chest and almost exploded. "It has nothing to do with security! It's winter on the upper Volga. It's frozen!"

He started to speak to the ambassadors so I made my last pitch. "Okay, then give me a chance still to use my visa. Give me permission to photograph the Kremlin and the Crown Jewels. They're the story of Russia itself—they're right outside my hotel window!" Chairman Khrushchev stood watching me for a moment before answering. "That is a very good story, too. But we must not discuss business on the sovereign soil of Turkey." He turned back to the three ambassadors.

Later, ten days later and without clarification, a phone call came from a voice that asked whether I would care to visit the Kremlin—with my cameras. I would understand, of course, that the objects could not be removed from their specially sealed cabinets on such short notice. If I could work, taking pictures of the Crown Jewels exactly as they were displayed, I had permission to photograph whatever else I desired of the Kremlin treasures. Because such authority had not been granted before and since there might be problems unfamiliar to the regular attendants on duty, if I had any requests I should explain them to my interpreter. Again, it was regretted that the objects could not be moved for my benefit. They had been revealed to the public for less than a year. To change them now was impossible while so much other work remained unfinished.

Three years—five trips—later the pictures and research were complete. The result is the first full-color coverage ever made within the Kremlin. All of the photographs were taken on Kodachrome with two 35mm Leica M3D cameras fitted with Canon, Nikkor and Zeiss-Biogon lenses. The interior scenes were made by time exposures, utilizing the existing light in each situation. Every photograph of the treasures was shot through the glass of the display cabinets with the same cameras to which were fitted a maximum of three synchronized Mighty-Light electronic flash units. The outfit was carried in an airline flight-bag. The plate engravings were made by Jan Schwitter in Basel, Switzerland, who ignored two terribly broken legs (skiing) to stand beside me for hours while forcing qualities from my films which surpass my most ambitious dreams for 35mm color. The following pages reveal but a fraction of the truly priceless and quite unimaginable Kremlin treasure hoard. At the moment it's there for anyone to see.

January, 1960

DDD
Lausanne

EVER SINCE EASTER SUNDAY, 1960, when The Kremlin *(a considerably smaller version of this book) was first published, I have regretted one enormous shortcoming of the work—a failure to credit my major source of all historical and technical data, religious lore, legends, and general background information pertaining to the Kremlin and its treasures. At that time it seemed prudent to by-pass this acknowledgment of debt and appreciation, rather than to emphasize it . . .*

Late in the summer of 1959, when making my fifth—and last—trip to Moscow in three years, I hoped to shoot several objects which I had ignored during previous journeys. I also carried a sheet of four-color engraver's proofs of Gospel covers and crowns, thinking they might interest the officials who had helped me earlier. My friends expressed surprise and enthusiasm over the quality of the reproductions—and immediately revoked my permission for using cameras in the Kremlin.

The following afternoon, an official from Intourist asked whether I'd like to take a leisurely stroll around the Kremlin walls—alone. He met me out under the ramparts, and laughed. "You must be wondering why you are no longer permitted to work among the treasures?" I admitted to curiosity, to say the least, after almost living among the Crown Jewels during other trips. My companion became serious. "I have been instructed to tell you, unofficially, why your permission has been withdrawn—officially.

"You first came to our country on a tourist visa, carrying miniature cameras and almost no lighting equipment. Naturally, we were aware of the fact that you were no tourist even though your photographic matériel appeared to support the claim of your visa. Now, you have returned with these page proofs from your color printer. I must tell you—and I speak unofficially—we of Intourist, and of the Commandant's Office of the Kremlin are excited and deeply pleased by what you have shown us. We do not, as yet, have the printing capability of achieving such results. However— officially—this spring our Government and the Government of Czechoslovakia signed an agreement permitting a technical mission of their photographers, researchers and writers to compile a book on the Kremlin treasury . . . and you already have done it. Your permission for further work had to be cancelled!

"Knowing that your photographic work is actually finished and that your visa for remaining in our country is valid for another month, I have now been told—unofficially—to offer you all available assistance in supplying precise data for every object you have photographed, in order that your book may be as accurate as possible. If you desire, a limousine will call at your hotel at 08.30 tomorrow morning. You will be met by a professor of English literature, an expert in both of our languages. You will be taken to the research library of the Tretiakev Museum of Russian Art. There,

you will be received by one of the foremost art historians in our country, who has been asked to help you—without any reservation whatsoever—until your research requirements have been met. If you are not finished by the time your visa has expired, please do not worry—it will be extended until all questions related to your book have been answered."

Every day for the next month—early morning until night—I sat like a schoolboy among the bookshelves of the Tretiakev library. On my left was a young, lovely, utterly dedicated professor of English—wife of an atomic physicist—now asked by her government to forgo her summer vacation with her family, in order to assist a foreigner with the exhausting, seemingly endless task of translating documents covering more than five centuries.

On my right perched a fragile, aristocratic gnome of a scholar with an uproarious sense of humor; a librarian-scientist with apparently total recall, fastidious in his devotion to the facts of history. At the time of our meeting, he was well through his seventies and overflowing with excitement at probing still deeper into every known Russian manuscript related to the Kremlin treasures and their history—his life's love, which he shared with a stranger.

Now—though much too late—seems to be a good time for dedicating this book:

To my friends
Nina Sinicina Alexander Sverin
here are some of your treasures
and many of your hours

DDD
4 July, 1967
Castellaras, France

. . . guarded within

THE MOSCOW KREMLIN

. . . glitters a treasury of

THRONES. . .CROWNS. . .ARMOR

JEWELS

PALACES. . .CATHEDRALS

. . . ordered by

GRAND PRINCES. . .TZARS. . .EMPERORS

. . . who ruled

EIGHT HUNDRED YEARS

THE STORMS OF MORE THAN EIGHT HUNDRED WINTERS
have swept across this remote hillock in central Russia since Man first wrote
of the wooden stockade on its crest—a tiny fortified village controlling a
twisting river below. Even then, in that year of 1147, both the settlement
and the stream were known by the same name, Moskva. As with all such
fortresses soon to be raised for protection against the Mongol hordes—who
destroyed every living thing in their paths as they surged westward out of
Asia—the fortress of Moskva was known as the *kreml'*. Centuries passed
and the two words became inseparably joined. Today, after almost a millen-
nium of attacks, fires, enemy occupation, devastation, liberation and rebuild-
ing; after almost continual invasions by Mongols, Tartars, Turks, Poles,
Lithuanians, Swedes, French, Germans, and the victorious elements of frat-
ricidal revolutions...after all this the fortress sits, formidable and mysterious,
atop its knoll where it dominates a realm vastly greater than just a few bends
of an unimportant river. It is the seat of absolute authority and leader-
ship for hundreds of millions of people—the symbol of fear and dis-
trust for hundreds of millions more. Behind its ramparts the fate of this
earth's largest nation has been shaped and its history preserved. Also back
of these walls, almost unknown to the outside world, is guarded a
treasure beyond measure or price—the heirlooms of men-gods and queens.
The Crown Jewels of Russia lie in the heart of the Moscow Kremlin.

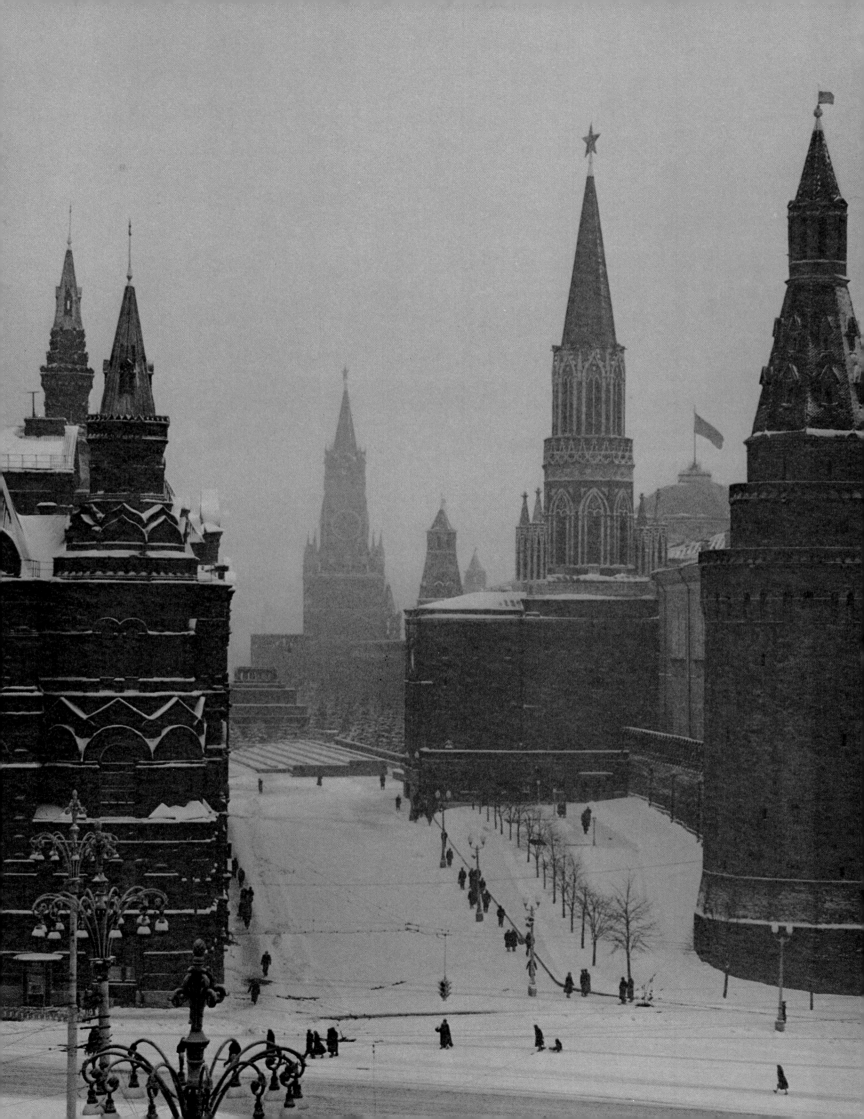

...RED SQUARE

SHADOWS OF THE PAST throw strange patterns upon these Kremlin walls where the clock tower of the Saviour rises over the rosebud cupolas of St. Basil the Blessed—shadows of the condemned through five hundred years, for this was their scene of torture and execution—shadows of merchants and minstrels of the same five hundred years, for this was their market and stage —shadows of ravaging Tartars who faltered, then fled, when faced with the icon-image of the Mother of Jesus—shadows of two Ivans, the Great and the Terrible, each a god, and a monster, to his own people—shadows of Napoleon and his generals who lingered, frustrated and freezing right here, then withdrew in defeat—shadows of Lenin and Stalin, whose gigantic double sarcophagus under the Kremlin wall is the goal of unending pilgrims who inch across the ice-encrusted cobblestones of Krasnaya Ploshchad...

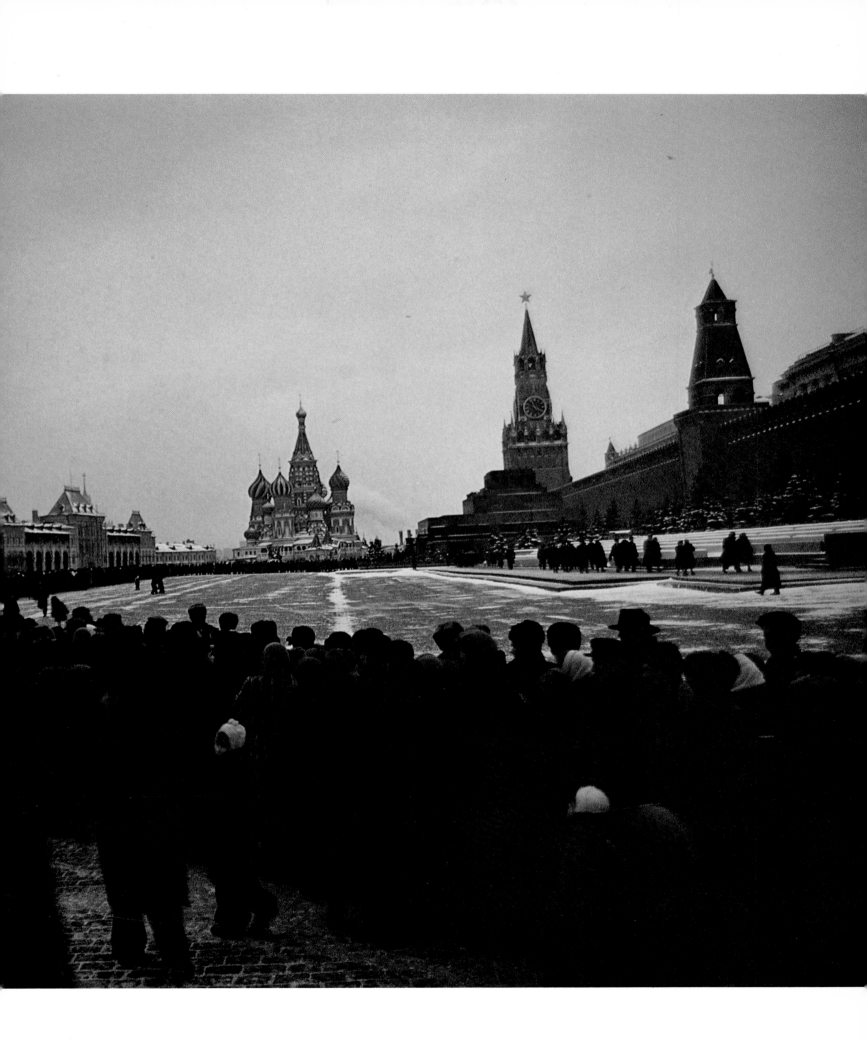

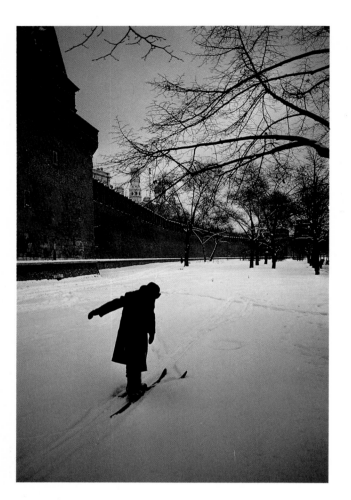

IVAN'S BELL TOWER

"GOD ALONE KNEW WHO THEY WERE, God and perhaps wise men learned in books," wrote the Russian chroniclers of Ghengiz Khan's Mongol cavalry Horde. When he died, in 1227, his four rapacious sons inherited a realm stretching from the China Sea to the Black Sea, from the Arctic Circle to the Himalayas. Russia, and Moscow, were infinitesimal pinpoints in the greatest empire ever known. A XIIIth century Chinese writer was more specific about the Horde. " The strongest among them have the largest and fattest morsels at feasts; the old men are put off with fragments that are left. In the capture of a town a loss of 10,000 men was thought nothing. After a siege all the population was massacred, without distinction of old or young, rich or poor, beautiful or ugly, those who resisted or those who yielded; no distinguished person escaped death, if a defense was attempted. " Planus Carpinus, envoy of Pope Innocent IV, told of seeing the Court of Batu, Khan of the Golden Horde, on the Volga. " His army consists of six hundred thousand men, one hundred and fifty thousand of whom are Tartars, and four hundred and fifty thousand strangers, Christians as well as infidels. We had to make prostrations and enter the tent without touching the threshold. The Khan and lords of the Court emptied from time to time cups of gold and silver, while musicians made the air ring with their melodies. Batu...is affable with his men, but inspires general terror. " Still farther east, in Mongolia far beyond Batu, was the Great Khan himself, before whom no man could stand uninvited and live.

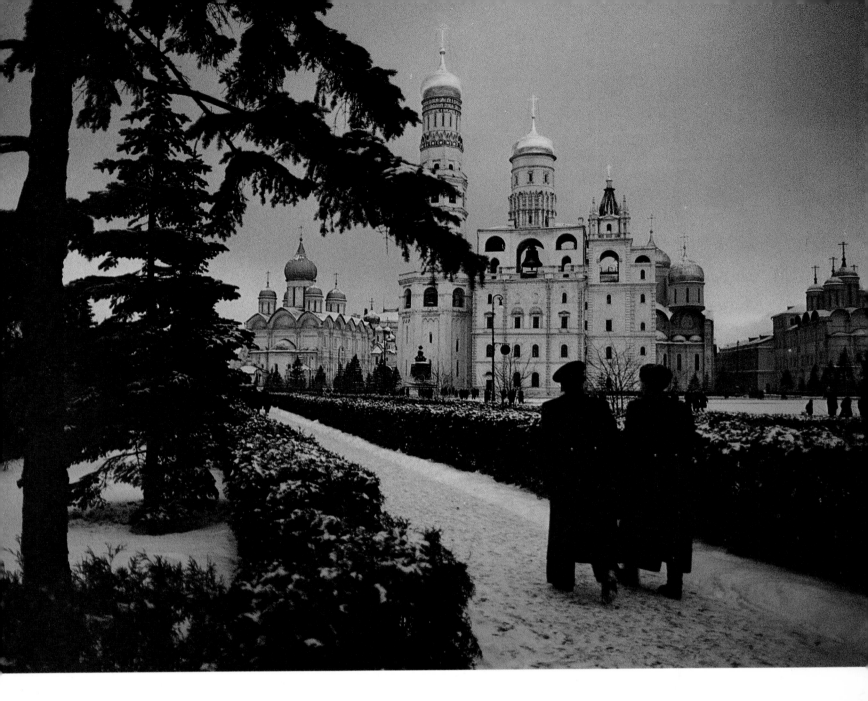

It was to those Mongol Khans that the Russian princes prostrated themselves and paid tribute for two hundred and fifty years—a tribute of tarnished pride, fraternal deceit, acceptance of murder as a political weapon, and the payment of men and money from their own families and lands in exchange for peace on the Khans' terms plus the Khan-bestowed title of Grand Prince. Opposition brought total devastation; subjugation promised survival. The Russian princes perhaps had no choice. However, as tax-collectors and census-takers for the Khans, the Grand Princes of Moscow acquired absolute authority within their own domains for the first time and thereby founded the autocratic dynasties which were to rule Russia for long centuries after the deaths of all the Khans, and their Hordes.

Generations perished while the Great Khans bled their world from tent-cities in Asia. It was not until 1380 that a young prince named Dmitri Ivanovich led an army out from behind the Kremlin's recently strengthened walls to attack their oppressors, the Golden Horde on the river Don. That battle of Kulikovo was a momentous instant in Russian history—for the Horde was routed. It was another hundred years before the Mongol grip broke completely. By that time the young prince had become one of his country's heroes, known to all as Dmitri Donskoi. Later ages would also remember him as the great-grandfather of Ivan the Great, for whom the mighty belfry was named which towers above the Kremlin today.

THE HEART OF RUSSIA

A GIRL NAMED ZOE CHANGED THE KREMLIN and the face of Moscow forever when she became the bride of Ivan the Great. Before her marriage her Christian name would have meant absolutely nothing to anyone in Russia, but her family name was Paleologus, enough in itself to command respect even of the Grand Prince. She was the niece of Constantine, the last Emperor of Byzantium.

In 1453 the Turks overwhelmed Constantinople, killed the Emperor and crushed the parent church of Orthodoxy. Zoe fled to sanctuary in Rome, a ward of Pope Sixtus IV. Lamenting the extinction of Byzantium, but probably rejoicing that a Cause had been thrust upon him which demanded a crusade against the rampaging Moslems—a crusade which might also bridge the schism between Latin Rome and Orthodox Moscow—the Pope hopefully promoted the marriage of Zoe to Ivan the Great. The wedding took place in Moscow, in 1472.

Ivan undoubtedly welcomed the union with little emotion but vast satisfaction, for it brought instant recognition and immense prestige to his reign—and a touch of legitimacy to his conquests. His agents and armies—using every device of intrigue and warfare—had vanquished the Tartars, subdued the Poles and Lithuanians, and destroyed almost every other independent Russian city-state until he had trebled the realm he had inherited. But far more important than winning foreign recognition, the marriage aligned the full power of the Russian Church squarely behind his throne. The Patriarchs of Orthodoxy—rejecting any thought of reunion with Rome—envisioned Moscow as replacing Constantinople for all Believers of the Eastern Faith.

The Church even helped to invent and circulate legends that Ivan was a direct descendent of Greek Emperor Constantine Monomachus *and* Roman Emperor Augustus Caesar. In keeping with his exalted new patrimony Ivan officially decreed himself " Sovereign of All Russia. " He then adopted the double-headed black eagle of Byzantium as his royal standard. Finally, when corresponding with the heads of lesser powers, or receiving ambassadors, he let it be known that he must be addressed as *Tzar* . . . Caesar.

Even while Ivan kept extending his frontiers in all directions—leaving everywhere the fearsome toll of his own sword, or his agent's dagger—the imprint of another person's character was being stamped into Moscow itself. Zoe, Ivan's new wife, soon made it obvious that she was not a docile young thing who had been packed off toward the frozen steppes unknowingly. Nor did she intend to disappear without a trace into the Grand

Prince's palace. To conform with her husband's nationality she changed her name to Sophia Fominichna—then started to do something about the rough, remote city which was her new home and which must have offered some startling contrasts to a girl coming straight from Italy in High Renaissance under Lorenzo the Magnificent and Leonardo da Vinci, to a girl who had been praying in St. Peter's and living in the shadow of the Vatican itself.

Within a few months the astonished Muscovites, accustomed to almost monastic seclusion, found whole legions of foreigners arriving in their midst. Ambassadors came from Frederick the Third, Maximilian of Austria, Mathias of Hungary and the Pope; envoys appeared from such distant places as Venice and Tartar Siberia. With the adoption of her new name Sophia also assumed a leading role in shaping the conduct of Ivan's court. Byzantine pomp and ceremony soon overlaid the earlier, almost barbaric pageantry of Kremlin rituals. Sophia nurtured Ivan's already soaring aspirations of grandeur, thus pushing him even further toward a position of awe-inspiring isolation from his people. At the same time he often listened to his wife's entreaties that he import Italian architects and engineers to make Moscow another Rome.

Possibly Ivan might have done nothing more than just listen to his wife had not Fate intervened. An earthquake hit Moscow the year of their marriage, leaving wreckage where local architects had been struggling to replace the Kremlin's ancient Cathedral of the Assumption, which had been erected in 1326 during the reign of Ivan Kalita, Moscow's first Grand Prince. Messengers soon headed south down the rivers of Russia, returning with Greek and Italian architects led by one of the greatest talents of his craft in all Europe, Ridolfo Aristotele Fioravanti of Bologna.

Fioravanti saw his new Cathedral of the Assumption consecrated in 1479, then stayed on for the rest of his life in the service of Ivan as his chief architect, military strategist and master of artillery. Between 1482 and 1490 other Fioravanti-influenced architects built the jewel-like Cathedral of the Annunciation near his Assumption. In 1505 another Italian, Alevisio of Milano, added a third great cathedral to the first two—and Ivan dedicated it to the Archangel Michael. It was one of his final acts as Grand Prince, for he died the same year. Sophia, the refugee girl from Greece—the niece of an Emperor, a ward of the Pope, the wife of a Grand Prince—lived to see Ivan's greatest architectural dream fulfilled, the Kremlin's Cathedral Square ... the heart of Russia.

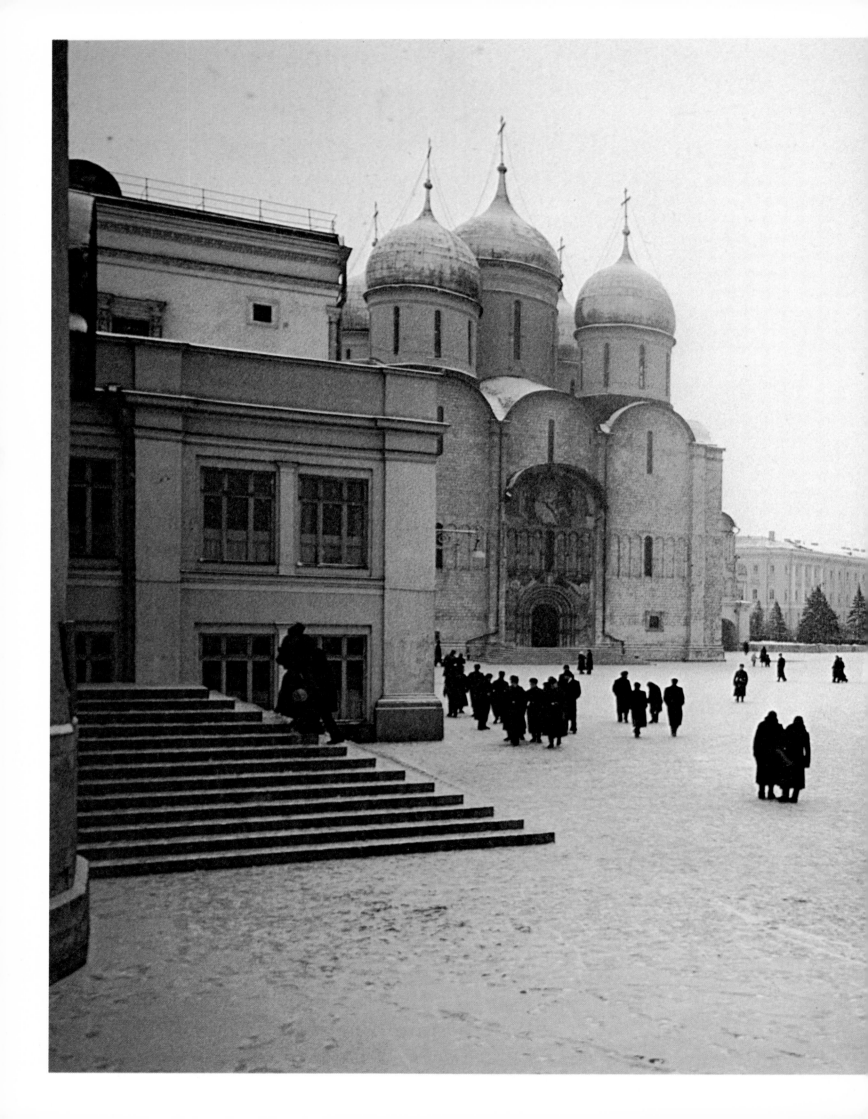

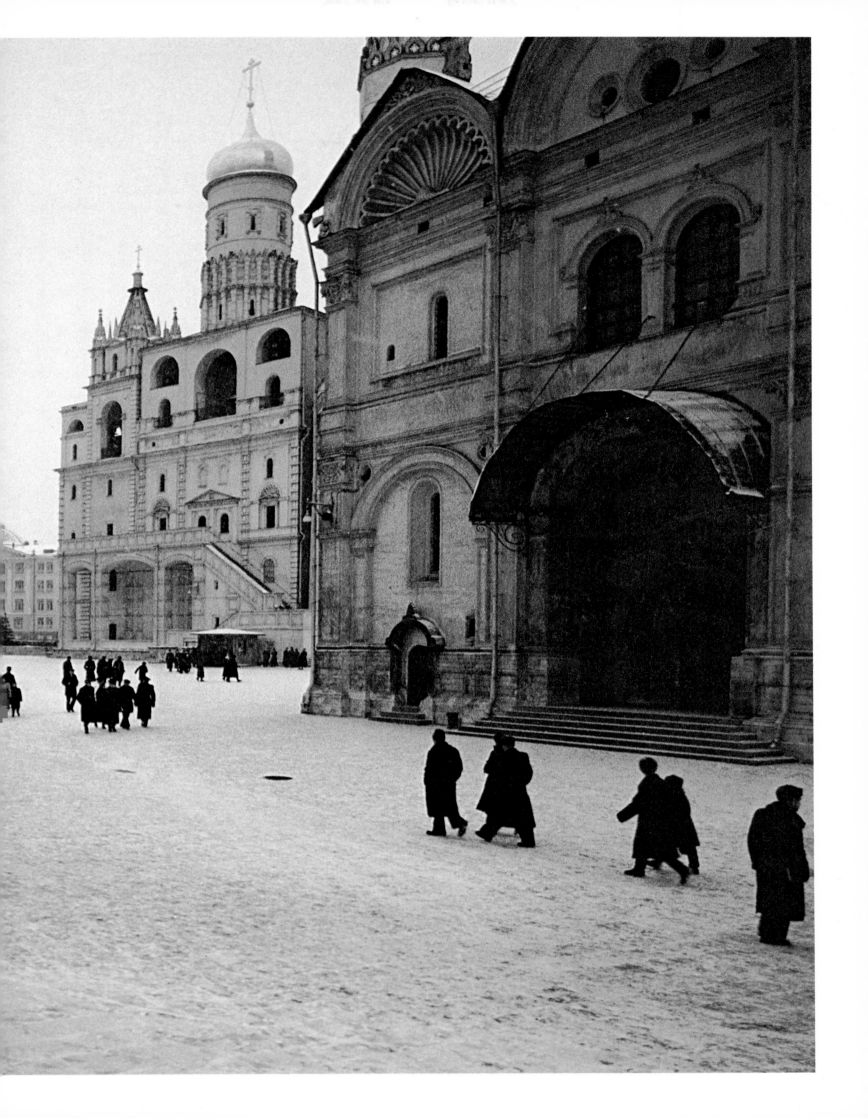

I...

TZAR...

AUTOCRAT...

SOVEREIGN OF ALL RUSSIA...

DIVINE IN THE EYES OF ALMIGHTY GOD...

I.....COMMAND!

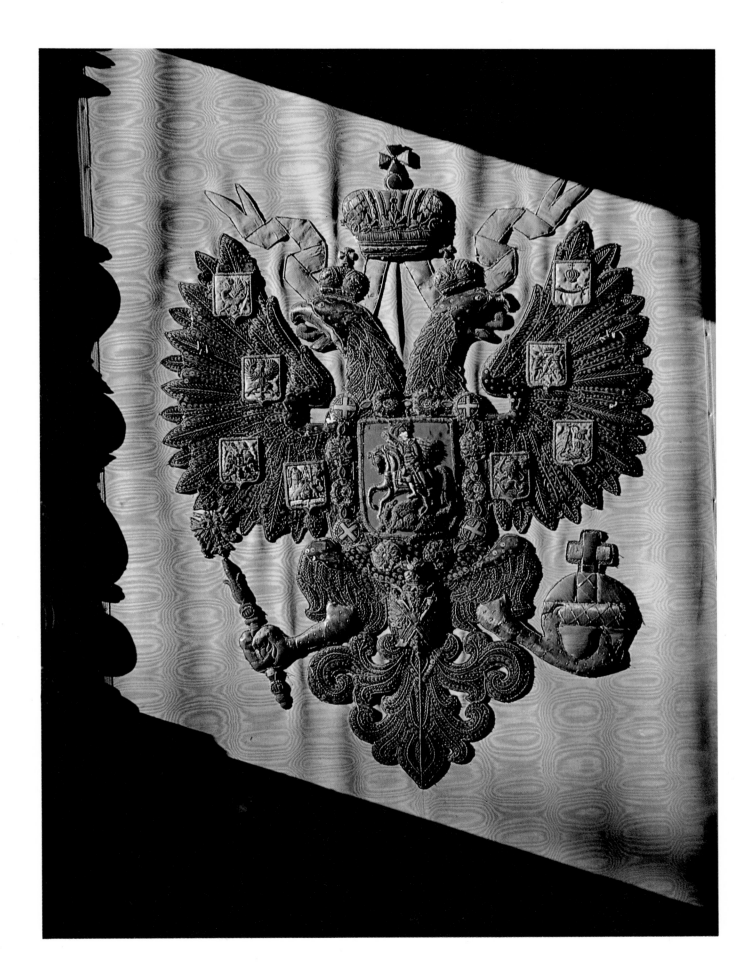

ASSUMPTION CATHEDRAL

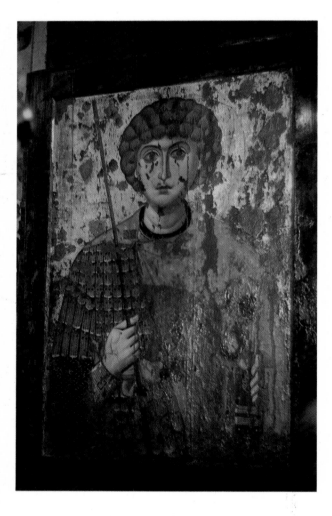

...AND IT SOARED INTO THE SKY—a holy place of tombs for lonely martyrs and mighty priests, for common prayers, and Tzars to be crowned; silent walls, hallowed ground, with tiers upon tiers of icon angels, a saint named George, and The Son of The Lord looking down; a golden place; and, once, under the enemy, a barracks and stable, too; yet, most of all, a place where simple folk just stood, looked around, and there found something to treasure and take away—to justify their day—for it was the Cathedral of the Assumption where, starting with the Great Ivan, every Prince, Patriarch and Tzar of Russia held sway.

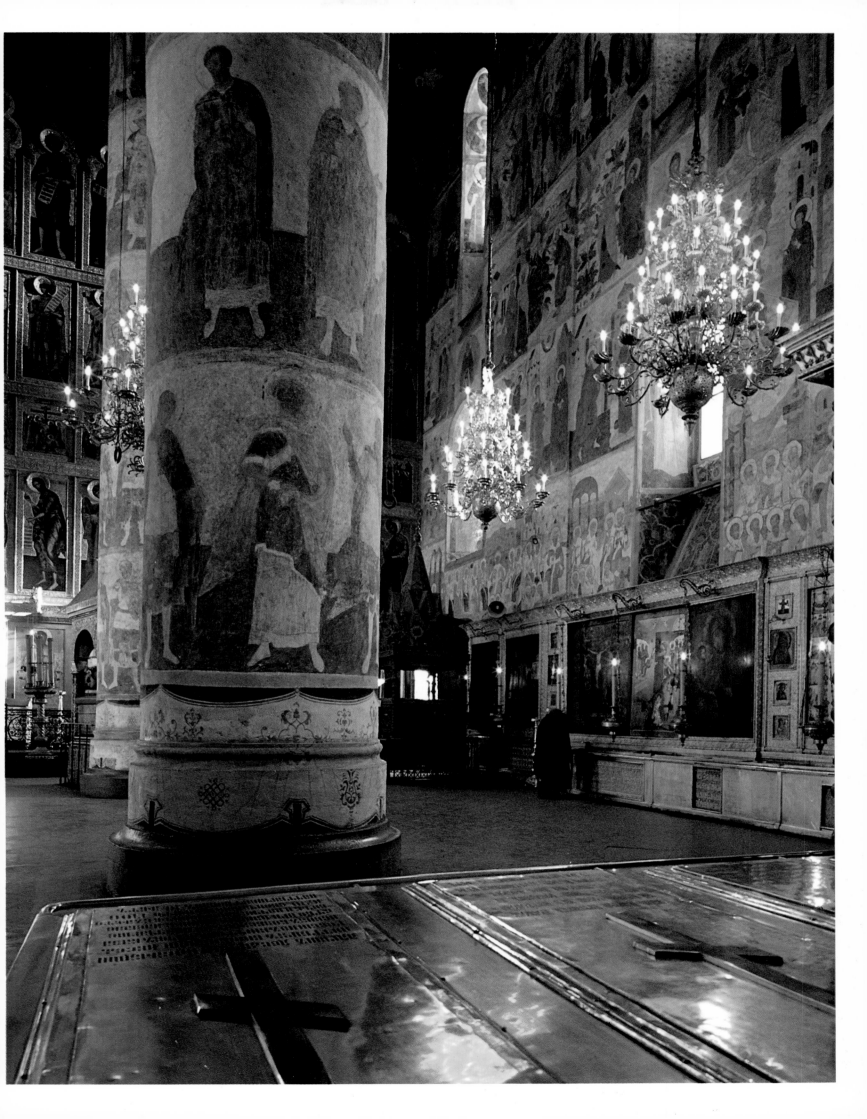

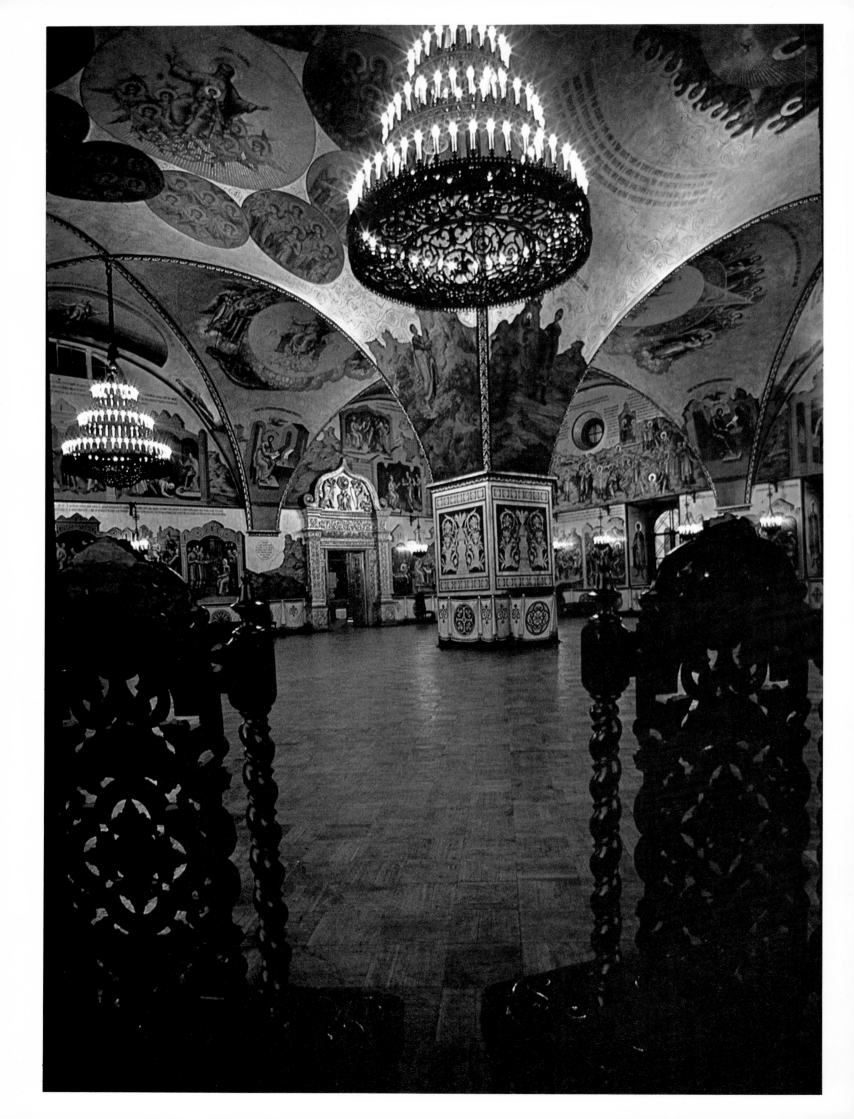

THE PALACE OF FACETS

"THERE DINED THAT DAY in the Emperor's presence above 500 strangers and 200 Russians, and all they were served in vessels of gold...," for it was Christmas, 1553, and the first Englishman ever to visit Russia sat sharing a six-hour feast with his gracious host—Ivan the Terrible.

It was here, too, the year before, that Ivan celebrated his conquest of Kazan, the Tartar stronghold on the Volga, which finally fell, opening all Asia to Russian expansion. Here Boris Godunov—who, many believe, murdered Ivan's son to usurp the Throne—stood looking up, supervising the finishing strokes of his artists while they painted the Bible Story, and the Life of Jesus. Still later, Peter the Great here toasted the defeat of his foe, Charles XII of Sweden, which victory assured Russia her long-coveted window onto Europe.

Ivan—Boris—Peter, they and many others came here to celebrate and commemorate historic moments in their violent lives, for it was the Kremlin's ancient Throne Room in the Palace of Facets—the glittering heart of a still semi-savage empire—whose frescoed splendor was rivalled only by the adjoining palace of the Tzars.

There, through arabesque arches of cloistered tunnels, where the efforts of an enslaved myriad-million glowworms seemed to light the way, there walked the jewel-slippered Tzars as they listened to their wives, played with the children, and wondered what was being prepared for dinner—and by enemies—while they dreamed of the land of which this fortress-palace was the heart...while they wandered—probably unseeingly— through color-drenched rooms thinking of other things...they were in Golden Garret...they were home.

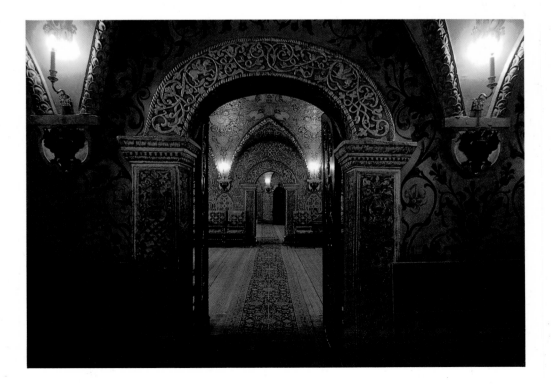

A GOLDEN GARRET

THEY MET IN THE GOLDEN GARRET above Cathedral Square. Moscow's worried aristocrats sat waiting, wondering how Russia's new sovereign would judge the petitions being handed up from their unruly serfs who were milling about in the Square below. The Tzar, on his rose-hued Throne, did nothing. He was just a sixteen-year-old boy named Mikhail Feodorovich—bewildered, inexperienced, unrecognized by his enemy neighbors—a compromise choice for ruling the shattered, bankrupt, starvation-ridden, rebellious land which was Russia in 1613; still, for all of his failings, in spite of all the forces at work against him, Mikhail continued sitting on his Rose Throne for thirty-two years—as did his son, Alexei, for another thirty-one, thereby establishing a dynasty which survived for three hundred and four years. They were the first of the Romanovs.

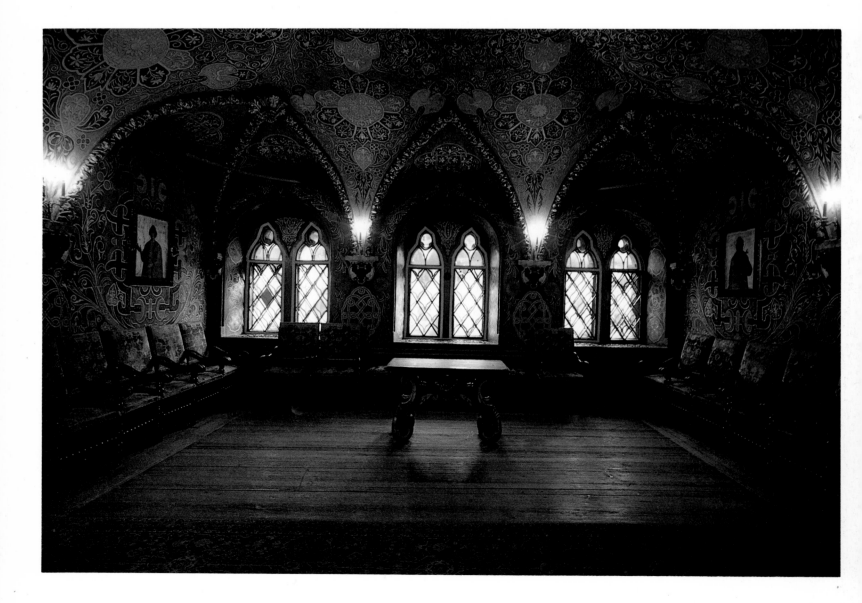

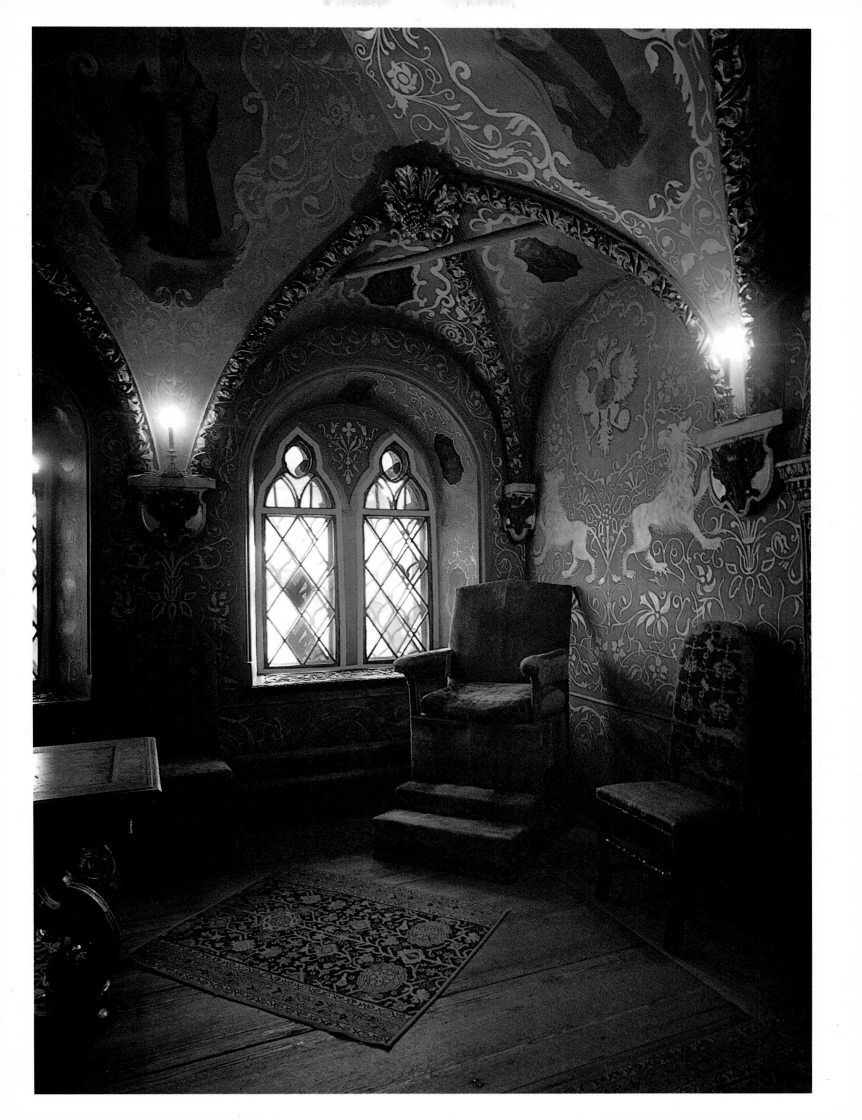

NO BABYLONIAN KING...
or Shah-en-Shah
No Pharaoh, Sultan or Caliph
No Maharaja, Aztec Emperor, Medici or Inca Chief
No one before the medieval Tzar
ever amassed such treasure during his life
and yet, despite it all,
each was chained at night to his sleepless fear
of the assassin's tread he would fail to hear.

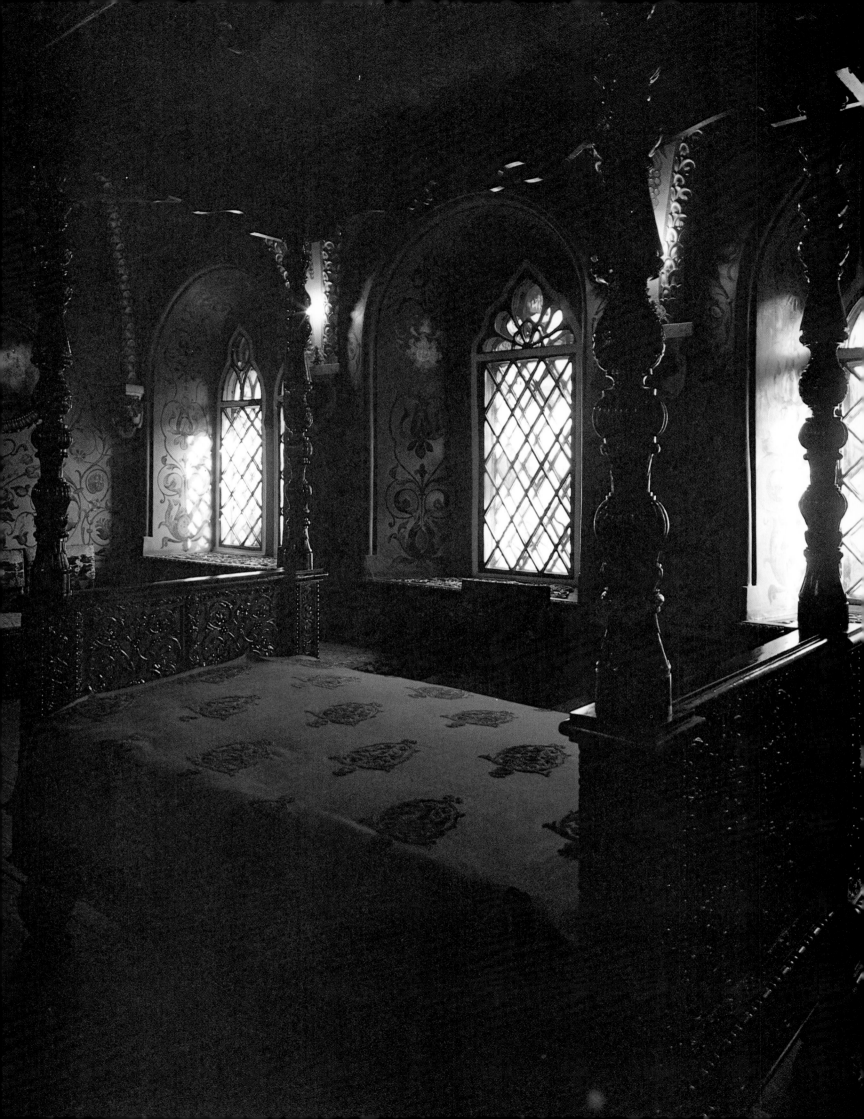

ANNUNCIATION
CATHEDRAL

ONLY THE TZAR'S FAMILY knelt before the great iconostasis in Blagoveshchenskii Sobor. The Tzar himself prayed at the altar beyond its golden door. When built in the XVth century for Ivan the Great, the Annunciation Cathedral served as a private chapel for Royal weddings, Princely baptisms, Ivan's prayers and little more. During the XVIIth century reign of Alexei Romanov a vast collection of precious Persian agate and red jasper arrived from the Shah—and soon became the floor. It was the smallest cathedral on the Square and the most beautiful, the favorite of the Tzars. Ancient legends told of icons having been seen hanging above the golden door, icons by Theophanos, a Greek whose panels were cherished a full century before Ivan was enthroned. They were said to be life-size images of Mary, and John the Baptist, with Peter and Gabriel and all of the Apostles at their sides—facing a scarlet figure of Jesus which filled the center of the wall. They were all thought lost forever, having vanished during one of the times when Moscow was sacked, or gutted by flames. Then, quite recently, someone probed through the old paint where they were hidden—exactly where Ivan had bidden—to the right and to the left on the iconostasis, above the door through which he had walked when praying in Blagoveshchenskii Sobor.

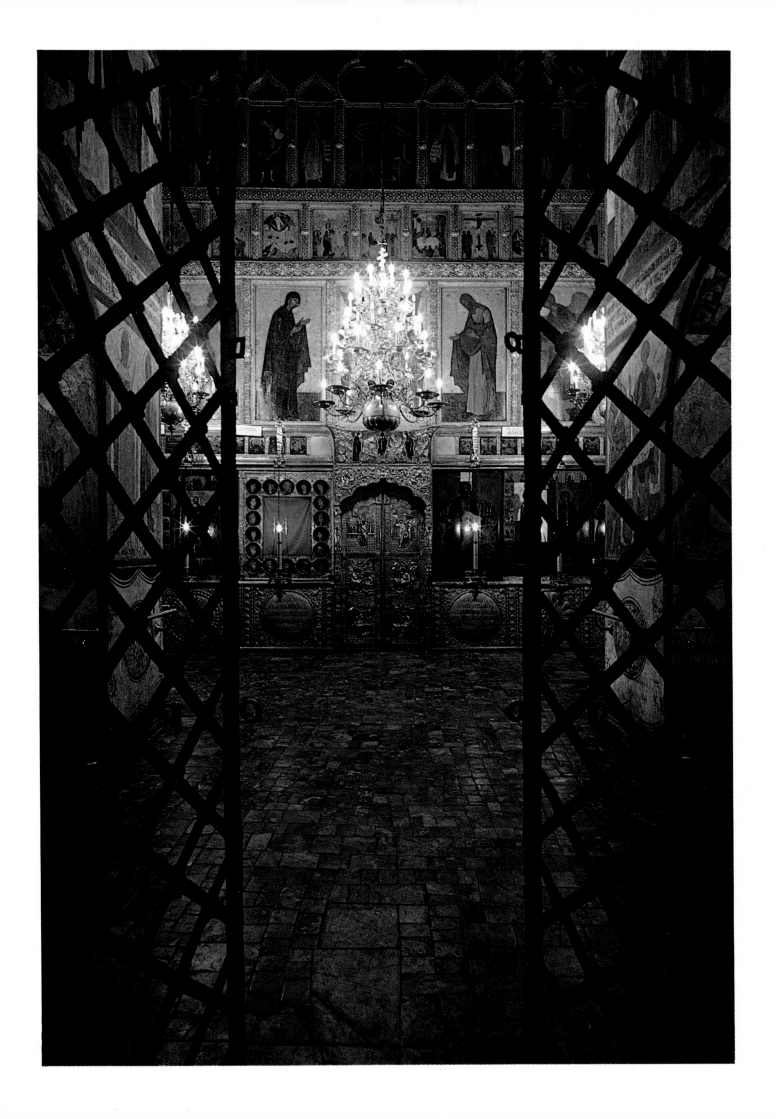

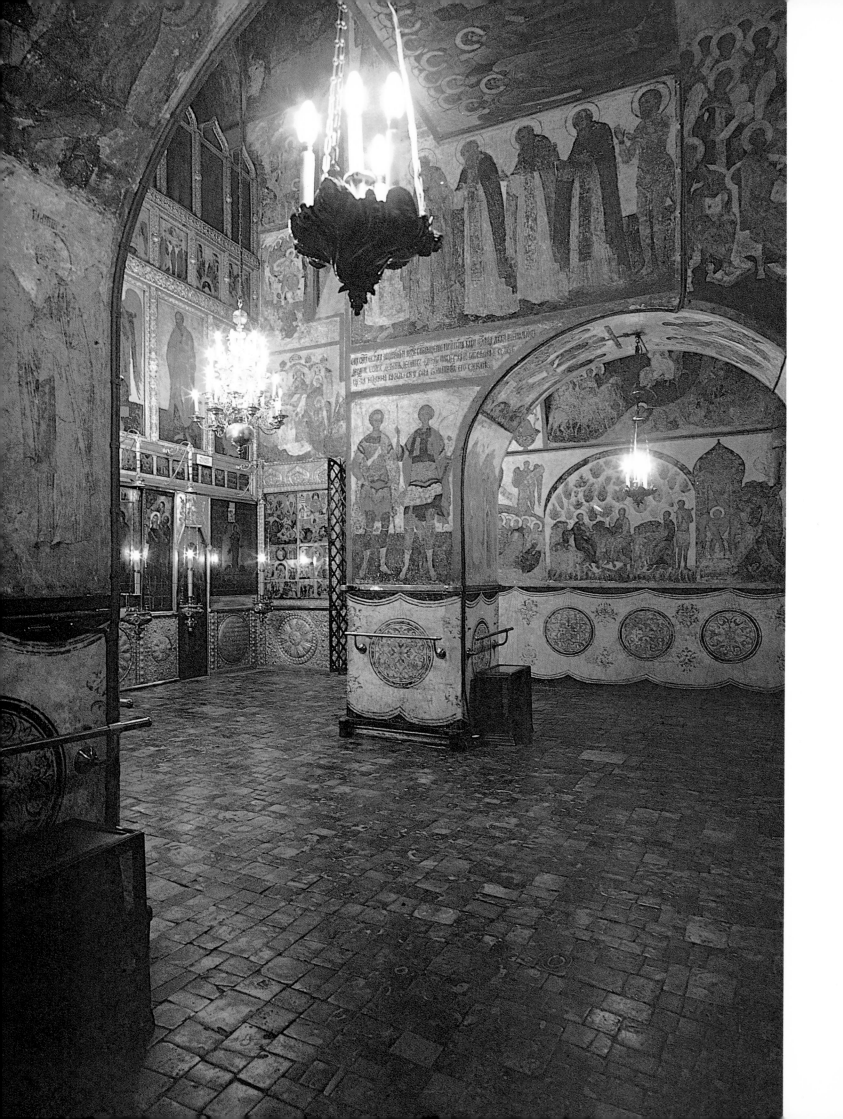

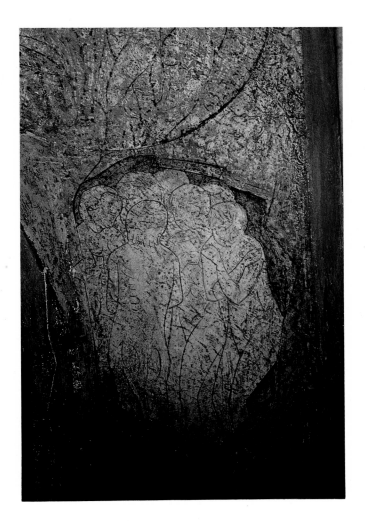

PRIMITIVE FRESCOES

OF

BLAGOVESHCHENSKII SOBOR

NAKED AND FORLORN, the eternally damned souls of Hell huddled miserably together in their dark corner. On neighboring walls of the Annunciation Cathedral richly illuminated scenes of Apostles and Saints wandering happily around Paradise offered almost blinding comparisons—to the Tzars who prayed there—of what a man might expect after Judgment Day. In the XVIth century these allegorical frescoes covered three full arcades in the Cathedral, then they gradually disappeared under successive layers of plaster until lost and forgotten. Rediscovered in 1947, they were much the same as in 1508, when the painter emphasized Hell's final horror by reducing drawing and color to a deathly minimum, something unseen before in the jewel-and-gold churches of Russia. Sadly, for the land and its peoples, the message of that long-gone artist was scorned by those incredible rulers of the Kremlin whose heritage was in itself believed to be an act of Judgment Day.

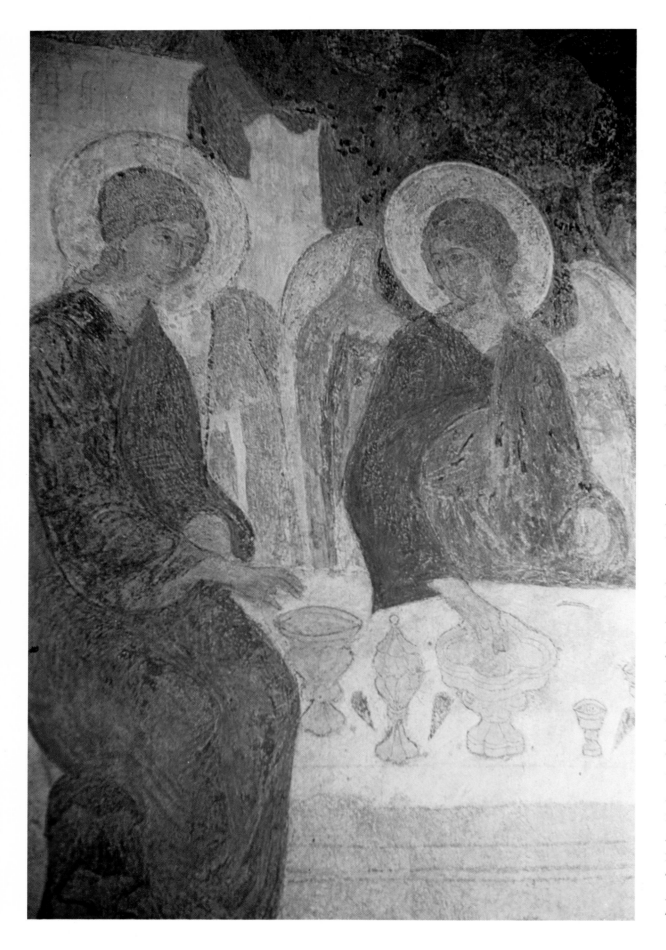

Inspired by the story
from Genesis,
of God appearing
in the form of Angels
to Abraham and
Sarah, this fresco
was painted by a
long-forgotten,
XVIth century
artist on the inner
arcade wall of
the Cathedral of
the Annunciation.

AND THE LORD
APPEARED
UNTO HIM

AND ABRAHAM RAN
UNTO THE HERD,
AND FETCHT
A CALF
TENDER AND GOOD...
AND HE TOOK
BUTTER,
AND MILK,
AND THE CALF
WHICH HE HAD
DRESSED,
AND HE SET IT
BEFORE THEM;
AND HE STOOD
BY THEM UNDER
THE TREE,
AND
THEY DID EAT.

A sensitive but
unknown
XVIIth century
painter turned
to this passage
from St. Mark
for his subject
while creating
an outer arcade
fresco for
the Annunciation
Cathedral of
the Kremlin.

AND JESUS
ENTERED INTO
JERUSALEM...

HE WAS HUNGRY:
AND SEEING
A FIG TREE AFAR
OFF HAVING
LEAVES,
HE CAME, IF
HAPLY
HE MIGHT FIND
ANY THING
THEREON:
AND WHEN HE
CAME TO IT,
HE FOUND
NOTHING
BUT LEAVES;
FOR THE TIME
OF FIGS
WAS NOT YET.

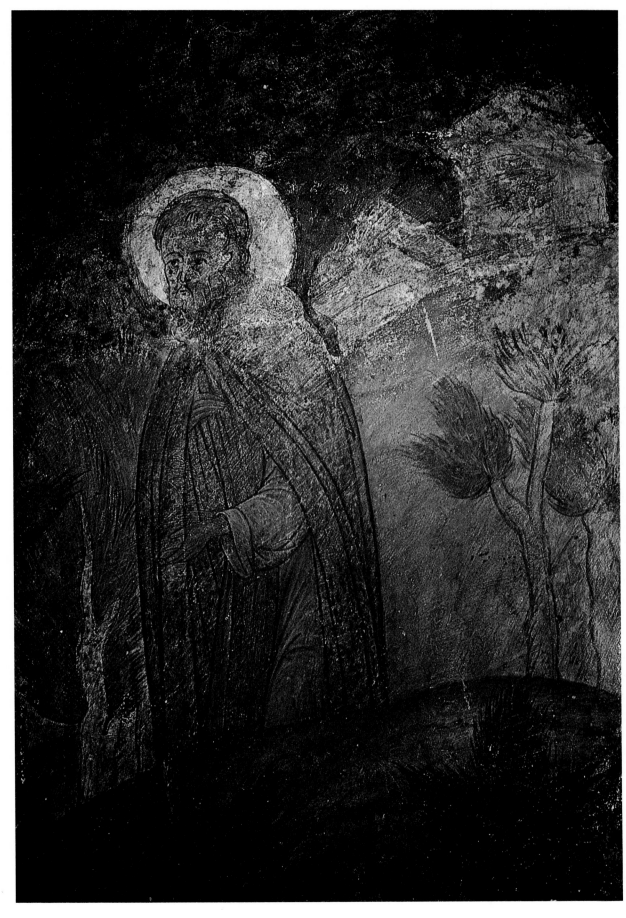

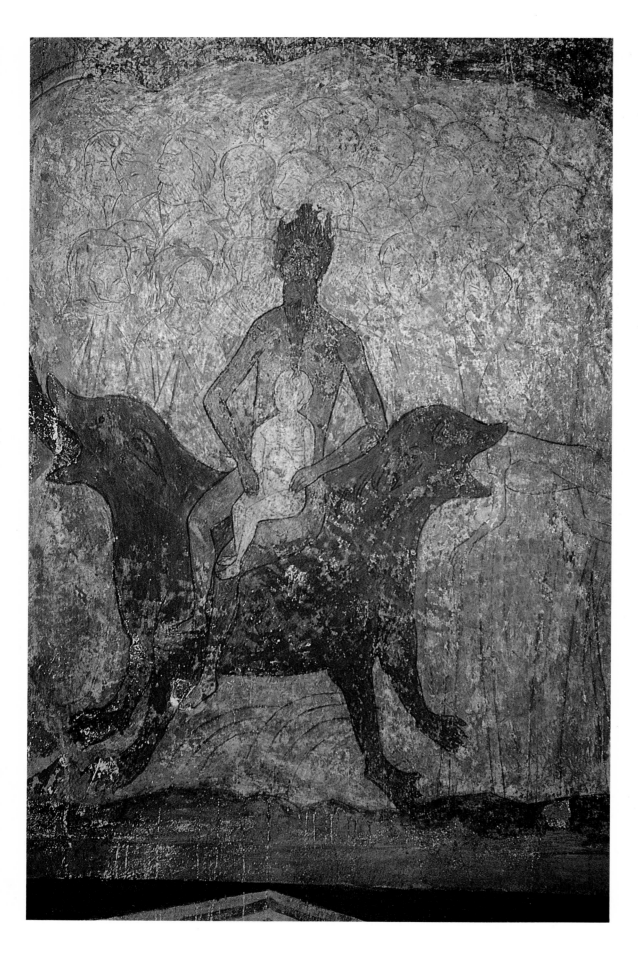

Lucifer, the Devil, weighed lost Russian souls before casting them into the Inferno. He grimly waited, nude atop his throne: a monstrous double-headed dog which ate the hopelessly damned while also holding in its jaws a serpent through which came each soul committed to Hell on Judgment Day. Silent legions of the condemned surged close around him, all hoping for Redemption. Thus the penalties and suffering paid later for a lustful life on earth were clearly drawn on the walls of Moscow's Annunciation Cathedral. Hidden under plaster and paint—by chance or by command—these early XVIth century frescoes had been forgotten until today. In medieval Russia there were few influences more powerful than the Holy Gospel, therefore a frescoed scene painted upon cathedral walls portrayed Fate itself for all men, not just the expression of an artist's vivid fantasy.

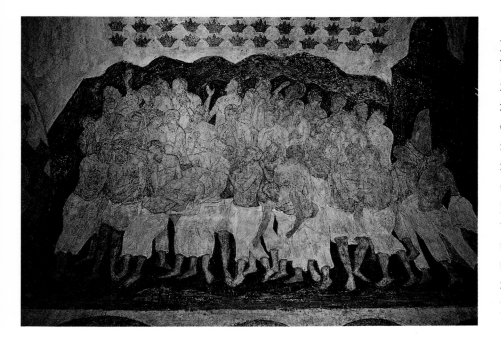

FORTY MARTYRS of Sebaste, arrested by Roman soldiers, chose death by drowning in ice water rather than renounce their new faith, Christianity. The Forty were crowned in Heaven. Legend says that a forty-first resident of Sebaste avoided death—and forsook martyrdom—by ducking into the doorway of a local *banja*, hot bath, near the place of execution. The *banja's* entrance and the back of the disappearing forty-first are seen at the extreme right in the fresco. This scene of martyrdom and many of the other frescoes in Blagoveshchenskii Sobor were painted in 1508 by Moscow artist, Feodosi.

LUCIFER - MARTYRS - ISAIAH'S DREAM

ISAIAH'S DREAM, of the Final Judgment Day, told of the Resurrection of all Earth's dumb creatures: "FOR AFORE THE HARVEST, WHEN THE BUD IS PERFECT, AND THE SOUR GRAPE IS RIPENING IN THE FLOWER, HE SHALL BOTH CUT OFF THE SPRIGS WITH PRUNING HOOKS, AND TAKE AWAY AND CUT DOWN THE BRANCHES. THEY SHALL BE LEFT TOGETHER UNTO THE FOWLS OF THE MOUNTAINS, AND TO THE BEASTS OF THE EARTH; AND THE FOWLS SHALL SUMMER UPON THEM, AND ALL THE BEASTS OF THE EARTH SHALL WINTER UPON THEM. IN THAT TIME SHALL THE PRESENT BE BROUGHT UNTO THE LORD OF HOSTS."

IMPERIAL TREASURY OF THE

ARMORER'S CHAMBER

THE FIRE STARTED IN A CHURCH. Flames raced through the Kremlin, reached the main powder magazine—and the place exploded. The year was 1547. Ivan Vasilievich had just married Anastasia Zakharin Romanov, the only woman he ever loved but who soon was to die of poisoning, he believed. Perhaps at that moment Ivan Vasilievich became Ivan the Terrible.

After the death of Anastasia her husband became a schizophrenic tyrant whose bestiality lashed livid welts across the sagging shoulders of his plodding, peasant land and its history.

At the time of the fire superstitious residents of Moscow may have guardedly whispered that the disaster, originating in a church and not sparing even the palace of their holy sovereign and his bride, prophesied still worse days ahead—and it did. Whole families and entire cities were exterminated by Ivan the Terrible. The northern city of Novgorod, which had had its own free government for centuries and thus resisted his threats, finally fell. Ivan, by his own hand, executed citizen after citizen until the dead totaled one thousand five hundred and five, recorded by him and, later, prayed for by him. Hundreds of others who toppled before him were considered too insignificant to list, completely unworthy of his prayers.

It was this same grisly Ivan, after the ruinous fire of 1547, who assembled master craftsmen from all parts of Russia and Europe—architects, goldsmiths, icon painters, jewelers, enamelists, filigree designers, pearl embroiderers, ivory engravers—representatives of every artistic talent known to sensitive Man—and ordered that they rebuild the Kremlin, then fill it with the most beautiful creations they could produce. In the Armorer's Chamber of the Kremlin—behind wrought-iron doors emblazoned even now with Imperial Tzarist eagles—much of Ivan the Terrible's treasure still exists. With it today is the shimmering hoard accumulated by Russia's rulers for seven hundred and fifty years. There is nothing else like it on earth—probably there never has been, including that day in 1576 when the ambassador of Maximilian II, the Holy Roman Emperor, wrote the following account of his audience with Ivan:

" Never in my life have I seen things more precious, or more beautiful. Last year I saw the crowns, or mitres, of our Holiest Father in the Castle San Angelo. I have seen the crown and all the clothing worn by the Catholic Kings, as well as the Great Prince of Tuscany. I have seen many decorations of French Kings, and His Majesty, the Hungarian King. I have been to Bohemia and many other places. Do believe me that all of these things can not in any way be compared with those which I saw here. "

THE VIRGIN OF VLADIMIR

TAMERLANE THE SCOURGE, Lord of Asia, Sword of Islam, Tamerlane the Great of Samarkand—stopped. Behind him across the tortured steppes of eastern Russia the pulse of life was almost dead. Before him, rich, submissive, paralyzed with fright, lay Moscow where envoys from his Tartar Horde were presenting an ultimatum to the Grand Prince. They were too late. A serene Mother and Child had already arrived at the Kremlin before them, alone and unarmed, to defend the city. Tamerlane, the insatiable looter, stayed inexplicably near his tents for several days, then wheeled the Horde and disappeared. The year was 1395. Muscovites crowded the Kremlin cathedrals giving prayerful thanks for their deliverance, attributing it to another of the miracles wrought by the already legendary Virgin of Vladimir, the holiest icon in all Russia.

Christianity was a thousand years old when a truly great artist, working in Constantinople, carefully selected a particularly fine-grained panel of limewood, and began to paint. More than a century later his icon of the Virgin was one of two chosen for shipment to Kiev, the capital of recently pagan Russia. Spectacular ceremonies undoubtedly heralded the pair of icons in 1131 when they were sheathed in frames of gold and placed upon the walls of Kiev's Monastery of the Caves, the Pecherskaya Lavra. Even in that day they were recognized as masterpieces of religious art. More than that, they were sacred, having come straight from blessings by the Patriarch of Orthodoxy, who for every Believer was the voice of God on Earth.

Thirty-eight years later, in 1169, all Kievan Russia was stunned by an unbelievable rumor—Kiev itself had been besieged and sacked by Russians! The rumor was absolutely true. Kiev had fallen after a three-day assault by other Russians under the command of a young prince from Rostov, Andrei Bogoliubski. After storming the city Andrei's followers pillaged the place, tortured and murdered the inhabitants and stripped the walls of the Pecherskaya Lavra, then withdrew, leaving only the smoldering carcass of what had been the greatest, the proudest, city of Russia. With Andrei went one of the beautiful new icons from the monastery. Tradition says that the horse bearing the icon along the road toward Andrei's home in Rostov balked before the town gate of Vladimir, refusing to proceed another step. Andrei interpreted this as a Holy Sign giving approval of his plan for establishing headquarters in Vladimir, which he did and where he died —murdered, in 1176.

Looters stripped the icon of its gold frame after Andrei's assassination. Again, in 1237, when the Tartar Horde plundered Vladimir, the icon survived but lost a jewel-encrusted frame and much of its original paint. As generations passed, the icon became closely associated with many Russians' prayers asking for protection from the Tartar terror. Its fame grew so great that pilgrims made journeys to the shrine where it was housed and where it had become known as the Miraculous Virgin of Vladimir. Thus, it was to her that Grand Prince Vasili of Moscow turned for help when Tamerlane and his Horde appeared from central Asia.

Following Tamerlane's flight—which left Moscow untouched—a special niche was cleared to the right of the sanctuary door in the Kremlin's Assumption Cathedral. It was the most venerated position of all. There, still known as the Virgin of Vladimir, she was to gaze down upon all Russian rulers and be a part of their lives for another five hundred years.

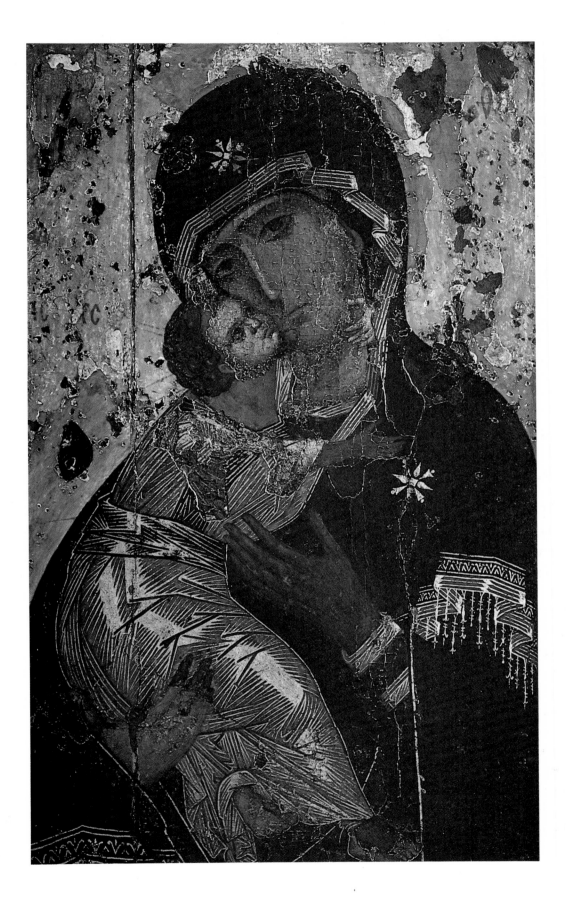

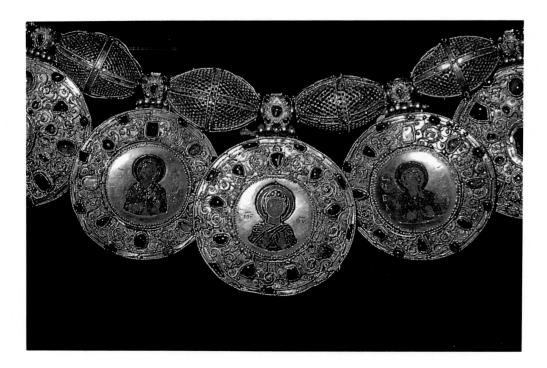

DIM AGES OF ANTIQUITY

ALMOST NOTHING REMAINS from those first centuries when Christianity was winning Russia, nothing more than a few fragments of gold filigree necklaces called *barmi*—worn probably by landlords of the scattered towns—and the rusted pieces of an ancient war helmet tipped with silver medallions of St. George and the Archangel Michael and Jesus Christ. Still, they were the beginnings, the glistening flash of something exciting lying deep among the twisted roots in Russia's black earth—the crude emergent thing which later was to burst forth with dazzling sprays of gem-laden blossoms in a profusion never seen before. So, as the beginnings they were significant—the rough XIIIth century treasure trove of a Riazan aristocrat: simple gold-and-garnet pendants decorated with faded enamel busts of the Virgin, Saint Irene and Saint Barbara; and the tattered helmet of Yaroslav II who, as a young man in 1216, panicked in the face of combat, tossed his helmet and chain mail under a tree and fled. Eighteen years later he redeemed his name fighting against the Teutonic Knights, in time to earn a place among his country's immortals six centuries before a Russian peasant struck something metallic while plowing and turned up all that remained of his youthful helmet and armor—right where he had dropped them.

During these same centuries bearded priests prayed in jewel-embroidered robes so ablaze with light that it seemed to the humble as though God Himself must have reached down to bless the holy men, and themselves, by permitting such glory to brighten their leaden lives, and yet, as centuries passed, probably neither the priests—surely not the peasants—nor anyone else could have remembered that the magnificence of their Metropolitans' robes stemmed directly from the simple *barmi*, buried so long in the dank Riazan mud.

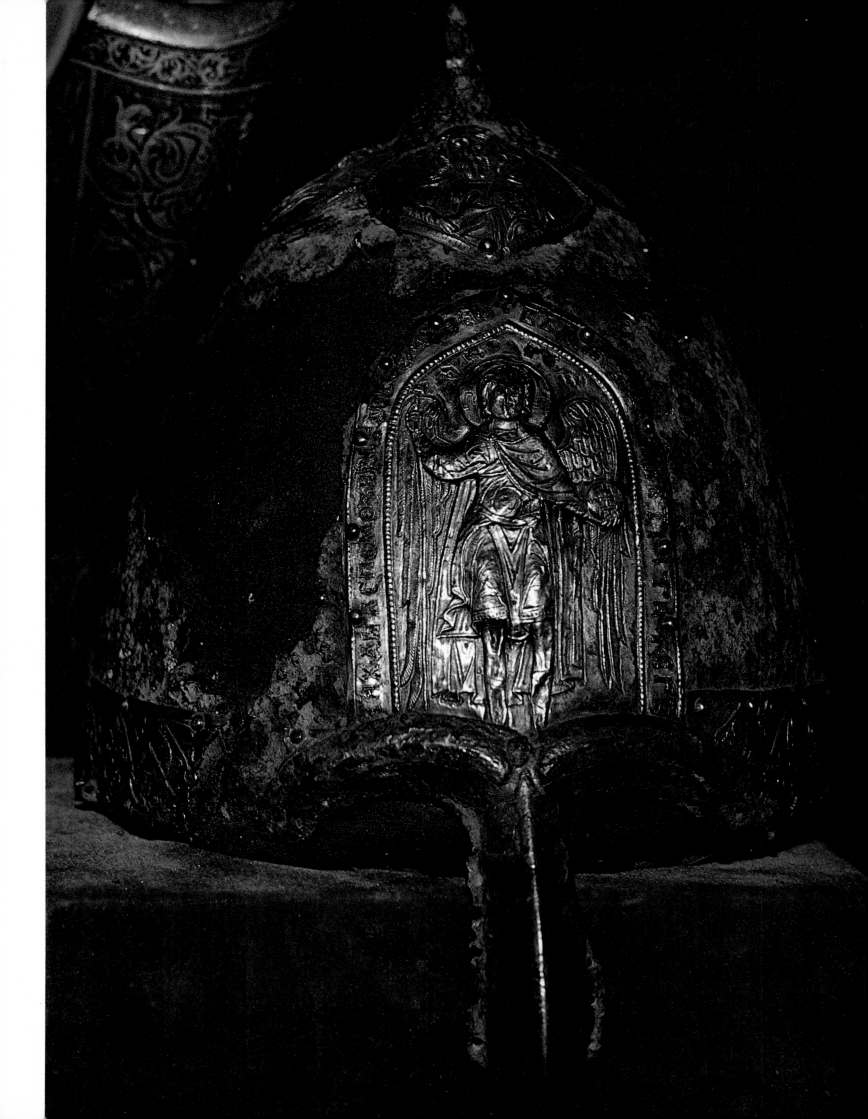

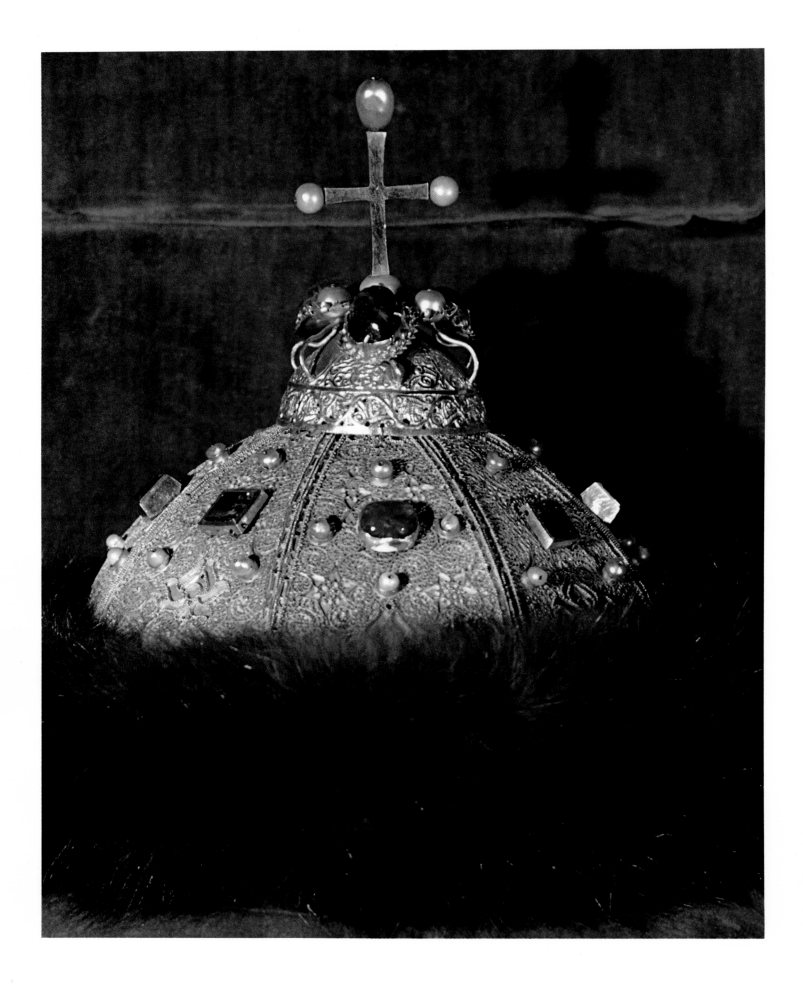

MONOMAKH'S CAP

A GOLDEN CAP was the treasure of treasures of every Grand Prince, all the Tzars, each Empress and Emperor; it was the symbol of Divine authority invested in the Throne. It was the Cross *and* the Crown. Its haughty splendor had no rival—yet no one, not a single person had ever been able to say where it came from. It was just a Fact, like the sun and the night, like winter's snow... like Eternity. It was the Cap of Monomakh under which every Russian sovereign had been enthroned.

Legend said—and it was one of the oldest legends of them all—that the Cap had belonged originally to Caesar himself, then later had been sent as a gift from a Byzantine Emperor to Vladimir Monomakh, Grand Prince of Kiev in the XIIth century. After Vladimir's soldier-son Yuri Dolgoruki founded Moscow the Cap was brought from Kiev to the Kremlin. Everything related to the earliest history of the Cap was a legend, a legend based upon a political necessity: it was imperative during later generations that the Kremlin rulers nourish superstitious Russian peasant minds with tales of their dynastic inheritance as sanctified by God's supreme Throne on earth, the Emperor of Byzantium. Then, with the great peasant mass swearing an emotional allegiance to the Cap—but rendered politically docile—it was possible to firmly entrench and constantly extend the Kremlin's realm.

Regardless of whether it was fiction or fact that Vladimir Monomakh was the first Russian owner of the Cap, he actually did bequeath another shining legacy to his people—one which was thrown aside and soon forgotten, but which merited all of the respect and affection later bestowed upon his name. It was only a word-covered bit of parchment—his final reflection on life and his Will to his sons:

" It is neither fasting, nor solitude, nor the monastic life, that will procure you the life eternal—it is well-doing. Do not forget the poor, but nourish them. Do not bury your riches in the bosom of the earth, for that is contrary to the precepts of Christianity. Be a father of the orphans, judge the cause of widows yourself.... Put to death no one, be he innocent or guilty, for nothing is more sacred than the soul of a Christian.... Love your wives but beware lest they get the power over you. When you have learnt anything useful, try to preserve it in your memory, and strive ceaselessly to get knowledge. Without ever leaving his palace, my father spoke five languages, a thing foreigners admire in us....

" I have made altogether twenty-three campaigns without counting those of minor importance. I have concluded nineteen treaties of peace with the Polovtsui, taken at least a hundred of their princes prisoners, and afterwards restored them to liberty, besides more than two hundred whom I threw into the rivers. No one has traveled more rapidly than I. If I left Chernigov very early in the morning, I arrived at Kiev before vespers. Sometimes in the middle of the thickest forests I caught wild horses myself, and bound them together with my own hands. How many times have I been thrown from the saddle by buffaloes, struck by the horns of the deer, trampled underfoot by the elands! A furious boar once tore my sword from my belt; my saddle was rent by a bear, which threw my horse under me! How many falls I had from my horse in my youth, when, heedless of danger, I broke my head, I wounded my arms and legs! But the Lord watched over me! "

THE CROSS AND THE KREMLIN

MOSCOW WAS ONLY ANOTHER WALLED TOWN, in 1325, when Metropolitan Peter swept into the Kremlin wearing his cassock of the Thousand Silver Crosses. He had just abandoned nearby Vladimir after its prince had challenged his worthiness and tried to take from him the highest religious office in Russia, which had been conferred in Constantinople by the Patriarch himself. It was an insult that doomed Vladimir to immediate obscurity and assured the ascent of Moscow's star. Peter appeared beside the Kremlin Throne shortly before a new occupant, Ivan I, was to journey to the Court of the Golden Horde and there prostrate himself before the Khan, promising complete subservience—in return for the coveted title, Grand Prince of Moscow. Within two generations, by 1364 when Alexei, Moscow's third Metropolitan, donned his cassock of the Golden Cross, the authority guaranteed by the strange coalition of Orthodox Church and Tartar Horde gave inhuman powers to whoever held the Kremlin. It was the fountainhead of autocracy in Russia, the source of strength inherited by every subsequent Kremlin ruler who grasped for empire.

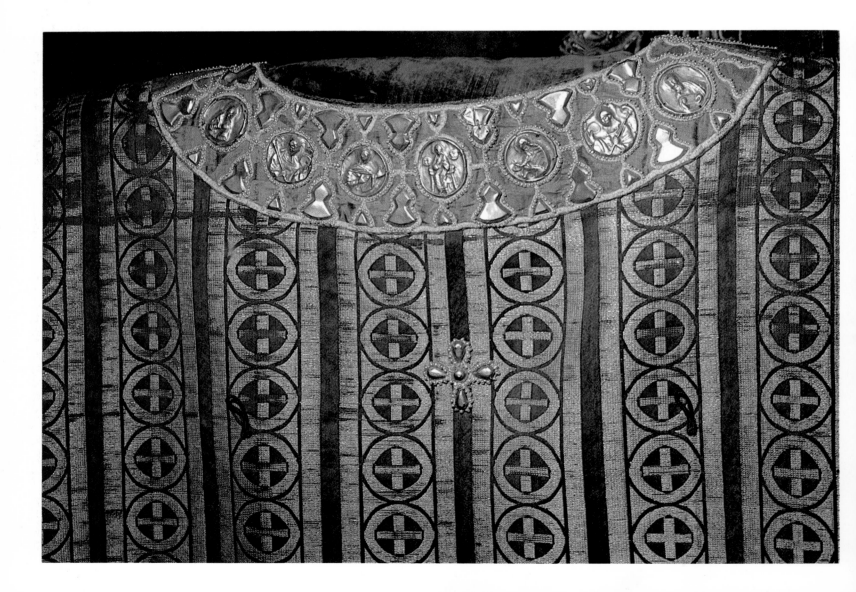

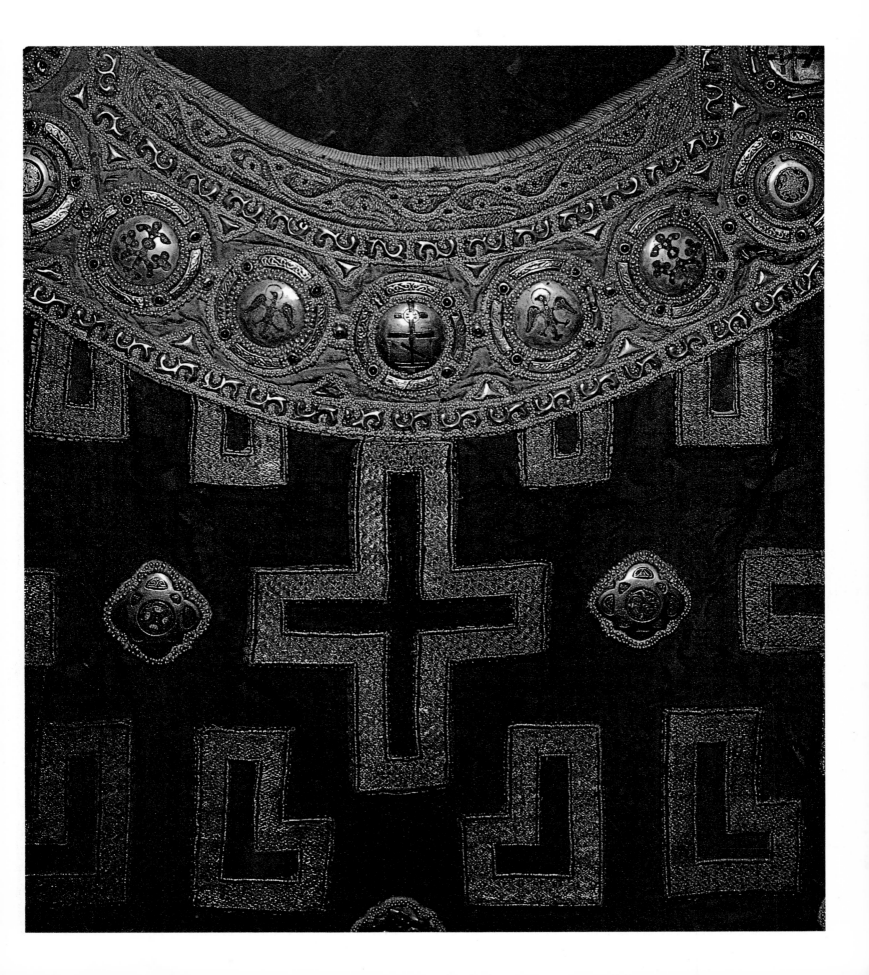

IT WAS A TWILIGHT, HOPELESS WORLD for the Russian peasant born in 1400, and there was no escape from the crushing servitude or the bleak illiteracy of daily existence—no escape, that is, except on those rare Sundays when as a boy he journeyed with his father to Moscow and there squeezed into a corner of the Assumption Cathedral for a glimpse of God's Own, Metropolitan Photius, praying before the altar in his cassock of pearls—the cassock of pearls which was known throughout Russia, for it told in pictures the Story of Jesus so that everyone could understand.

AND HE BOUGHT FINE LINEN, AND TOOK HIM DOWN, AND WRAPPED HIM IN THE LINEN, AND LAID HIM IN A SEPULCHRE WHICH WAS HEWN OUT OF ROCK, AND ROLLED A STONE UNTO THE DOOR OF THE SEPULCHRE. AND MARY MAGDALENE AND MARY THE MOTHER OF JESUS BEHELD WHERE HE WAS LAID.

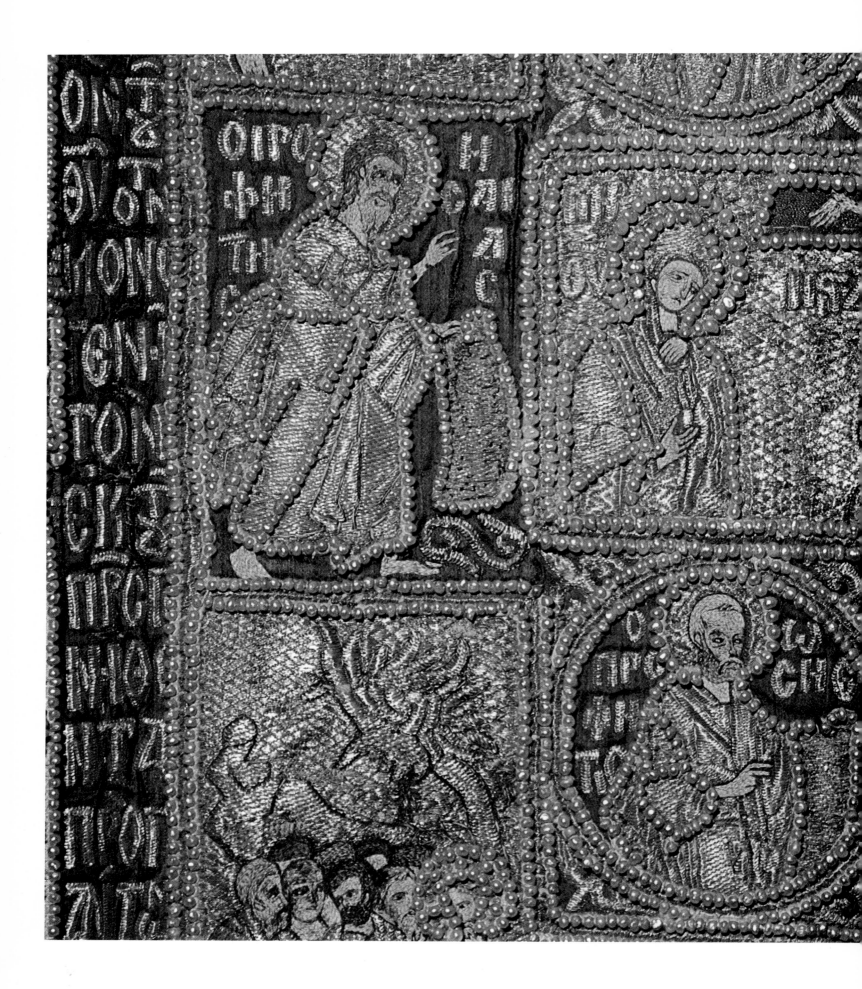

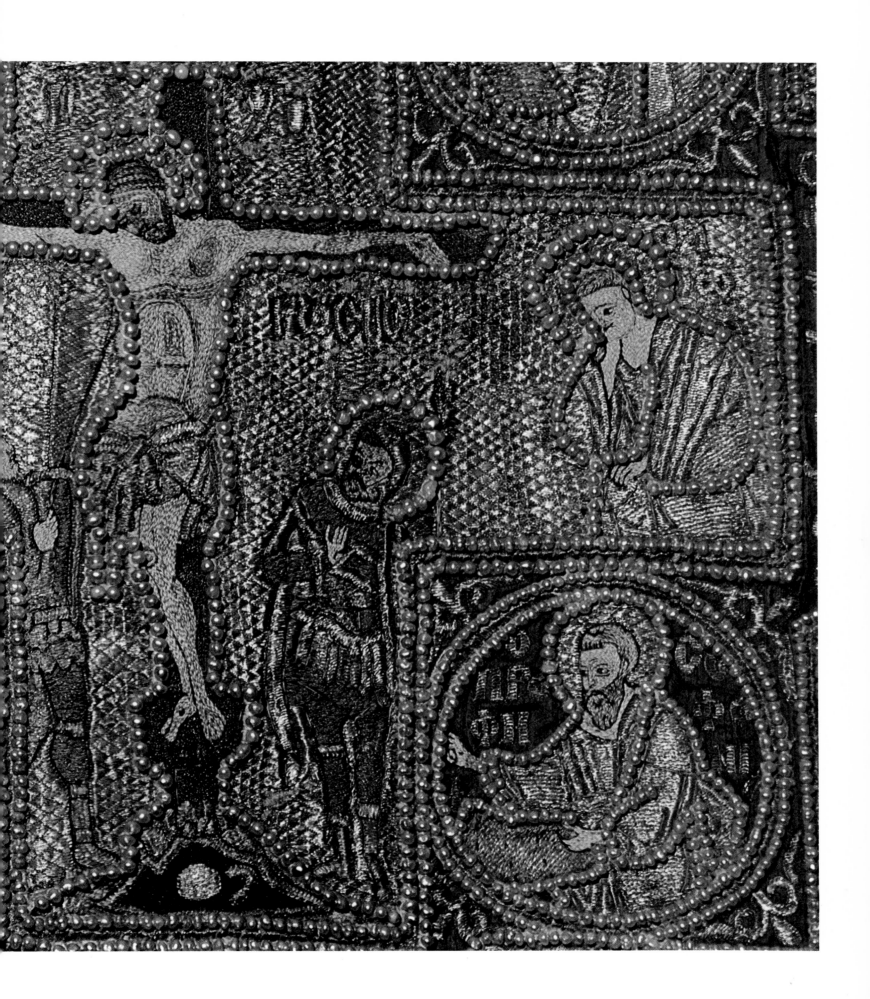

...and Photius had another robe, a pageant robe,
with Christ's Story woven upon Crosses of flaming gold...
yet its message still was pure and plain—for everyone, forever, it was the same...

THEN JESUS SAID,

FATHER, FORGIVE THEM;

FOR THEY KNOW NOT WHAT THEY DO.

WHILE HE BLESSED THEM, HE WAS PARTED FROM THEM,
AND CARRIED UP INTO HEAVEN.
AND THEY WORSHIPPED HIM...

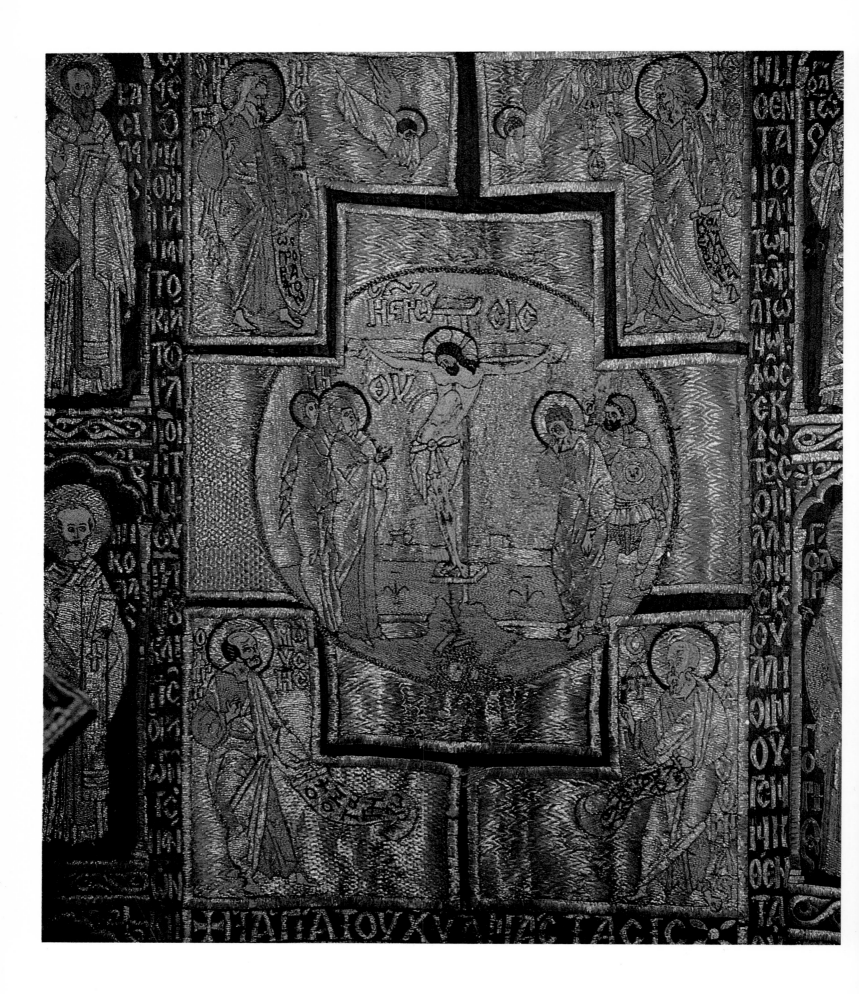

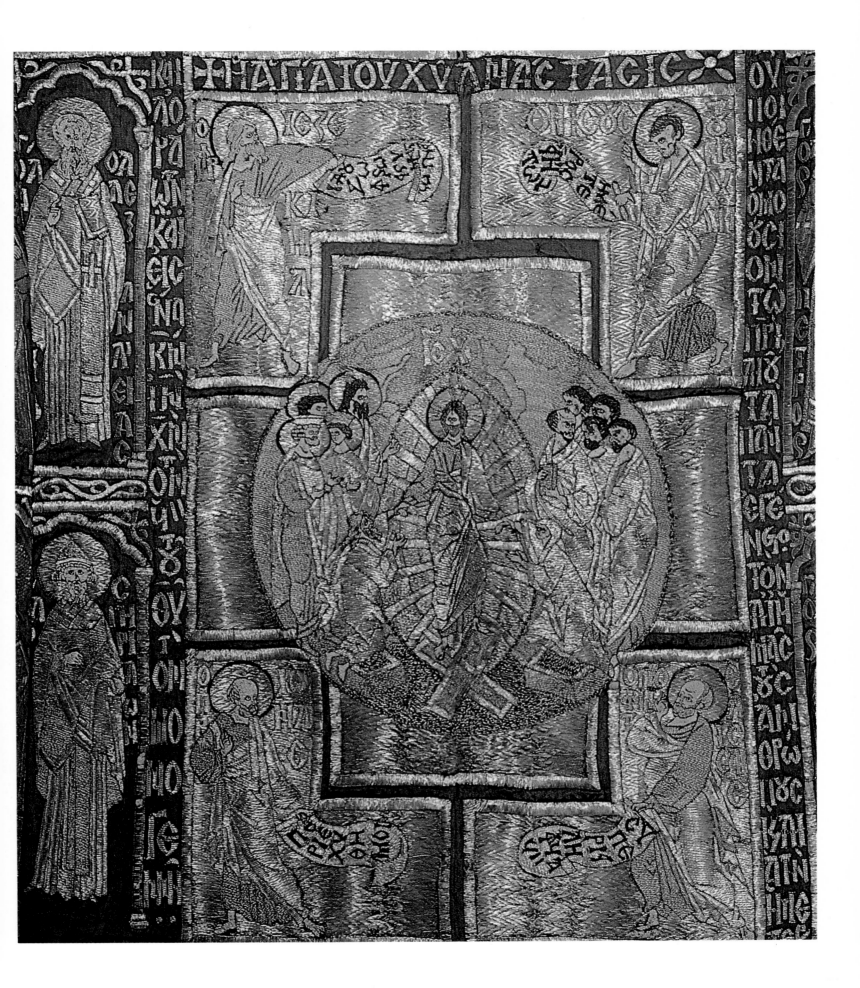

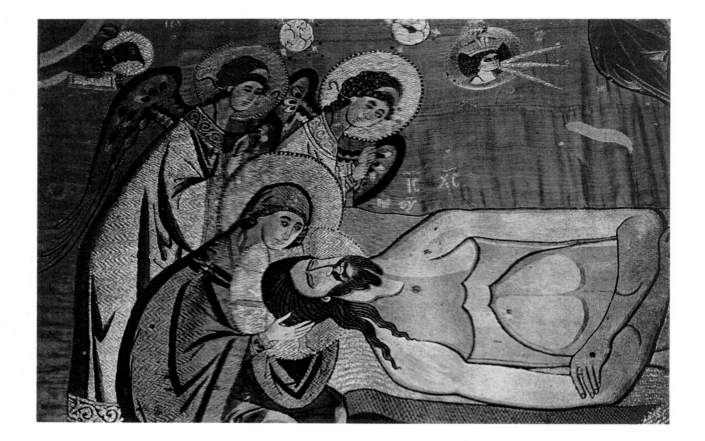

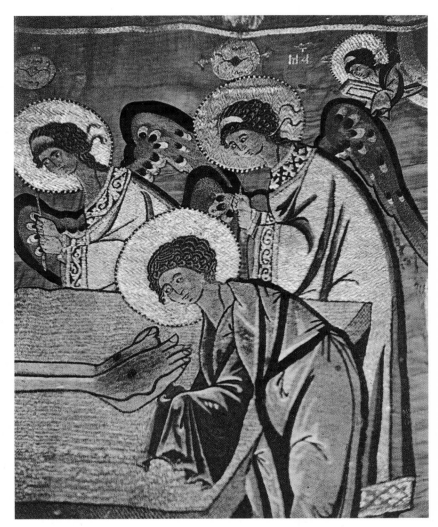

...there it lay, draped across the altar each year,
each year after 1441; silent and silken it lay there,
just once a year, from Good Friday through Easter
and all in the passing multitude bent,
and they did kiss it,
for it was...

THE CLOTH OF CHRIST

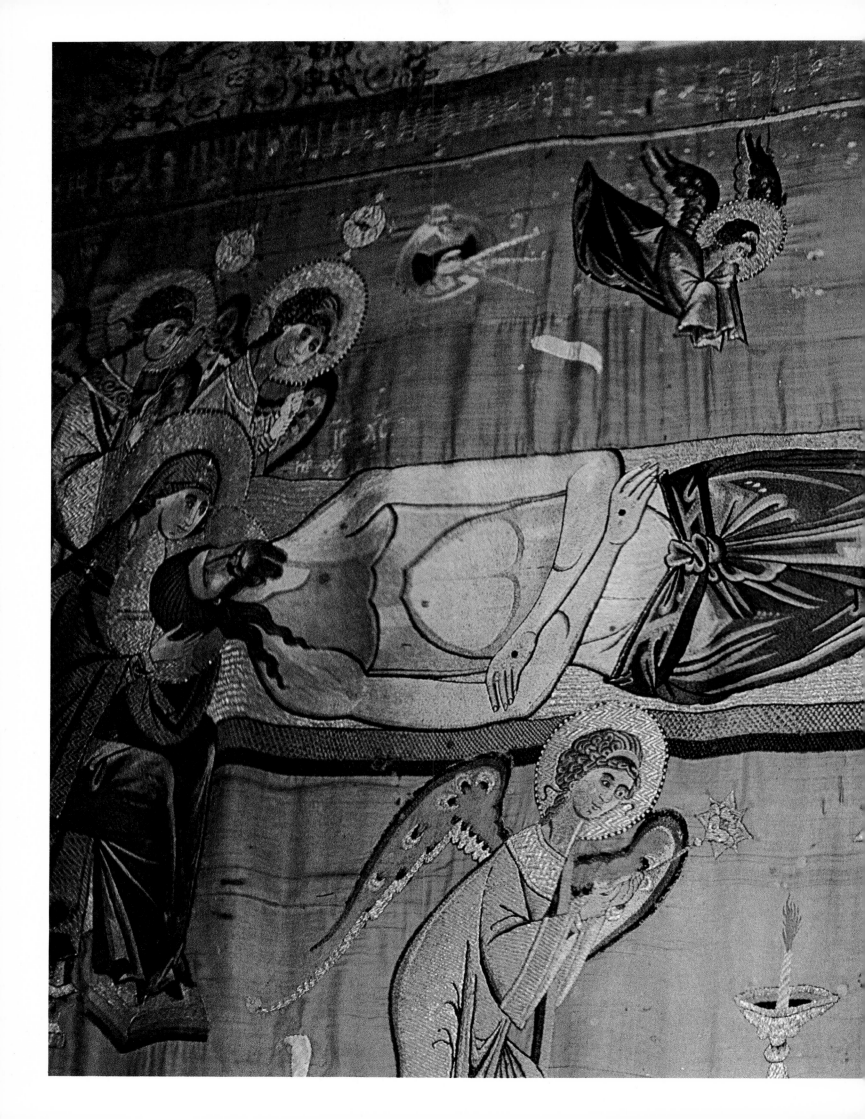

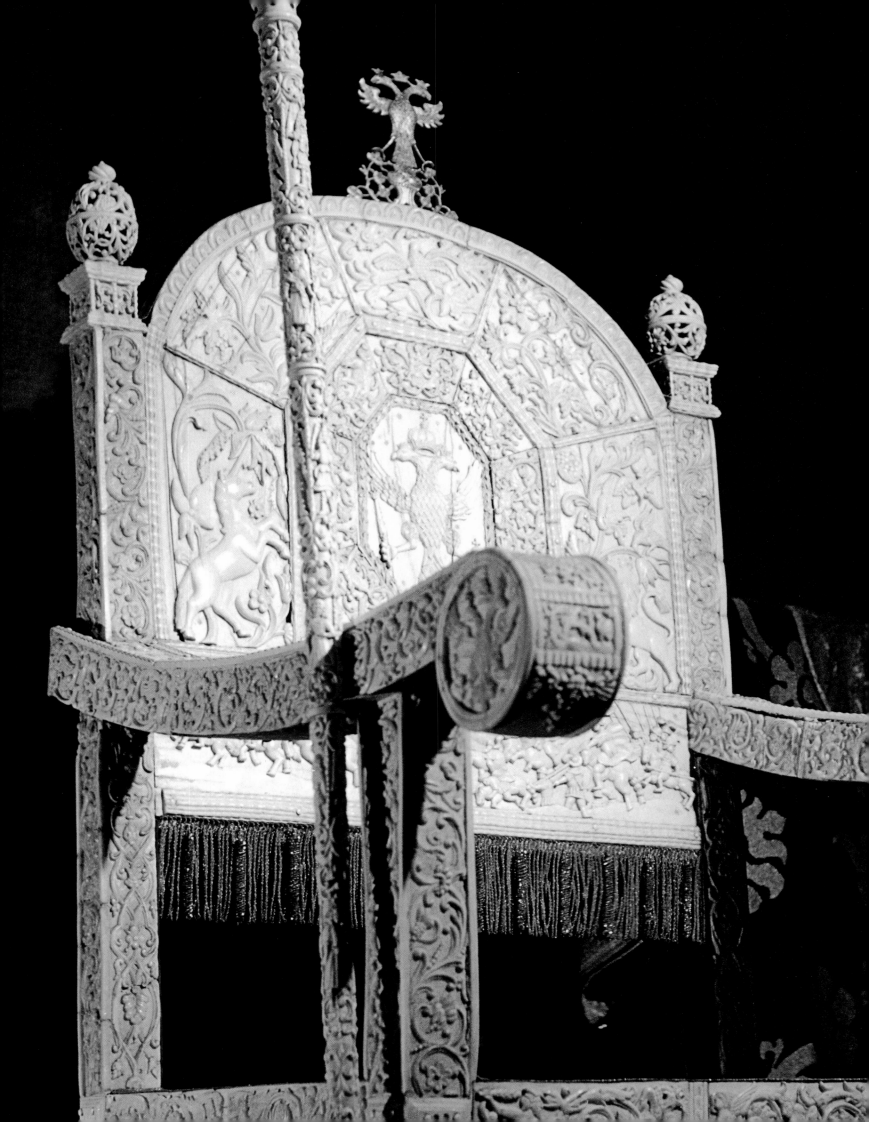

"WE, BY GOD'S GRACE, are sovereigns in our land from the beginning, from our first forefathers, and our appointments we hold from God." After that curt reply to the Holy Roman Emperor's offer to call him a king, Ivan III promptly ordered an assembly of priests and aristocrats into the Kremlin and proclaimed himself "Sovereign of All Russia." The year was 1494 and he had just finished a war against his ancient enemy, Lithuania, from whom he forced the same recognition of title. By 1503, two years before his death, Ivan's territorial ambitions had aroused such deep anxiety that he received threatening protests from the thrones of Hungary and Poland, and even complaints from the Pope—all of which he ignored. He was the helmsman of his country through forty-three turbulent years when sprawling, archaic Russia was welded into an empire by his political intuition, murderous ambition, designs of grandeur, sheer treachery and outright military good luck.

When Ivan the Third moved into the Kremlin, in 1462, the fortress was a decaying wood and stone relic of Russia's dark ages. Moscow itself was only another tribute-paying vassaldom of the Khan of the Golden Horde who ruled from Sarai, his distant capital on the Volga. Hostile Poland and Lithuania continually sent armies to chew great chunks from the country's western frontiers. Far to the south in Constantinople the parent church of Russia's Orthodox faith had just fallen to the Turks. Finally, right within the land which Ivan had so magniloquently heralded as "All Russia," there was constant intrigue and even open warfare raging between Moscow and such odd-sounding but important places as Tver—Yaroslav—Verea—Vyatka—Perm—Vladimir. The chaos was such in Russia at that time that a folk tale handed down by later generations began with the lines: "What man could have thought or divined that Moscow would one day become a kingdom? Or what man could ever have foreseen that Moscow would be accounted an Empire?" But there *was* precisely such a man—a pitiless, unscrupulous visionary named Ivan Vasilievich, who, as Ivan the Third, was the Ivan who:

In the first year of his reign was confirmed by the Tartar Khan of the Golden Horde as the Grand Prince of Moscow and in exchange became the Khan's tax-collector, census-taker and administrator of justice—and injustice—to other Russians; arranged the marriage of his daughter to a Lithuanian prince soon to inherit the Polish throne, in hopes that she might intrigue for him within those courts—then attacked to "save" her when she refused to compromise her husband's faith; chose as a second wife a niece of Byzantium's last Emperor, who may have brought to Moscow in her dowry the magnificent, carved Ivory Throne that was later used in the coronation of every Tzar and Emperor and which tradition attributes to his bride; took the double-headed Byzantine eagle as his own crest; bestowed upon himself the additional title of *Tzar* (Caesar); referred to Moscow as the phoenix of Christianity, the Third Rome; imported Italian architects to rebuild the Kremlin's walls, towers, palaces and cathedrals; by infiltration and assassination defeated and absorbed his princely Russian neighbors; in 1480, after provoking the Tartar Horde into attacking Moscow, tried to flee but was paralyzed by the words of a scornful priest, named Vassian, who thundered the threat of Doom in his ears: "You are not immortal. Fear you, too, shepherd! Will not God exact this blood from your hands?"—then later, rigid with fear, stood at the edge of the frozen river Oka on the morning of 19 November, 1480, and saw a sight unique in the military history of the world: 100,000 men of the Muscovite army stood poised to repel the 100,000 men in the Tartar Horde across the river's ice—then both armies simultaneously broke and ran, thus ending forever the Mongol threat to Russia. Thus, too, was added ignominiously, but irrevocably, another laurel to the crown—and to the name of Ivan Vasilievich, Ivan III, Sovereign of All Russia—Tzar:

IVAN THE GREAT

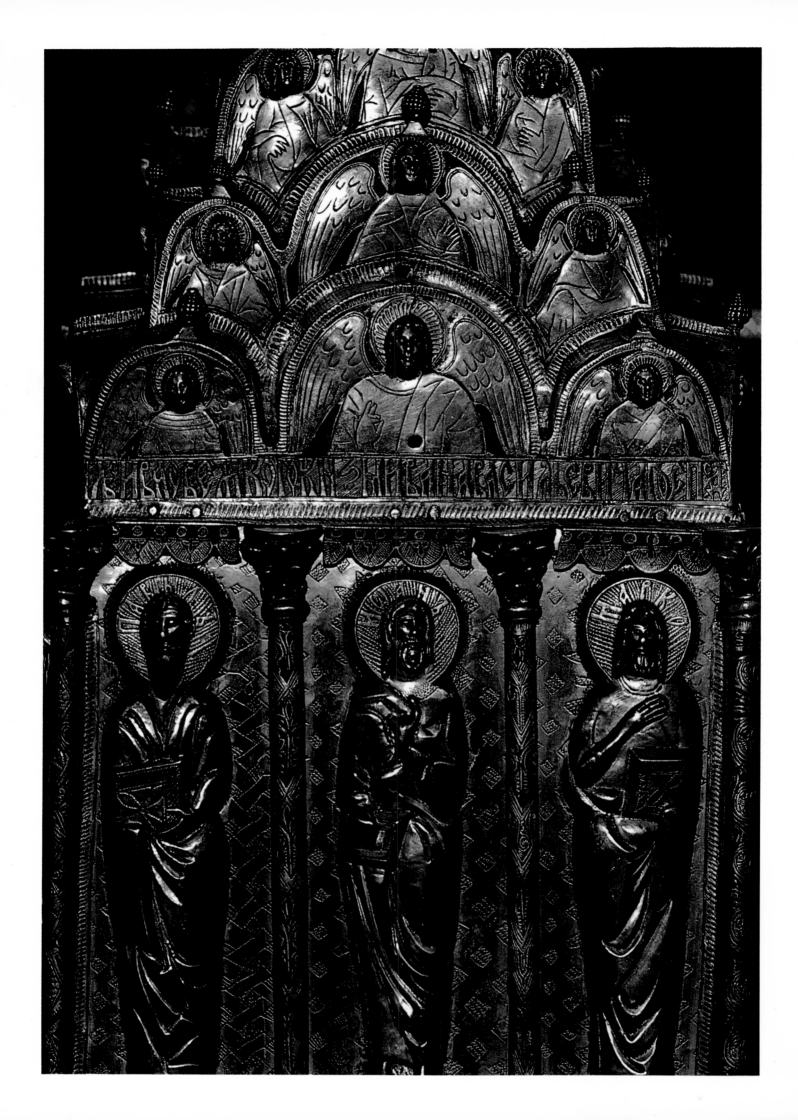

TWO GIFTS—and the life-seed of Russian empire—were handed down to succeeding generations from the reign of Ivan the Great; one, a silver " Jerusalem " or Tabernacle of Jesus, which was carried by priests in cathedral processions so that each of the faithful could see Him and His Mother and all the Apostles crowned with an aureole of angels; and the other, an emerald-enamel and spun-gold filigree web enmeshing the Book of Holy Gospels which Ivan deposited upon the Assumption Cathedral's altar fourteen hundred and ninety-nine years after...

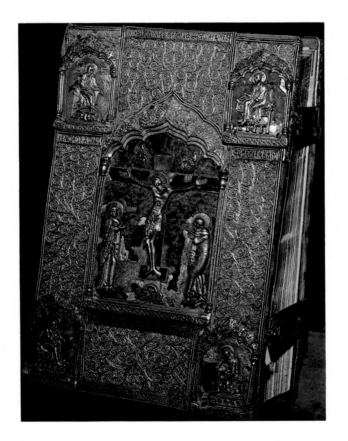

HIS TEACHINGS AND CRUCIFIXION

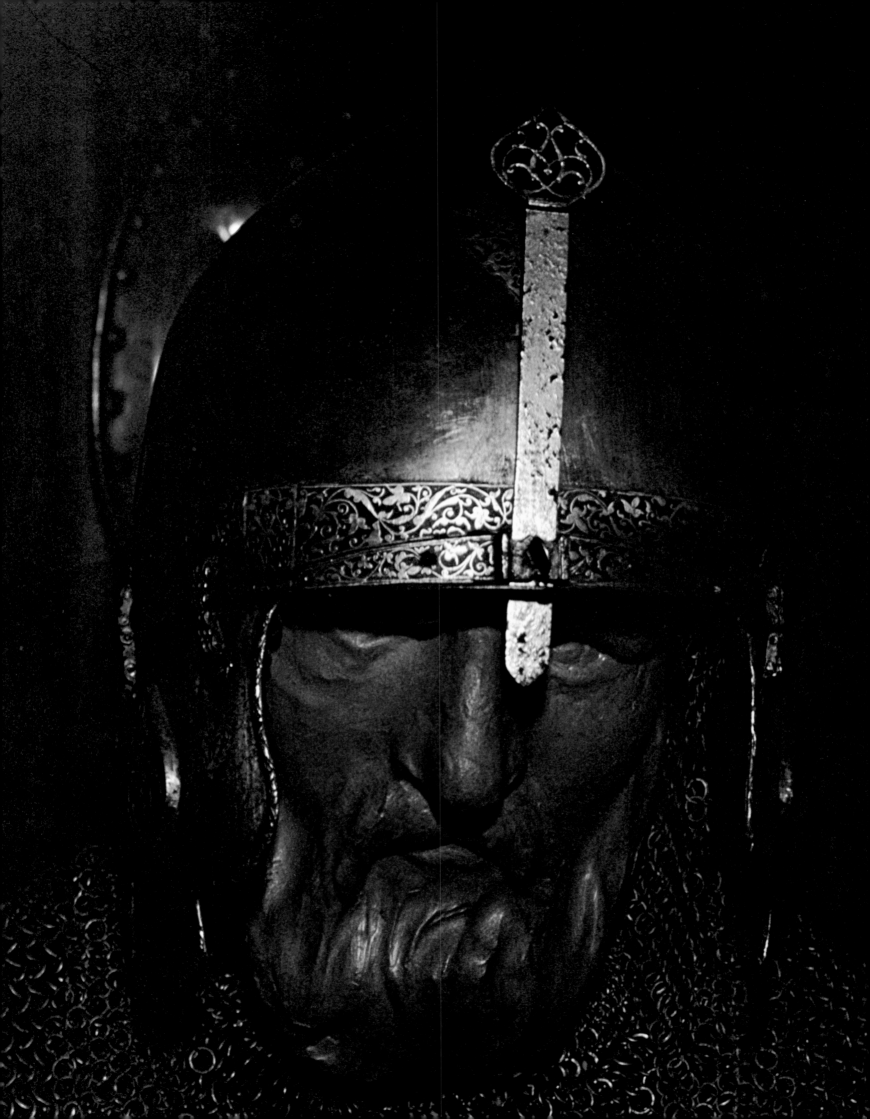

"DOST THOU THINK THYSELF THEN IMMORTAL, O TZAR...
Dost thou think that thou canst escape the incorruptible Judge, Jesus our
God?" The message was read in a whisper. Never before had such a letter
been received in the Kremlin. The servant who had carried it from his
refugee Russian master—at that moment safe in faraway Poland—now
stood in agony but without a word, a steel-tipped pike pinning his foot to the
royal staircase which he shared for those last moments of his life with...

IVAN IV
THE TERRIBLE

HIS SADISTIC IMAGINATION

THE GHASTLY LIFE of Ivan IV fills perhaps the most tormented page in the entire history of mankind. He was born in the Kremlin, in 1530. He became Tzar at the age of three. His young brother was an imbecile. His mother, acting as his Regent, was murdered when he was eight. His devoted nurse, Agrafena, was imprisoned. Riotous boyars who fawned over him in public were openly contemptuous of him and his throne in private. One Andrei Shuiski, a leader of the aristocratic boyars who were looting the treasury and land, even went so far as to sprawl upon the bed of the child-Tzar's father—and there taunted the youth's frustrated anger. It was a mortal error. The boy, through self-taught reading, had learned that he *was* the Tzar. During the next assembly in the Palace of Facets the thirteen-year-old ruler raised a hand for silence— which was humorously granted by the boyars—then commanded court attendants to seize Shuiski, wrap him in animal hides and throw him to caged wolfhounds which, of course, ripped him to pieces.

At the age of seventeen Ivan staged his own coronation—the first of any Russian sovereign—where he also officially for the first time took the title of Tzar. The year before he had married Anastasia Romanov. Domestic happiness and military good fortune seemed to bless those early days of his reign—despite the ill omen of a holocaust which destroyed Moscow and parts of the Kremlin the year of his wedding. When only twenty-two he personally led his armies against the mighty Tartar kingdom of Kazan, Islam's bastion on the middle Volga. Heeding the advice of a German engineer—while experimenting with recently introduced gunpowder—he breached the city's walls, then massacred its inhabitants. The victory opened central Asia to Russian colonization. Four years later, in 1556, the Tartars' Caspian kingdom of Astrakhan fell to Ivan's generals. Muscovy had won the entire Volga, Europe's greatest river.

In the same year that Astrakhan was conquered Ivan played host to an adventurous band of English traders under Richard Chancellor, who had " discovered " the Kremlin three years earlier while searching for a northern passage to India and China. The Tzar granted vast commercial concessions to the foreigners in return for little more than their promise of friendship. He foresaw approaching war with Poland, Sweden and Lithuania, and hoped to secure supplies of modern weapons, military instructors and possibly even an ally far beyond the flanks of his enemy neighbors. He was the first Kremlin ruler to envision an outlet into Europe, a goal which his western enemies were to spend the next century and a quarter trying to prevent. War with the Baltic states started in 1558—ending in disaster twenty-five years later just before he died. They were the same twenty-five years when Ivan's star fell and Russia quivered under the paranoiac atrocities of his sadistic imagination—when fellow countrymen were hung, quartered, boiled alive, roasted on spits, thrust beneath rivers' ice, starved in solitary dungeons, stuffed with explosives and set afire, poisoned, or simply hacked into halves by the saber-wielding Tzar himself.

Ivan's wife Anastasia died suddenly in 1560. The Tzar was convinced that she had been poisoned by agents of his formerly trusted adviser Alexis Adashev who, together with the priest Silvester, another adviser, had objected strenuously to his plan for launching war in the Baltic, a plan which Anastasia had understood and approved. They had proposed war against the Crimean Tartars; Christianity against Islam. Adashev was exiled in the west; Silvester to a monastery in the Arctic. With Anastasia's death and their departure all cords

TURMOIL AND RUIN

of restraint fell away from Ivan's wrists. In mid-winter 1564, he unexpectedly loaded most of the Kremlin treasure and his immediate family upon sleighs and vanished into the snows of the north. No one knew why—nor his destination—and none dared to follow. Moscow's population panicked; peasants feared aristocrats, and the aristocrats dreaded the peasants. A month passed without any word from the Tzar.

Then two letters arrived in the capital. One, addressed to the Metropolitan of Moscow, accused the aristocracy and clergy of treachery, graft and treason. The other, Ivan addressed to the ordinary citizens and merchants of the city, stressing the point that all troubles of the Throne were the fault of the boyars' greed and church interference. In each letter Ivan hinted that he would return to the Kremlin if petitioned by both groups but only if given complete freedom to rule as he thought necessary. The coup was successful. Wailing delegations marched out through snowdrifts to the monastery where he had taken refuge and there beseeched him to return under any terms he decreed. Ivan re-entered Moscow—and eighty gibbets appeared simultaneously in Red Square. The carnage which followed, as reported by the few foreign diplomats who ventured out of their compounds, was so frightful as to be mostly unprintable.

It was at this moment that Ivan invented the *oprichnina*, men dressed in black, mounted on black horses, a dog's head on the pommel and a broom alongside the saddle. They were his watchdogs, charged with routing evil from the land. He concurrently created a counter-group called the *zemshchina* and gave it to the aristocracy—even installing a Tartar-converted Christian on a throne and mockingly calling him "tzar". The two factions were forced to battle each other in a civil war that was prompted and controlled by the Tzar. Russian life was rent to shreds during the years that the *oprichnina* rode the countryside. Children saw their parents dismembered in front of their houses. Husbands were forced to share dinner tables with murdered wives whose bodies they were prohibited from burying. No individual or home was secure from their raids, no property immune from confiscation. The few survivors of ancient nobility who fled to the outermost corners of the land were forbidden from marrying within their own social level. Almost none escaped beyond Russia's frontiers, because the Tzar exorbitantly fined nearest relatives and neighbors if anyone disappeared. Thus Ivan shattered families equally as aristocratic as his own, and destroyed all opposition to his dynasty.

A truly heroic priest, Metropolitan Philip of Moscow, tried to turn Ivan's hand—and was strangled for his efforts. It was hopeless. All Russia was in turmoil and ruin. Abroad, Swedes, Poles and Lithuanians sliced vast wedges from the territory which Ivan had inherited from his father, Vasili III, and his grandfather, Ivan the Great. The Crimean Tartars surged north to pillage and put Moscow to the torch, avenging the loss of Kazan and Astrakhan. Only in Siberia, where a renegade Cossack named Yermak had turned pioneer and settler, was Russia's horizon still expanding. But it was in the Kremlin itself that final disaster descended upon Ivan. He had been mercilessly taunting his daughter-in-law, who was soon to bear a child. His son, Tzarevich Ivan, in coming to his wife's rescue so infuriated the Tzar that he struck the boy with his steel-tipped pike. The blow was fatal. Ivan had murdered his own pridefully tutored heir to the Throne which he believed had been placed in his trust by an act of God. Three years later, broken, gaunt, wracked by paroxysms of incoherent lunatic babbling, Ivan the Terrible died. He was fifty-three.

73

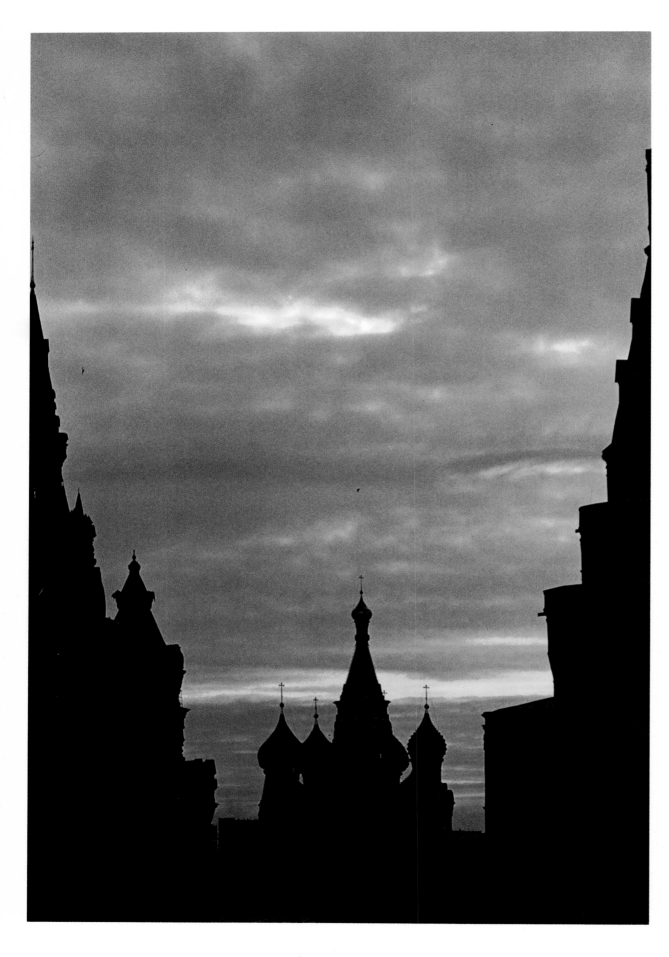

Wild revelry and a cathedral and crown were ordered by Ivan the Terrible to commemorate his 1552 victory on the Volga over the Tartars of Kazan. Four centuries later, visitors to Russia still cherish sunsets viewed from across Red Square with its silhouetted Vasili Blazhenni, the Cathedral of St. Basil the Blessed. During those same centuries no one beyond the walls of the Kremlin saw the Tzar's other masterpiece — Ivan's Crown of Kazan — a double handful of gold filigree, turquoise, pearls, rubies and topaz which mirrored every contour of St. Basil's shrine. When first completed and delivered to the Tzar a cabochon ruby —pigeon-blood red— glowed ominously on the Crown's peak but it was removed to be set into a crown for old Ivan's namesake, Ivan V, more than a century later—even though the last Ivan was a total idiot so perhaps did not like the great gem at all.

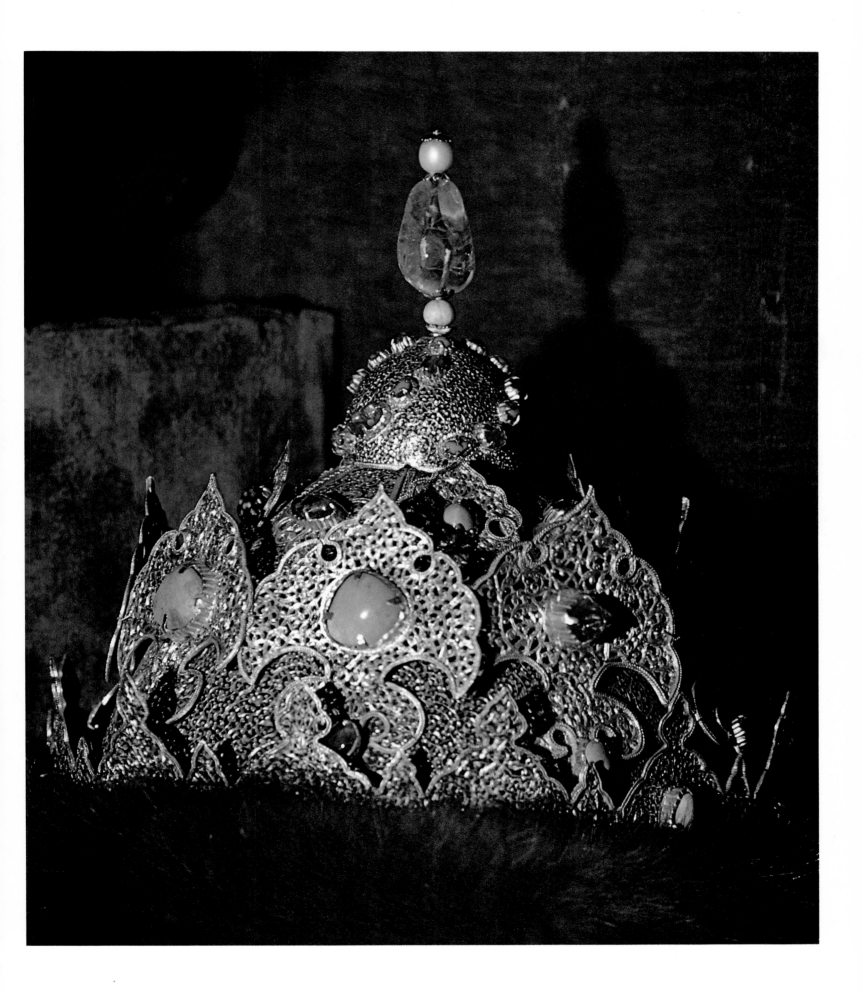

ONLY MEN OF GOD

A few Metropolitans of Moscow stood alone in their Cathedrals—stood denouncing the tyrant's reign—

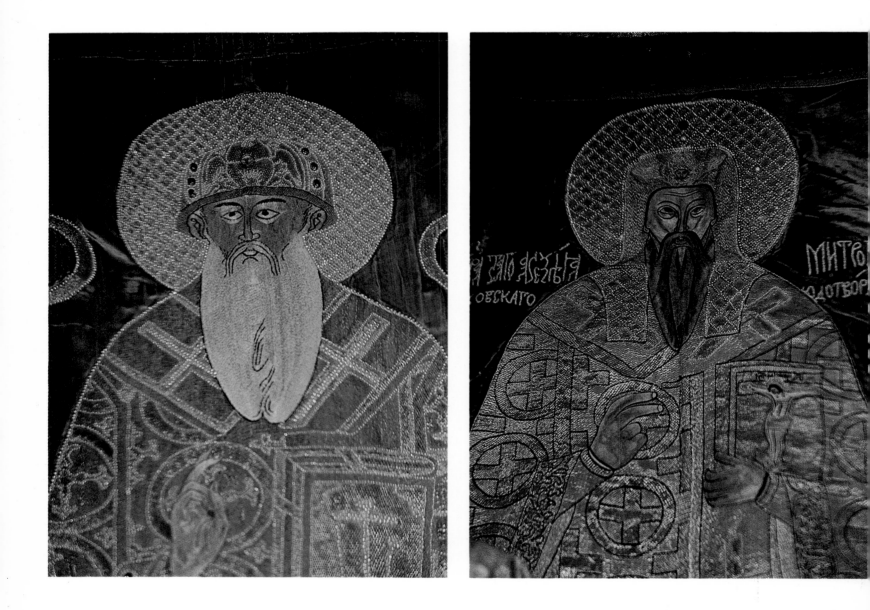

DEFIED THE TZAR

-stood and spoke and perished—by the same hand that spread portrait-shrouds of gold on their graves.

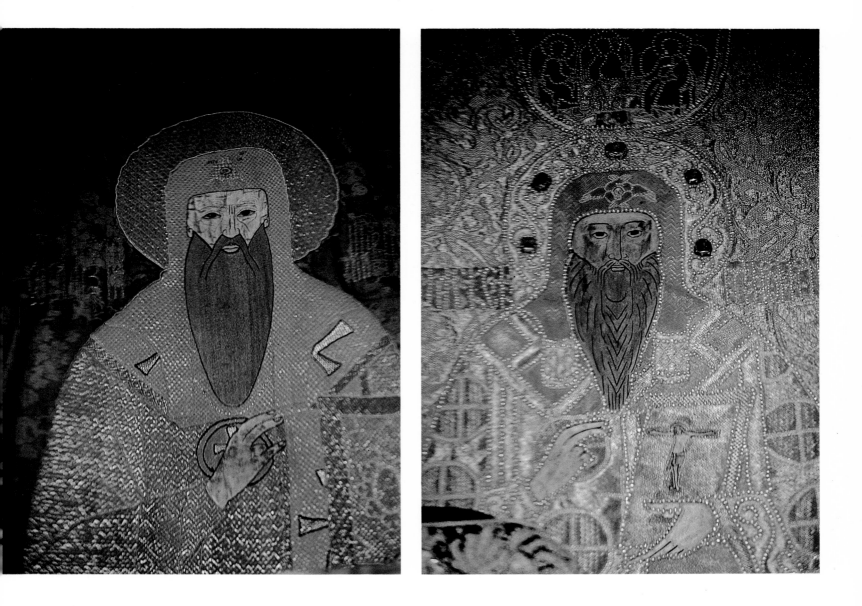

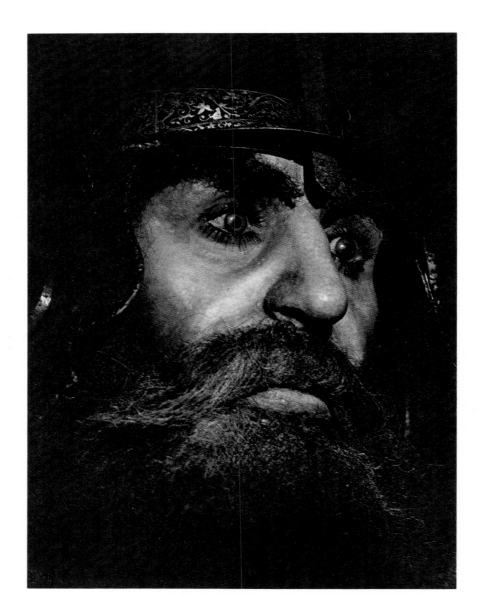

Because he thought of himself
as a most saintly man...

THE TERRIBLE IVAN
CONSTANTLY PRAYED

...for those legions of souls
whose earthly existence he had destroyed.

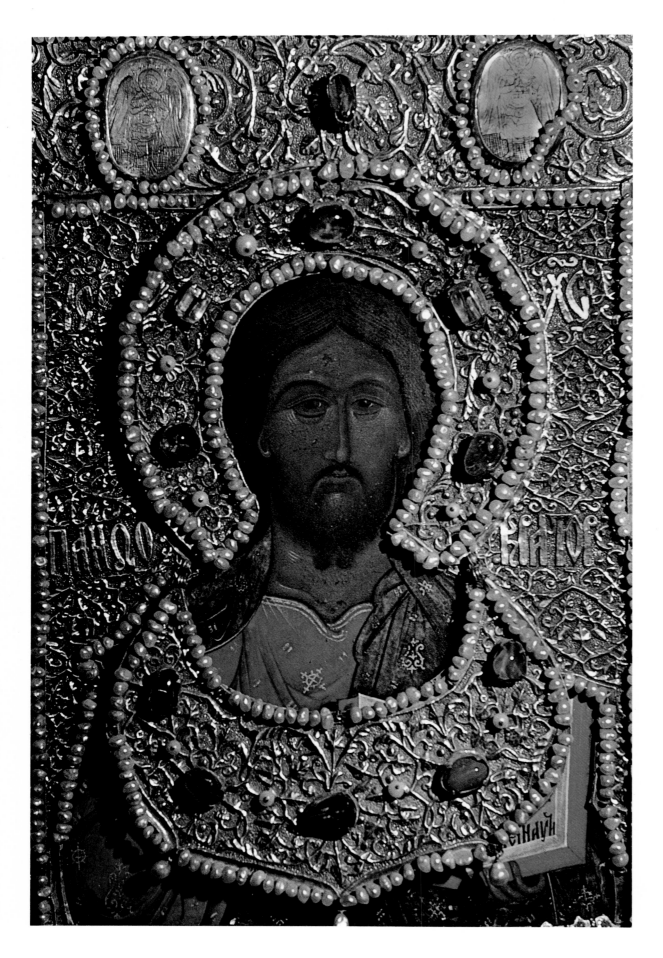

Ivan IV, the Terrible, slumped into eternal silence before whole walls of sacred icons to which he daily stumbled for solace after murdering his eldest son. During fits of sheer madness and frenzied, head-pounding anguish, he would never have noticed some subtle changes in a few of the images of Jesus gazing steadily down from their silver-and-jewel frames upon the wall. Influenced by their immediate environment, young local painters of the end of the XVIth century had begun to portray God's Son with a Russian face, unmindful of traditional, centuries-old Byzantine laws which dominated all Church art within the land.

A gift was presented to the Annunciation Cathedral in 1571. It was a Book of Holy Gospels, embedded with rubies, great sapphires, and four solitaires of golden topaz. The Resurrection of Jesus—almost lost amidst the gems—shone in pure silver and sky-blue enamel. The Holy Gospels had been placed on the altar by pious Tzar Ivan the Terrible at the same moment that he and his black horsemen, the *oprichnina*, were massacring the neighboring ancient Russian city called Novgorod. Later he prayed "Remember, Lord, the souls of thy servants to the number of fifteen hundred and five persons..., all Novgorodians."

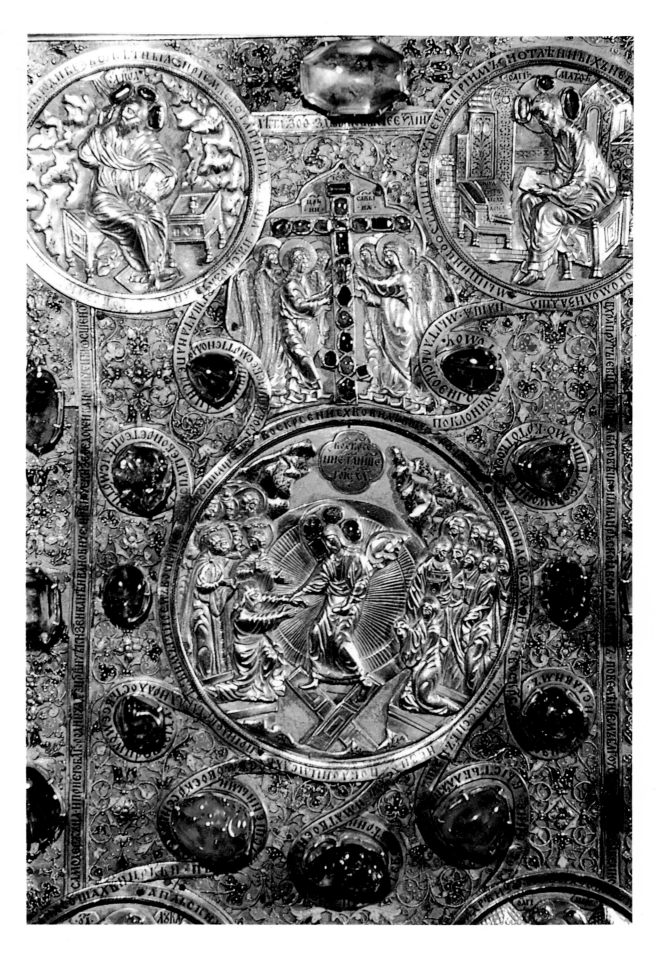

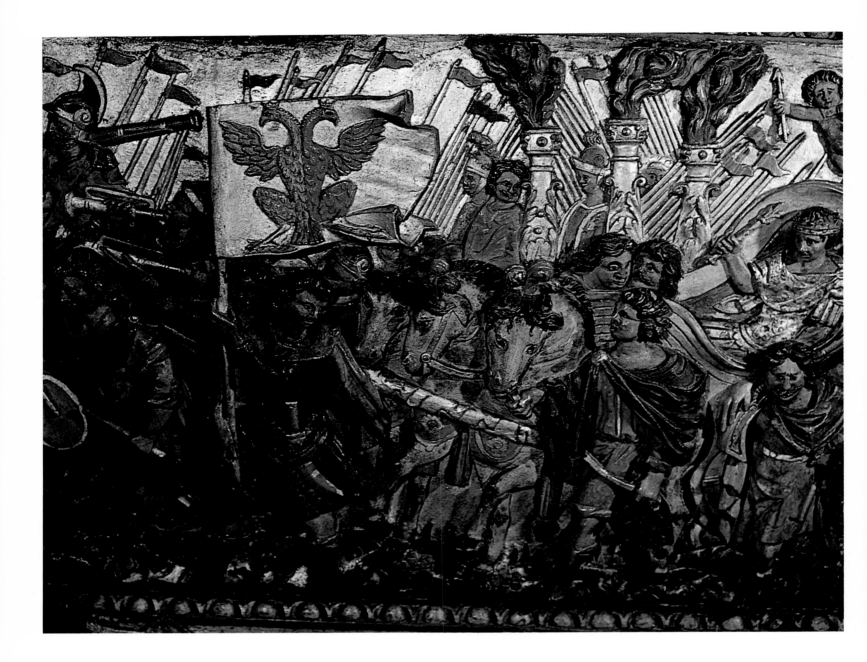

THE VIRGIN QUEEN OF ENGLAND, ELIZABETH, was among the first of western monarchs to recognize the Kremlin's new regime of 1598, when death took feeble-minded Feodor, Ivan the Terrible's pathetic last son—who also was the end of a dynasty that had supplied fifty-two sovereigns for Russia, starting with a Norseman named Riurik eight hundred years before. During Ivan's lifetime Elizabeth had been crudely assailed by the Tzar for not entering alliances aimed at outflanking his enemies on the Baltic. He had accused her of eyeing his under-developed country's friendship only from the viewpoint of a lustful merchant. Elizabeth ignored his insults, which grew even more biting when he sought, but was refused, the hand of the Queen's cousin, Lady Mary Hastings—as his seventh wife. Then, fourteen years later, with Ivan gone, and his son, too, English diplomacy again began to function. Elizabeth ordered a magnificent State carriage—adorned fore and aft with heroic bas-reliefs on carved-wood panels—sent to the Kremlin as a gift for the first man ever to be elected to the Russian Throne, a wily, personable Tartar, Boris Godunov, upon whose name still lingers the suspicion of murdering the son of his friend, Ivan the Terrible, while winning the Crown.

A WILY,
PERSONABLE TARTAR,

BORIS GODUNOV

BORIS DIED IN 1605, long before Elizabeth's gift was delivered at the Kremlin, so he never saw the front panel of the carriage where he was depicted as a golden-armored, garland-crowned, chariot-borne Roman Emperor. Nor did he see the bas-relief carvings on the rear panel which dealt vividly with one of the burning religious issues of that day—the defense of Christianity and the Western world against the onslaught of Islam and the Eastern world, which fought under the war banners of the Sultan of Turkey. The fact that Boris felt Elizabeth might not be fully aware of the dangers in dealing with the Orient, Turkey in particular, was well documented in a letter delivered in London, in 1600, by his envoy Gregory Mikulin. After learning that England had provided assistance to the Turks for campaigns against Austria, Russia's traditional ally in guarding the Moslem frontier, the Tzar wrote: " We are astonished at it, as to act thus is not proper for Christian sovereigns; and you, our well-beloved sister—you ought not for the future to enter into relationships of friendship with Mussulman princes, nor to help them in any way whether by men or silver; but, on the contrary, should desire and insist that all the great Christian potentates should have a good understanding, union, and strong friendship, and make one against the Mussulmans, till the hand of the Christians rise, and that of the Mussulmans is abased. "

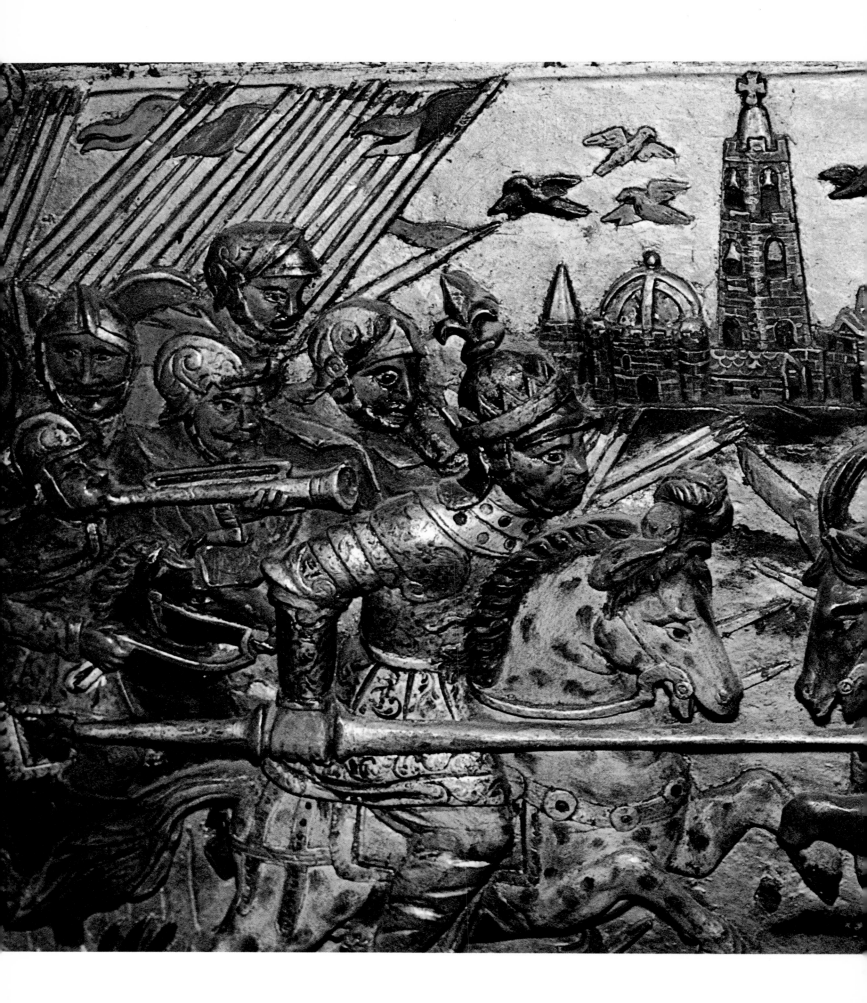

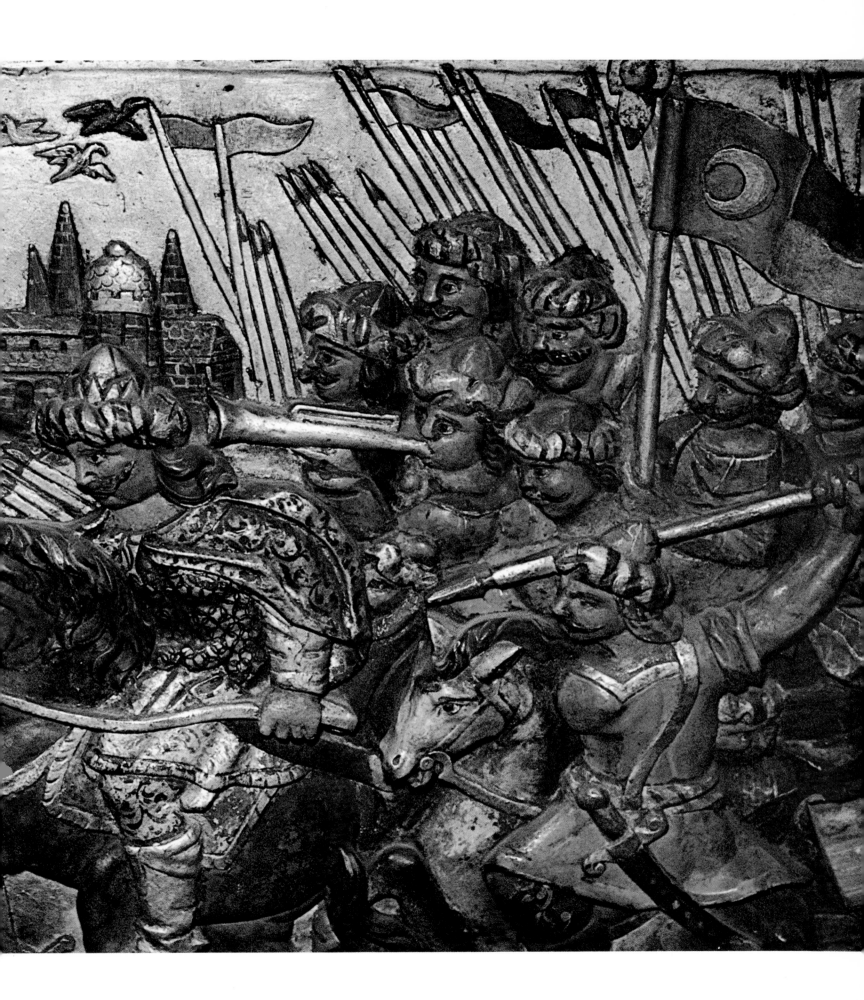

THE TIME

IT SEEMS ALMOST INCONCEIVABLE, in looking back, that any one chapter in the Russian story should be labeled by historians as *the* time of troubles, yet there was just such an epoch at the beginning of the XVIIth century. The Troubles had been brewing for generations under a succession of homicidal tyrants who squeezed the final juices of life itself out of any person or community that resisted their master plan of forging a single autocratic State from the raw stuff which was Russia. After three hundred and fifty years of combined Mongol-Kremlin despotism, superstitious ignorance, total illiteracy, fruitless labor and the corrosive fear of government by murder, there was no real leadership nor even any general concept of cohesive resistance remaining in the few scattered aristocrats, or the mute mass of peasants who survived. The explosion came while the Tartar boyar Boris Godunov was on the throne—when the faceless body of the Tzars' political state fell thrashing back into the black earth from which it had arisen.

The black earth...the peasant mass...the landlord aristocrats...the Church—these four elements were the keys to the Kremlin for any man who aspired to rule Russia. Boris Godunov understood this very clearly. He had learned quickly and unforgettably while serving in the ministerial shadows behind Ivan the Terrible. Watching the death tremors of Ivan's dynasty, when the old Tzar compounded one atrocity with another to cover his failing strength, Boris also discovered that tactics sometimes served better than terror. By the day that Ivan died he was nearly ready to reach for the Crown which Ivan's seventh widow, Tzaritsa Maria Nagoy, refused to accept for herself, nor could accept for her infant son Dmitri, whose legitimacy was unrecognized by the Church which granted no man the right to more than three wives.

Earlier, as one of Ivan's most trusted confidants, Boris had married the daughter of the dreaded Maliuta-Skuratov, chief of the *oprichnina*; his sister Irina had married Feodor, Ivan's only surviving adult son who now was being appointed Tzar. With this power in hand, Boris still quietly waited while Nikita Romanov, Feodor's uncle—the brother of Ivan the Terrible's adored Anastasia—was designated Regent for the vapid young sovereign. Nikita served in his high capacity for only two months, then fell strangely ill and died two years later. With his life fading, Nikita decreed that the Regency should pass to his faithful friend and counselor Boris Godunov.

Boris moved fast. At the very outset of his Regency, in 1588, he won an enormous victory for the Russian Church by persuading the visiting Patriarch of Constantinople to raise Moscow's Metropolitanate to the

OF TROUBLES

rank of Patriarchate—the centuries-long dream of Russian Orthodoxy. Boris then maneuvered an old friend, Job, into the celestial role of being Russia's first Patriarch. It was patronage which the priest did not forget in later years when Godunov was insisting on a free election by the *Zemsky Sobor*—General Assembly—before ascending the throne of the Tzars. With almost equal celerity Boris invoked decrees to arrest the flight of frantic tenant peasants from the fields of insensible, barbaric landlords. It was an age of limitless horizons but little manpower. The decrees reduced the peasant to serfdom but won support for Boris' reign from the increasingly important small landholders. It was this act, as much as anything attributable to Ivan the Terrible or the early Princes, that fueled the ground-fire already creeping toward Moscow from across the desolate steppes. And it was at this moment that Boris seemed to sense the enormity of the conflagration which soon was to sweep Russia, engulfing Moscow and the Kremlin—and him. He knew, too, of his one fatal weakness against which there was no defense. He was not *born* to the Crown. Fear became his companion for the remaining years of his life.

Death struck everywhere around Boris during the following decade. In May, 1591, the Tzarevich Dmitri, Ivan the Terrible's infant son, lay stabbed in Uglich, the village to which he and his mother had been banished. In 1592 a daughter was born to the vacuous Tzar Feodor and Irina, Boris' sister. The child, Theodosia, died the following year. In January, 1598, Feodor himself died. Immediately, Boris Godunov was acclaimed Tzar of All the Russias—after insisting on the propriety of election by a *Zemsky Sobor*. The first to bow before his throne were representatives of the rural small landholders, and bearded Patriarch Job.

Under Boris, fraternal espionage blossomed into a meritorious, highly refined art. Deportations struck every notable family; executions went unheralded by anything more conspicuous than an empty chair at a dinner table. Nearly all of one generation of the Romanov family disappeared in 1601—exiled or killed—which extermination curiously spared one set of widely scattered parents and one son, who was to establish the final imperial household of Russia.

Boris resorted to every imaginable device of atrocity and torture in holding the Throne but his time was fast running out. Uncontrollable murder and cannibalism stalked the streets of Moscow when the food shortage of 1601 became a famine of such frightful proportions that practically nothing edible entered the capital for three full years. Then, in 1604, a monstrous sigh escaped the broken land—Tzarevich Dmitri, Ivan's

HYSTERIA AND HOMAGE

son, was *alive*! He had escaped his murderer. Even now he was marching on the Kremlin. He would put the despised Tartar Tzar to flight. But Boris did not run. It was too late. He simply died. His son, Feodor, ruled as Tzar for six short weeks, until assassinated. Then the living myth, an absolute impostor, the False Dmitri mounted the Throne amid hysteria and homage paid by a multitude of men—who knew he was a fake.

The False Dmitri, who now became Tzar, was an extraordinary character and phenomenon even for Russian history. He may have been born plain Yuri Otrepiev—his origin was never known—who had served for a brief time in the household of Nikita Romanov then later, under the name of Gregory, had lived as a monk in the Patriarchate of Moscow. It was there, after rummaging through Church files on the Tzarist regimes, that he let it be known that he was the Tzarevich Dmitri who had actually escaped the killer's knife. Outraged priests expelled him from the Patriarchate. He fled south to join the renegade Zaporog Cossacks, then wandered through Lithuania and into Poland everywhere telling the same story of his royal parentage. Whether the tale was true or false made scant difference—the land was ripe to rally around anyone who appeared with a cause which justified marching on Moscow to expel the despised Boris Godunov.

In Poland, after falling in love with a nobleman's daughter, Marina Mniszek, the impostor became ill and on his "deathbed" confessed his noble origins to the attending Jesuit priest—who felt obliged to reveal the "confession" to the Polish king, Sigismund. From then on the False Dmitri's cause took wings. Support for a campaign against the Kremlin came from all sides, particularly from exiled and refugee Russian aristocracy. Dmitri embraced Catholicism to placate Marina's father and to win approval of the Polish clergy who had long prayed for a way to unify Poland and Russia under one church—the Roman Catholic. Dmitri crossed the frontier of Muscovy in October, 1604. Eight months later, on 19 June, 1605, after battles, reverses and victories—with Boris Godunov and his son both dead—the False Dmitri entered the Kremlin and was crowned Tzar of Russia.

Shortly after ascending the Throne the impostor sent for his Polish fiancée. They were married in the Kremlin. Doubts soon arose about the imperial lineage of the impostor's blood. He sent for his "mother" the Tzaritsa Maria Nagoy—who had taken the veil as the nun, Marfa. Much to everyone's surprise, probably including his own, she confirmed that he was indeed her son, the Tzarevich Dmitri. The identification perhaps delayed the end but only slightly. Eleven months after being crowned Tzar, at dawn of 17 May, 1606, the False Dmitri and hundreds of his Polish consorts were murdered upon the palace courtyard of the Kremlin.

TOTAL ANARCHY

His " mother " then retracted identification of her " son " whose body was burned to ashes, poked into a cannon and fired back toward Poland. His assassin, Vasili Shuiski, took the Crown just in time to meet the threat of still another false Tzarevich, this time Peter—said to be the son of feeble Feodor in total disregard of the fact that Feodor's child had been a girl. The origins or fate of the impostors meant little to men who sought any excuse to rebel against the depressingly futile nature of their lives. Peter was hanged. Then, as though to underscore the depth of chaos existing across Russia, new followers rallied to the banner of a *second* False Dmitri. An inspired vagabond claimed that he was the late Tzar Dmitri, who had not perished in the early morning massacre of 17 May. The evidence that the first False Dmitri was a redhead, while he was dark, was ignored. Finally, to stretch the incredible into the fantastic, the false False Dmitri demanded a face-to-face meeting with *his* mother —the same nun Marfa—who again joyfully exclaimed that he was her son! To nail down his legitimacy beyond any doubt the false False Dmitri then confronted Marina, *his* wife from Poland, who joyously threw open her arms and cried that he was her husband! Total anarchy ruled Russia.

Polish, Swedish and Cossack armies swirled across the countryside. Tzar Vasili Shuiski abdicated, tried to escape, but was captured by the Poles who shipped him off to Warsaw where he was dragged through the streets like a criminal—a novel experience for a Russian ex-Tzar. The Poles also got to the Kremlin first, where they placed upon the Throne a boy named Vladyslav, a son of their own King Sigismund. The youth and his troops were almost immediately trapped by the first genuinely spontaneous national army ever raised in Russia, led by a butcher named Kuzma Minin, and a petty prince, Dmitri Pozharsky. This national army alternated between fighting the Poles and skirmishing with the Cossacks who, with camp-following rabble, were ravishing the land even worse than the invaders. The Swedes stayed in the north where they had occupied the city of Novgorod. Finally, the national army and the Cossacks were obliged to join arms to face a common foe.

Fresh Polish columns were marching to relieve the starving garrison still trapped in Moscow. The invasion was repulsed and on 27 October, 1612, the Polish flag was ripped from the Kremlin. Its defenders had been under siege for one and a half years. Among the first of the Russian prisoners to be liberated from the wreckage of the ancient fortress was a young nobleman who soon was to mount the vacant Throne and lead his country into more peaceful years. The Time of Troubles had passed.

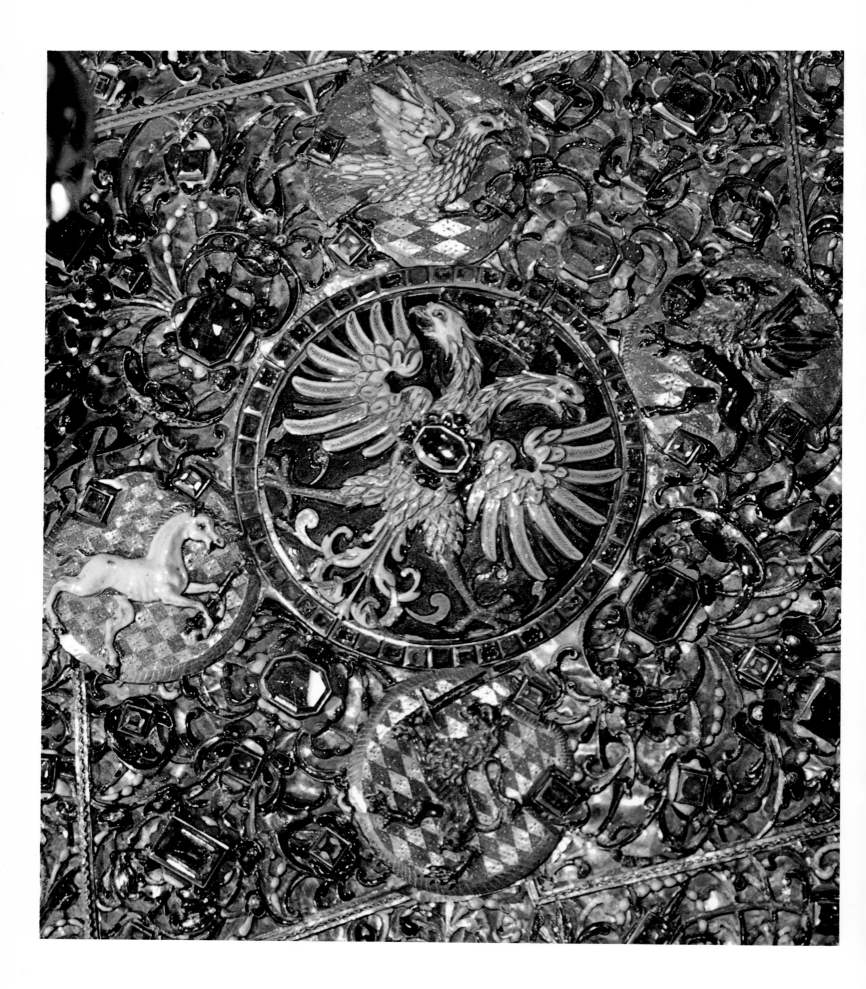

MOSCOW...THE KREMLIN...11 JULY, 1613
Mikhail Feodorovich...unpretentious...uneasy...sixteen years old...
Monomakh's Cap held aloft for one final, suspended instant—
Then he was Tzar; the first Tzar of a reign that was born of revolution
and would die in revolution, but between the two upheavals
would sit on the Russian Throne in jeweled splendor for three full centuries.
It was the first day of...

THE
ROMANOV DYNASTY

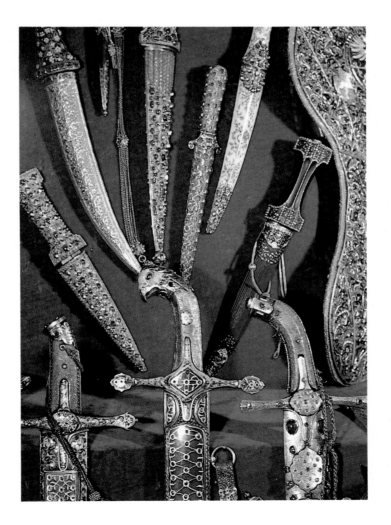

MIKHAIL FEODOROVICH ROMANOV

PRACTICALLY NOTHING, nothing but his untainted, pioneer name qualified the sixteen-year-old boy for Russia's Throne. Weak...nearly illiterate...devoid of ambition...unfettered by imagination...unblemished by any mark of character—the campaigning members of Russia's first unmanipulated *Zemsky Sobor* would have been hard pressed to unearth a less gifted candidate for Tzar. Apparently his obvious inadequacies were the very qualities which appealed most to many in the Assembly who expected to dominate him immediately, and the Throne. It seemed as though nothing whatever had been learned, nothing remembered, from the grim years of The Time of Troubles. The Court of the Kremlin was just as before.

Mikhail's mother, who had been exiled as a nun by Boris Godunov, reappeared to loom behind him—acid and avaricious—for his first six years on the Throne. Then in 1619 an extraordinary priest was returned to the Kremlin after many years in Polish prisons. He was Mikhail's father, Feodor Romanov, who had been forced into the Church as a Metropolitan named Philaret, then banished by Boris only to be jailed by the Poles. Prior to his taking the Cloth, Philaret had been Moscow's most ingratiatingly capricious man-about-town. When driven to the Church his knowledge of things theological was limited to the cut of the cassock on his back. Upon his return from prison he had lost his whimsy but knew very little more of the Church. His son immediately installed him as Patriarch of Russia, then retired to order his own jewel-encrusted State regalia and other activities so trivial as to have left no trace.

Patriarch Philaret—widely traveled, ambitious, politically ruthless, held the full power of the Church and the Crown in his hands for fourteen years while bringing a semblance of stability and unity to the tattered fragments of the dreary, war-swept land which every Russian had inherited from the past. Peace treaties were written with Poland and Sweden, treaties costing whole cities and their fertile lands in exchange for annulment of all foreign claims upon the Throne—heirlooms from The Time of Troubles. Sensing the urgency of dealing with the West, Mikhail-Philaret's reign opened Russia's borders to merchants and scientists, the visitors' only obligation being to share their knowledge with local inhabitants. Philaret founded Russia's first academy of Latin, Greek and Romance languages. Envoys were sent to Persia and China to negotiate trade routes into the Orient. In 1632 an ill-advised, abortive campaign was launched against Poland with hopes of regaining lost lands. It only cost more cities and lives. Peace was restored in 1633 just before Philaret died. On his throne screened by bickering boyars, Tzar Mikhail survived in almost anonymous obscurity until 1645, when he too died—a natural death. His son took the crown to which he was *born*. The Romanov dynasty was an accepted fact of Russian life.

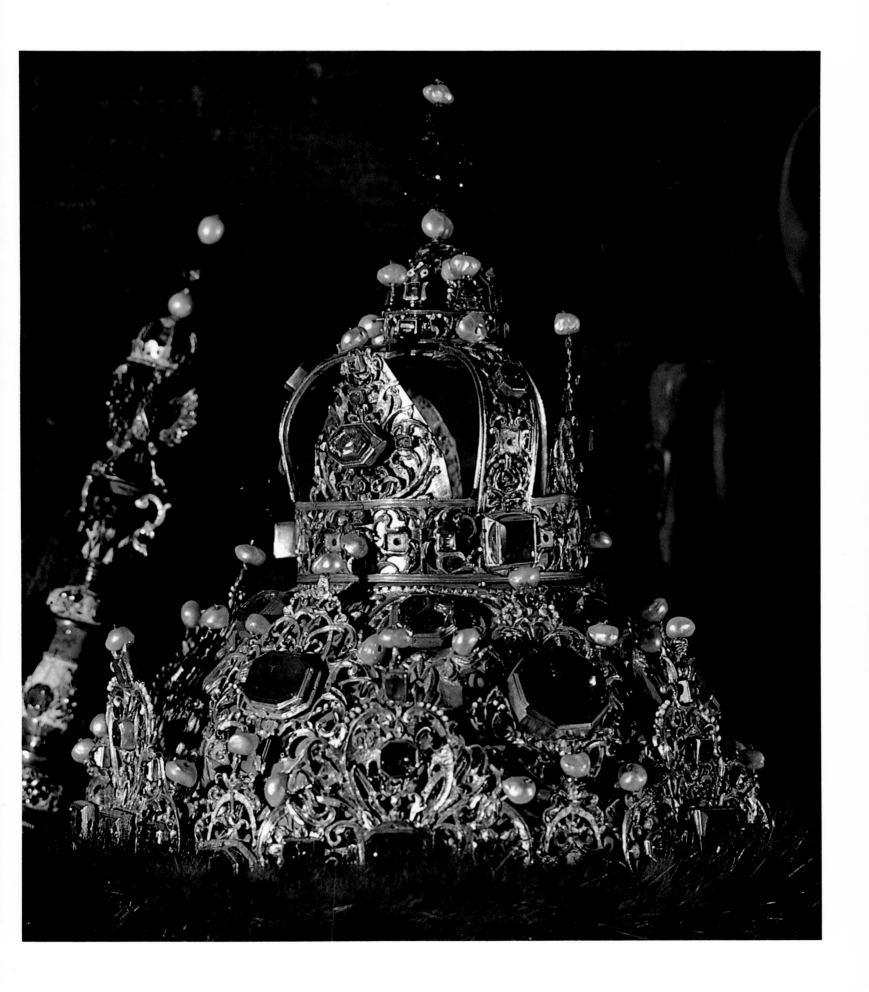

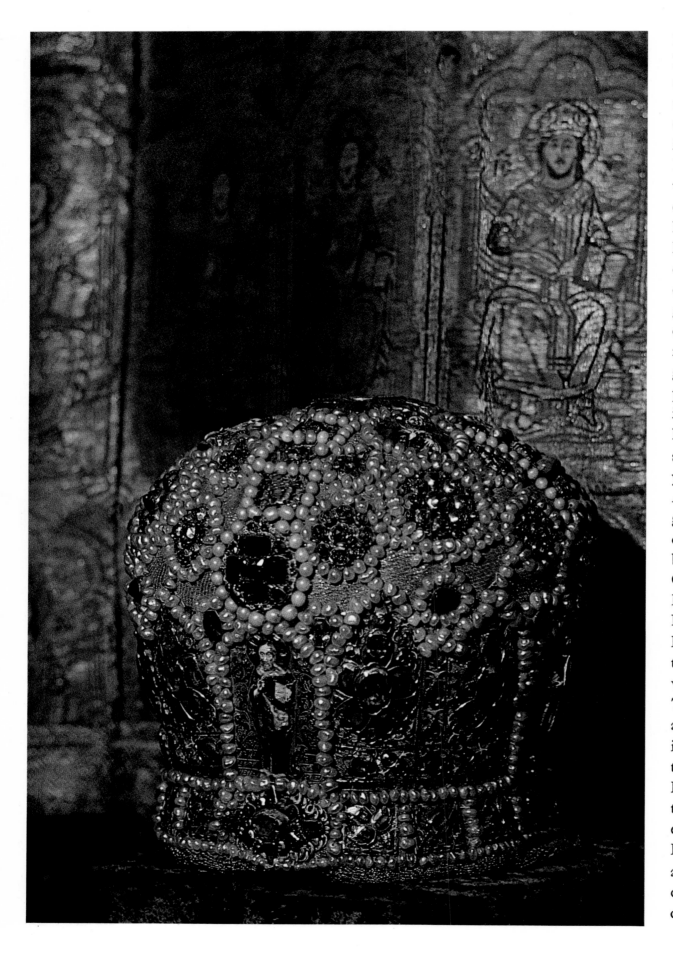

Romanov gifts to the Patriarchs of Moscow ranked among the most lavish ever created by jewelers in the Kremlin. Tzar Mikhail Feodorovich, who did little else, spent endless hours at the sides of his artists while they developed elaborate designs in pearls and gems. This mitre of emeralds, enamel and rubies, and pearls on gold thread, was the present from Mikhail in 1634. A few years later, in 1648, the son of Mikhail (the youthful new Tzar Alexei Mikhailovich) gave a golden cassock covered with embroidered figures of Christ seated on His Heavenly Throne to Patriarch Joseph. Old Kremlin records list the cassock as being woven on double Turkish satin. Patriarch Joseph placed it in the *riznisa*, church treasure room, of the Kremlin. Most of the church and sovereign treasures in Kremlin repositories are still in perfect condition, proof of centuries-long care.

Hero Alexander Nevsky wore this helmet while he was routing the Swedes in 1242— if legends are believed. Before that it was worn during the Holy Land Crusades. These stories of its early history, in addition to its own intrinsic beauty, must have appealed deeply to Mikhail Romanov, whose chief artist Nikita Davidov had to work many months restoring the aged helmet for Mikhail's use. Davidov, who was the master metalsmith of the Kremlin shops, finished it in 1621. It was then named "The Hat of Yerikhon," for a Biblical town. Without any prior design Davidov created the gold crowns of Old Muscovy inlaid upon an arabesque frieze asking the Lord to give help and quick victory to Believers. Archangel Mikhail in white enamel was on the golden face-protector. Filling the background are the jeweled *topor*, *bulava* and other symbols of the Tzars' power.

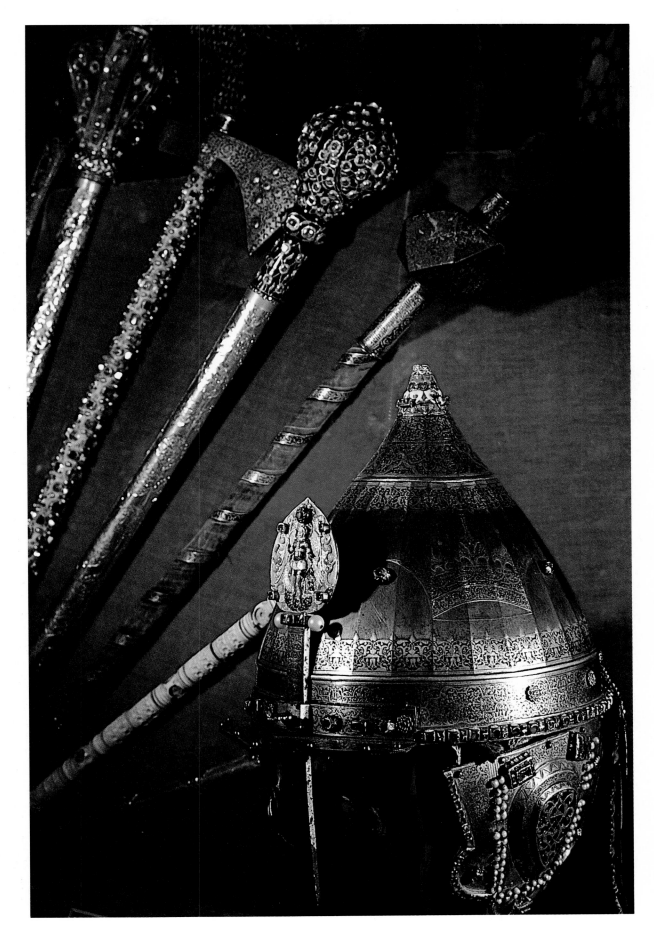

THE
JEWEL AGE
OF
TZARDOM

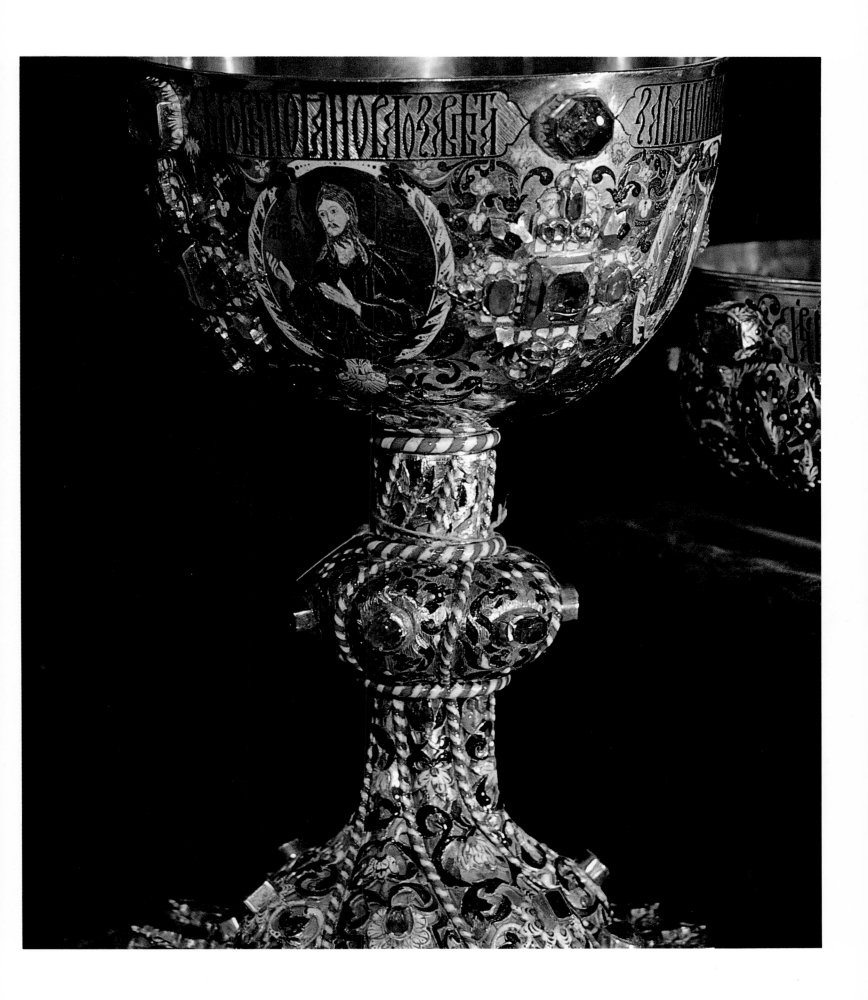

ALEXEI MIKHAILOVICH ROMANOV

THE DIAMOND THRONE AND BLAZING ORB OF ALEXEI MIKHAILOVICH added awesome brilliance to his otherwise petty Court and superficially obscured the mediocre talents of the second Romanov Tzar who, during thirty-one years in the Kremlin, delegated to palace favorites all such headaches as wars with Poland, Sweden and Turkey—plus revolutions championed by the Ukrainian Cossacks—while he grieved over the execution of his contemporary, England's Charles the First; genially presided over Court cultural innovations like the dramatic recitals of "The Prodigal Son" and "Joseph Sold by His Brethren"; exchanged embassies with the Courts of Spain and France; married twice and sired fourteen children. The fame of one son—Peter the Great—would later rival that of any name in Russian history.

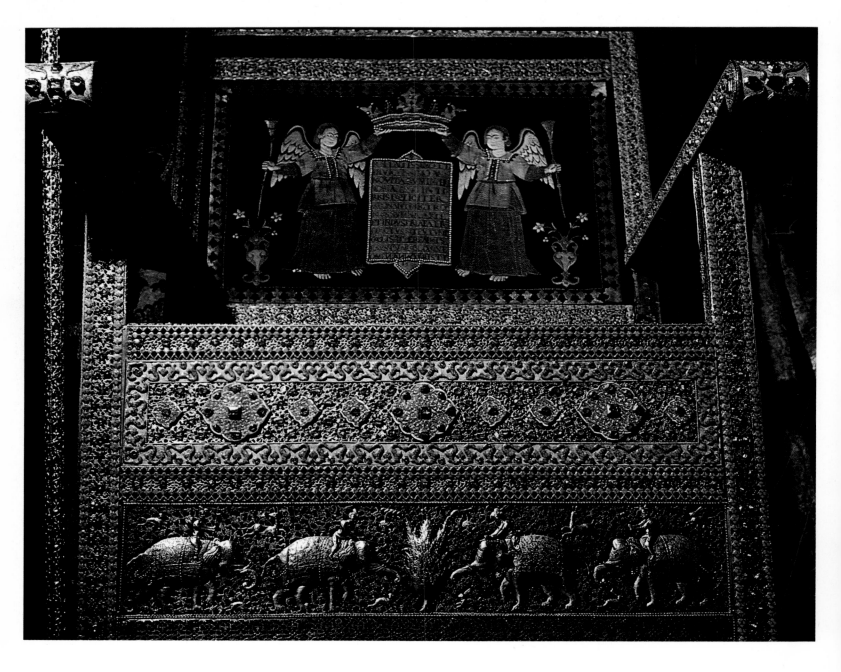

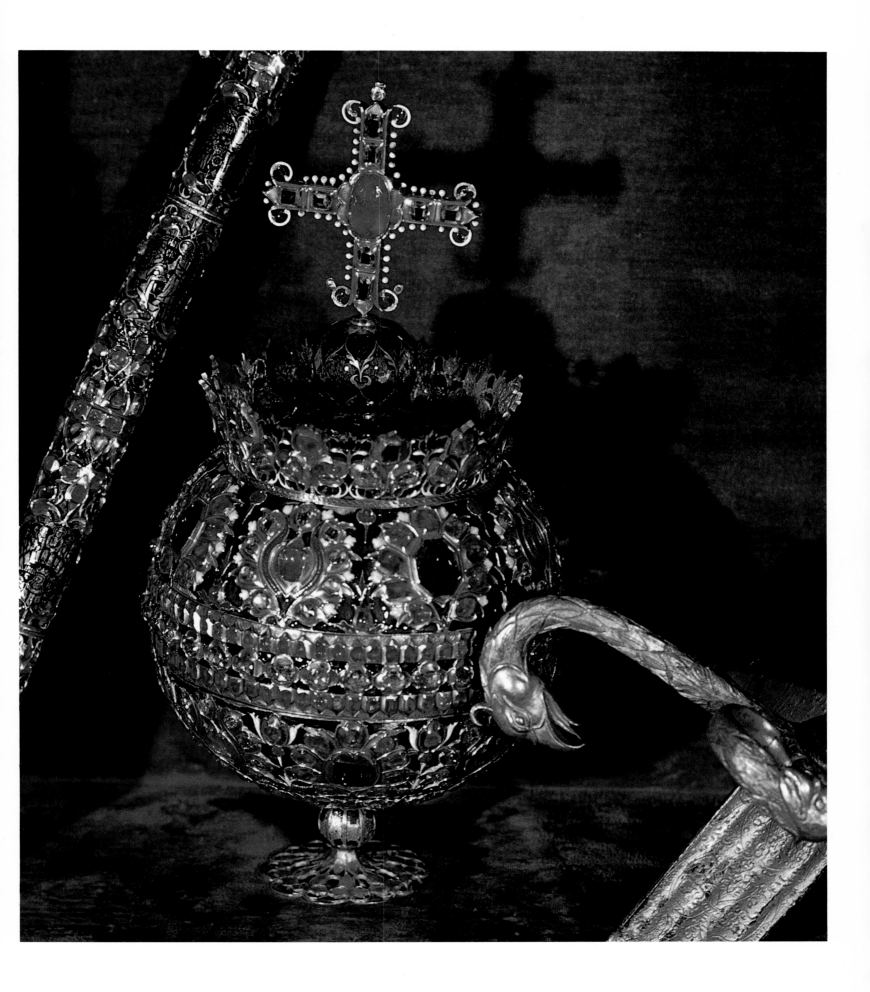

Until Moscow's rise, no civilization had lavished more of its wealth upon the holy images of its faith than was the custom of Russia's Church in the Middle Ages. Kremlin princes and lordly priests gave the finest of their earthly riches as a sign of devotion to cherished icons of Mother and Child. Then appeared the early Romanov Tzars, men who claimed an almost godly origin for themselves, who achieved ostentation rivalling the most sacred of all icons. Rivers of jewels and the rarest of metals flowed unrestrained. Midas-masses of icon covers in the Kremlin today are relics of Alexei Romanov's and Patriarch Nikon's reign, an age when a nation's treasury was hung upon its walls and kings, thus lost, all in God's name.

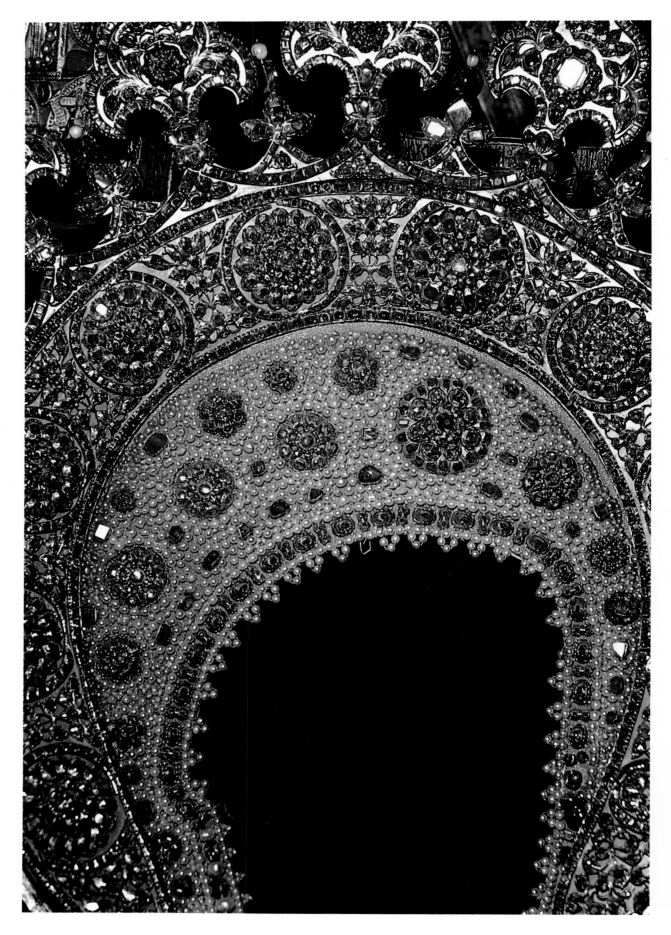

PATRIARCH NIKON

vs

THE ORTHODOX CHURCH

EVEN THEIR ERRORS WERE HOLY, any changes blasphemy, to the semifanatic clergy of a nation teeming with religious extremists. Both priests and populace were also almost universally illiterate. Such were the obstacles, in seventeenth century Russia, facing any reformer who attempted rectification of the mistakes in their Gospels or who suggested eliminating discrepancies in the church service itself. The errors had originated with the first Slavonic translations of the Gospels and then had been compounded through centuries of mutations by a hierarchy of defensively obstinate priests who were dependent upon memorized incantations of the sacred words. They were men who preached that it was sacrilegious to shave one's beard; that the sign of the Cross was made with two fingers, not three; that the name of Christ Himself must continue to be spelled *Isus,* instead of *Iisus,* as in the original Greek. If there were differences, especially from the hated Roman Catholic Latin versions, all the better! By the very fact of centuries-long worshipful usage the Russian variations of the Book of Gospels had in themselves become sacred. Nearly every Russian would continue making his devotions with a two-fingered sign before the glowing, jewel-and-pearl framed Madonnas in the great cathedrals. Anyone who tried to interfere would face the fury of an aroused, primitive man.

Patriarch Nikon, who led the Russian Orthodox Church for many years during the reign of Alexei Romanov, was himself a man of the black earth. He was born Nikita, a simple peasant. From childhood the farm boy aspired to the priesthood even though his father objected. As a young man he married, mostly to satisfy his parents, but after ten years both he and his wife decided upon lives dedicated to monastic studies in separate religious orders. Nikita journeyed to an isolated sanctuary on an island in the White Sea where he lived for three years in total, freezing silence and meditation. While there he changed his name to Nikon. That he was a man of restless impatience, extraordinary intelligence, supreme devotion, haughty pride and icy intolerance was affirmed during his meteoric rise from being an unknown monk to Patriarch of Russia and favorite of Tzar Alexei, who further accorded him the title of Chief Noble and Sovereign—a title granted only once before, by Mikhail Romanov to his own father, Patriarch Philaret.

Probably it was only natural that a man of Nikon's uncompromising, puritanic idealism should have undertaken the hazardous crusade of correcting the Russian Gospels and Church in defiance of such heretical sects as the Drinkers of Milk, Champions of the Spirit, Old Believers, and the Flagellants. The battle lasted from 1654, when Nikon enjoyed full support of Alexei—and the power behind his Throne, a boyar intellectual named Morozov—until 1681, when the ex-peasant Patriarch died in disgrace. During the twenty-seven in-between years the ordinary Russian church-goers watched aghast while the highest religious dignitary of the land met in head-on collision with ostensibly respectful but grimly determined echelons of lesser priests. Nikon had the support of the Tzar and even his troops in crushing hold-out forces in some of the remote and even more dogmatically heretical monasteries. The fanatics, for their part, possessed that resilient strength which could only have flowed from the broad stream of national prejudice itself. Nikon's army forces assaulted recalcitrant monasteries as though repelling foreign invaders. One fortress-monastery on the White Sea withstood an eight-year siege before it finally fell—then its monks were hung. In the end, however, Nikon's crusade collapsed, not because of the reforms being advocated but because of the Patriarch himself.

After his unequalled rise from obscurity to omnipotence in the Russian Church—where even the Tzar himself seemed subordinate to his proclamations—Nikon assumed so outrageously arrogant a manner with his sovereign, and authorized such blatant confiscation and destruction of non-conformist icons that he alienated Alexei and Morozov, while also arousing the wrath of the land. Wounded pride lead to anger; anger lead to accusation, which in turn caused an unprecedented scene in the Kremlin's Assumption Cathedral. Having listened to an emissary from the Tzar denounce him, Nikon concluded his prayers, turned to his congregation and quietly apologized for whatever failings he had exhibited while their Patriarch. He then slowly removed his holy vestments before their astonished eyes and walked out of the Cathedral.

Nikon retired to a nearby monastery probably expecting to be recalled to his robes by a repentant Tzar. The call never came. Instead, in 1666, he was summoned before a Church Council which had been convened to hear his case. He appeared before an assembly of two Patriarchs, ten Metropolitans, eight archbishops including that of Mount Siniai, plus countless bishops and priests. The assembly reviewed his case three times. Each time he was absolved from all charges of any misconduct in championing his reforms of the Church and eliminating errors in the Gospels. But for abdicating the Patriarchate, for abusive attacks on the Tzar and for his ruthless measures against fellow priests he was sentenced to life imprisonment in a hermitage near the place where his religious life had commenced, on the edge of the White Sea.

Only at the end of his days, when pardoned by Alexei's son, was Nikon permitted back in Moscow. He died in his favorite monastery. His funeral was his final victory for he was buried with full rites of a Patriarch of the Russian Orthodox Church. The religious revolution which he had fomented flared into open conflict again during following generations, splitting to its very base the ancient, interwoven column of Church and State which had supported the whole structure of Russian government since the days of the first Grand Princes. The fissure would still be noticeable in Moscow nearly three hundred years later—after the Tzars and their dynasty were dead—in a feebly fluttering remnant of the Church of Old Believers. Some majestic icons and a Kremlin treasury filled with their jeweled covers were all that remained. Everything else was gone.

ALEXEI'S WARS

HORSES WITH JEWELED CROWNS—rubies, turquoise and gold—swept past Tzar Alexei Romanov when his cavalrymen rode through Red Square and off to the wars: wars of rebellion right at home over legalized serfdom, the price of salt and the government's confiscation of corn; wars with Poland over possession of the Ukraine; religious wars over the Gospels' spelling of Jesus' name; wars with Sweden over frontier footholds on the Baltic; wars with a brigand Cossack named Stenka Razin, who admitted final defeat only as he was being quartered alive—wars which impoverished an already destitute land—wars which lasted through almost the entire lifetime of a Tzar himself so gentle and tolerant as to have written his cousin the following: " We have lost fifty-one men killed and thirty-five wounded of all ranks. I am thankful to God that from an army of three thousand only this number has suffered; all the other men are well because they had fled..."

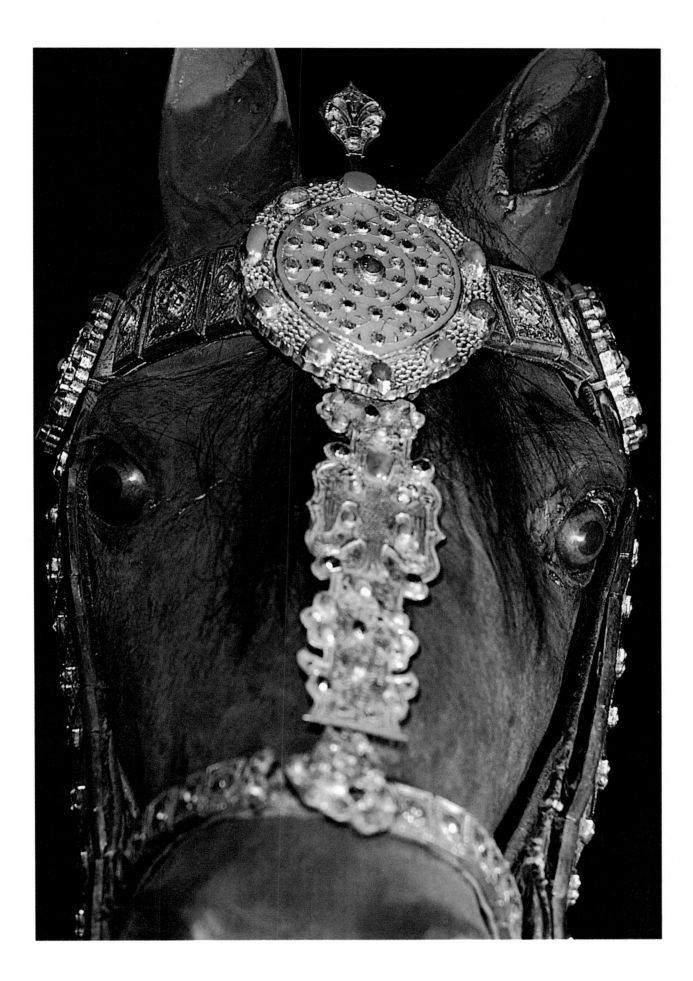

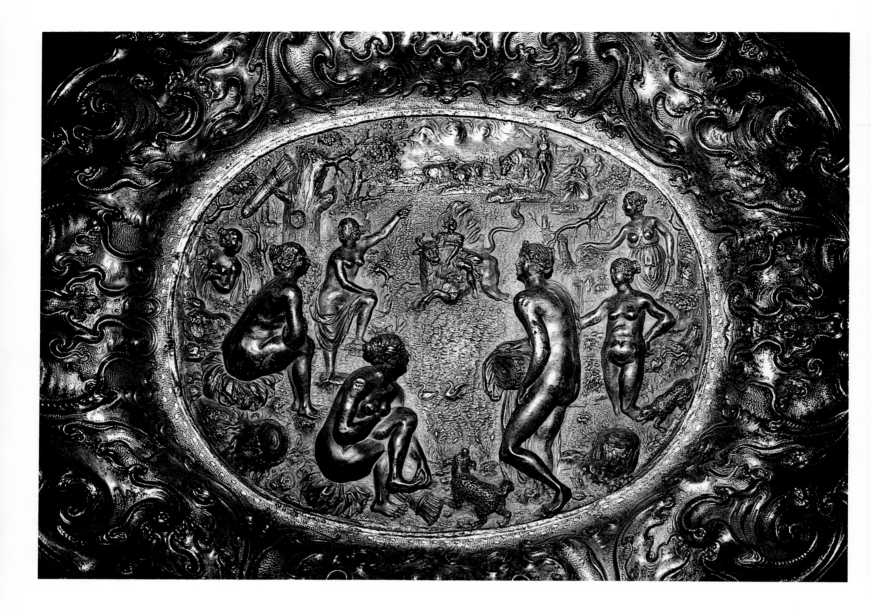

THE RAPE OF EUROPA

PRESENTS POURED INTO THE KREMLIN during the sparse periods of peace between the XVIIth century wars of Alexei Mikhailovich, when Russia's neighbors hopefully began using gifts instead of guns to win security from the awakening colossus next door. Yard-wide silver trays, called *lokhans*, were among the most-favored offerings. It was well known at other courts that the Tzars gloried in displaying their immense wealth on State occasions—like ambassadorial receptions in the Palace of Facets—at which times Kremlin courtiers carried staggering loads of treasure past assembled guests to the Throne. The most exotic or priceless things were exhibited on *lokhans* placed near the Tzar himself. Many of these great trays still exist deep in the Kremlin. One of the most beautiful, "The Rape of Europa," was sent by the Hanseatic city-state of Hamburg to the second Romanov Tzar.

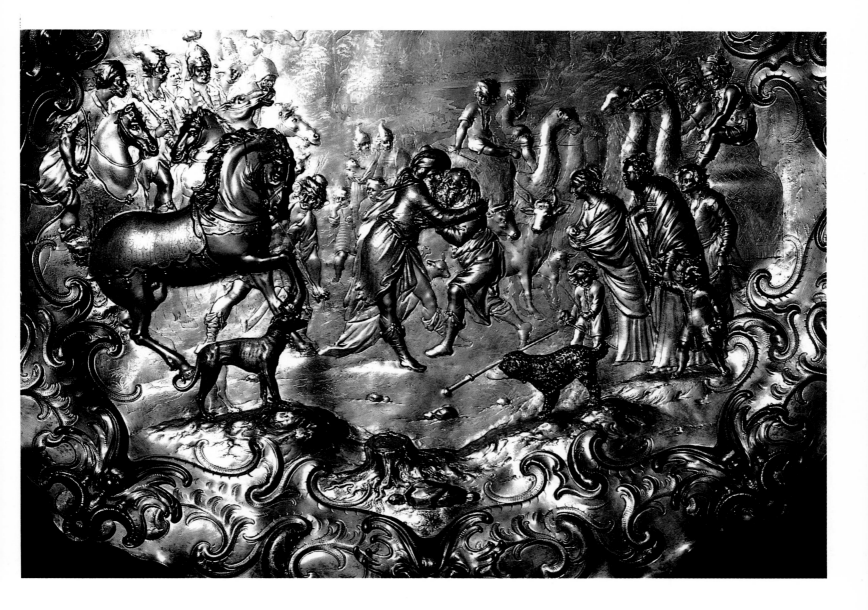

THE RECONCILIATION OF JOSEPH AND JACOB

NO GIFT IN THE KREMLIN TREASURY surpassed the craftsmanship of the deeply chased *lokhan* sent in 1647 by Queen Christina of Sweden to Tzar Alexei Mikhailovich. It was made in Augsburg by metal-smiths who were masters of precision when dealing with silver but nearly defeated when portraying creatures like camels. *Lokhans* such as this were revealed only during formal State functions, then put aside. Others, of smoothly polished gold and silver, were filled with water and offered to the Tzar so that he might wash his hands after they were kissed by non-Christian envoys and non-Russian visitors who bowed before his Throne. The Augsburg artists who re-created this Bible scene of " The Reconciliation of Joseph and Jacob " on Queen Christina's *lokhan* were also renowned for their trays depicting mythological heroes and great historical events.

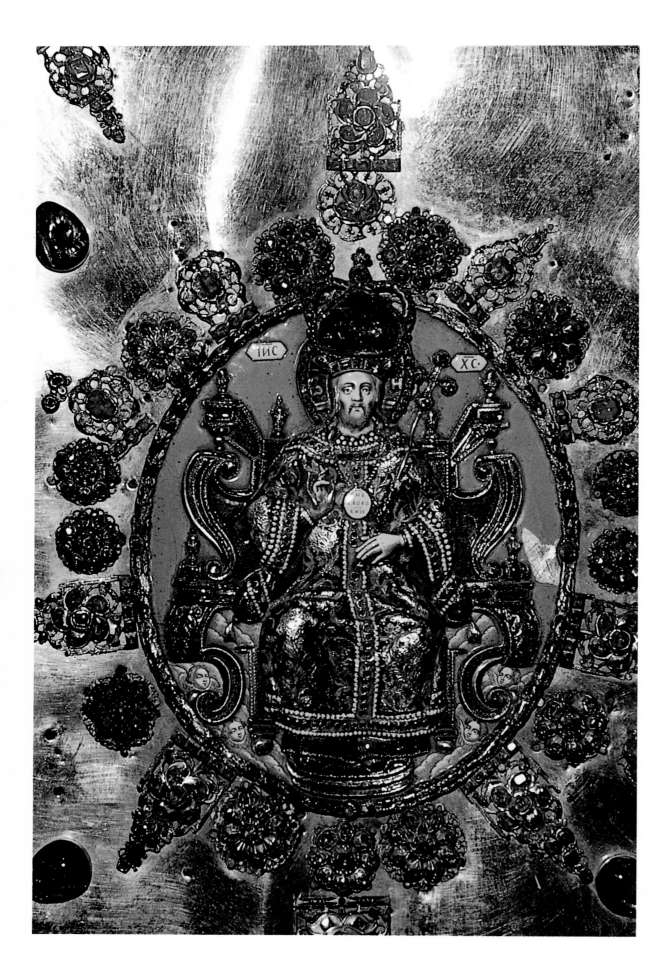

Fifty-seven pounds of the purest gold and a cupful of tear-shaped emeralds went into an enormous Gospel cover during erratic Feodor Alexeievich's brief six-year reign as the third Romanov Tzar. He was a youth but he made history. He alone eliminated the Books of Heredity in which the origins of each major family were enscrolled. All governmental work, army and navy ranks, and positions in life itself were decreed by one's family tree. The Tzar simply viewed the problem in terms of frustrated talent, with Russia penalized most of all. He took drastic action. Each Book was brought to Moscow for checking. When all were piled together he ordered them destroyed. He also proposed starting academies of the classics but the project collapsed when applicants' interest dwindled, then died, on learning that anyone who failed would be first expelled—then burned at the stake.

Young Ivan V never actually ruled when his older brother, Feodor Alexeievich, died. He was only fifteen—mentally ill. In 1682 Russia was a country of chaos. Rebellion against an official indifference toward the continuing condonation of serfdom, when linked to shocked rejection of Nikon's reforms within the Orthodox Church, fused many kinds of furies into a common flame. Temptation beckoned to Ivan's sister, Sophie. She might have met with little trouble usurping the Crown, had it not been for her ten-year-old stepbrother, Peter I—the Great—who shared the other side of Ivan's Eagle Throne. For the only time in Russia's sad history two co-Tzars reigned, with still another power, their Regent sister, hidden back of them both. In seven long years she and Peter agreed to just one thing— to leave gentle Ivan unmolested with his magnificent crown.

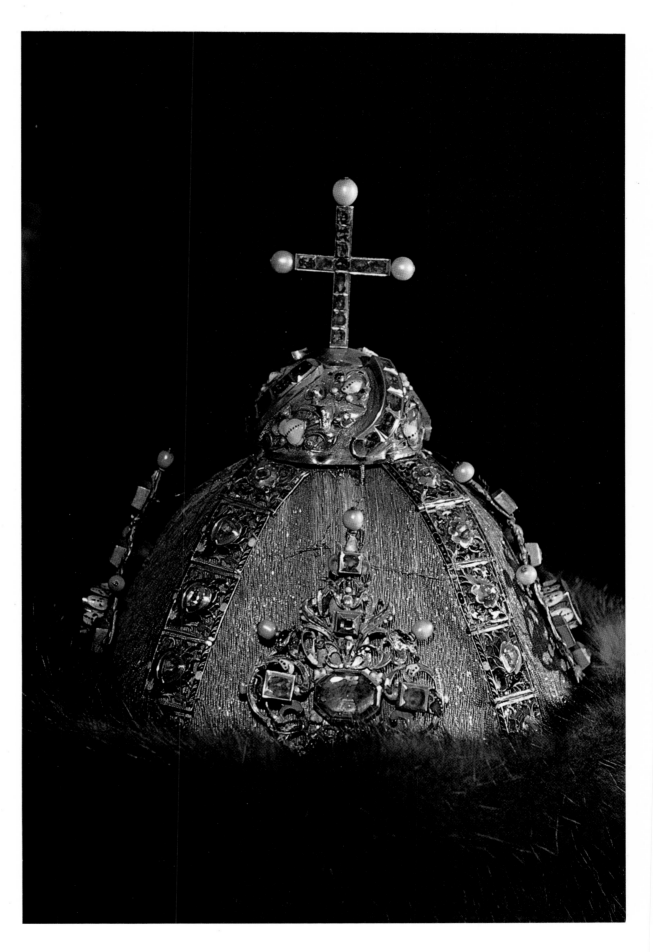

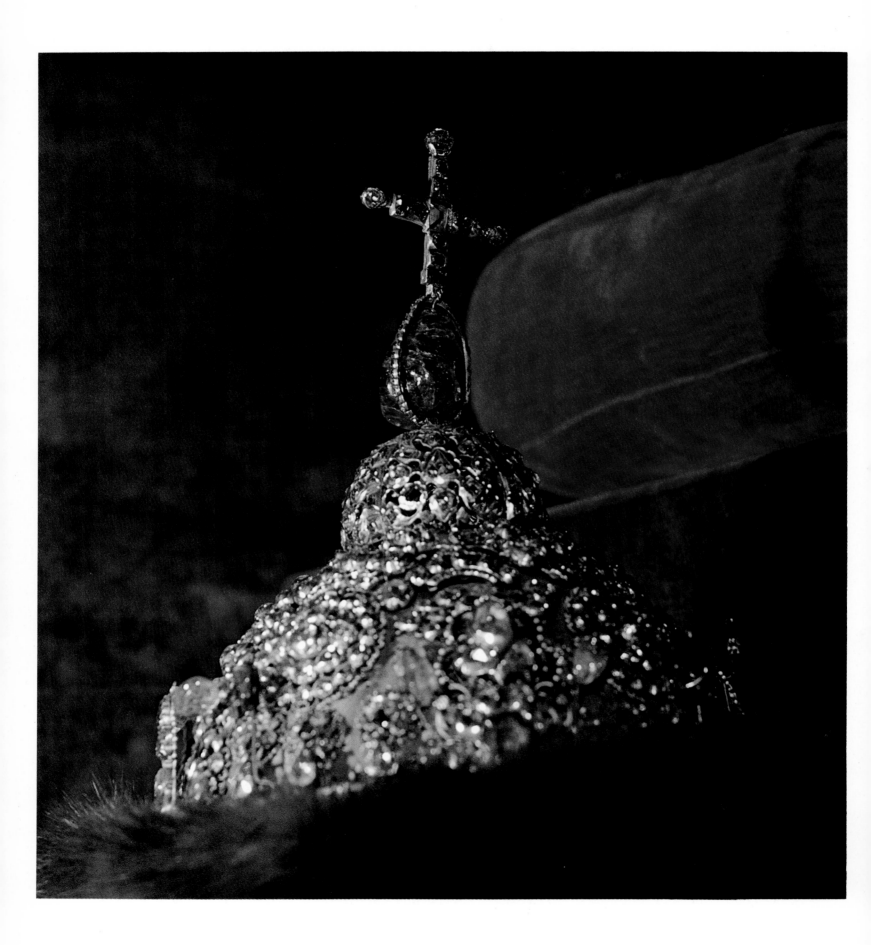

PETER THE GREAT

HIS CROWN WAS A BUBBLING FOUNTAIN OF JEWELS, where luminous droplets of diamonds and sapphires splashed down from the great rough ruby on top. It was hailed as the pinnacle of the gem-setter's art—and used as a sledge hammer in the fists of towering Peter the Great to shatter tradition, super-stition and all opposition as he personally carried that stubbornly resisting old hermit, Medieval Russia, into the eighteenth century western world.

Peter wore his Diamond Crown for forty-two years, thirty-five of which saw Russia threatened, beaten, seduced, pampered, cajoled, pushed and finally dragged across the threshold of a civilized century, then propped up, reeling and only semidressed, in the northeast corner of Europe to be introduced to the rest of the world. Peter did it alone, after overthrowing the seven-year Regency of his stepsister Sophie, and after his moronic stepbrother, co-Tzar Ivan V, was dead. Much of what he attempted was premature, illogically executed, over-ambitious and often inexpressibly brutal. Yet every additional reformatory blow on the gnarled, seemingly insensitive body of his ancient country, while appearing to land almost unnoticed, actually shook it to its core.

Too impatient and inept to conquer through diplomacy, yet possessed by visions of his own heroic mission, Peter launched frenetic wars in all directions. Fighting with Turkey, Sweden and Persia filled almost every year of his reign and emptied his treasury. His exhausted people were chronically numb from making torture-induced contributions of money and men for badly generalled legions and a flotsam navy. His Turkish and Persian campaigns began with easy successes, then ended in stalemate and defeat. But Peter was as tenacious as he was temperamental. From initial disaster he fought to final glory over Swedish arms. The victory of 1709 at Poltava, followed by the 1721 Treaty of Nystadt, forever destroyed Sweden as a major power and left Russia weak, bearded, begrimed, but standing starkly silhouetted in the Baltic, blocking the eastern doorway of Europe. In that same year he threw aside the rank of Tzar and took for himself and heirs the more exalted title of Emperor, which was reluctantly but progressively recognized by Prussia, Holland, Sweden, Turkey, Austria, England, France, Spain and Poland. Russia had arrived and was waiting to be seated with the veteran nations of the world.

During these same decades while Peter campaigned abroad he was crusading at home against illiteracy, intolerance and inertia—the latter being perhaps his single most-hated opponent. He personally led explora-tory missions into western Europe and England, studying boat building, astronomy, dentistry, navigation, warfare, finance, anatomy, the theater, drawing, engraving and a multitude of other subjects in which his curiosity seemed insatiable. He hired over a thousand experts in dozens of crafts and professions and shipped them east for service in Russia. His enormous stature, childlike inquisitiveness and naiveté, obvious intel-ligence and uninhibited, riotously drunken parties left indelible impressions upon stunned hosts who stood surveying the wreckage of each place that had been his royal quarters.

All Russia felt his reformer's lash. He made all bear the load of a professional army and navy; codified inheritances; inaugurated universal schooling for children of landed gentry; introduced heavy industry; modernized the alphabet; dispatched explorers throughout the realm; abandoned Moscow and built the entirely new capital of St. Petersburg on a swamp; taxed everything in the land including men's beards; personally rewrote the laws of Russia; founded a Senate which, among other duties, interpreted the laws; assured State domination of the Church by eliminating the supreme single voice of the Patriarchate, substituting a Holy Synod of appointed hierarchs; assigned treasure-bearing, bribery-instructed ambassadors to every major Court on earth; professed sympathy for serfs while condoning increasingly depraved crueties by landholders who enslaved labor in order to meet taxes; married and abandoned a boyar's daughter whom he loathed; sought the company of, and later married, an illiterate Lithuanian servant girl who was destined to become Empress; with his own hand directed the torture and execution of his eldest son by his hated first wife; tried to provide for every eventuality in ruling Russia by abolishing all earlier laws governing inheritance of the Throne, then proclaimed it the right of an Emperor to select his own successor. Finally, ironically, in January 1725, after saving several soldiers from drowning, Peter the Great threw the country into generations of turmoil by collapsing with pneumonia and dying in the middle of his last command—" Give all to.... "

THE WOMEN

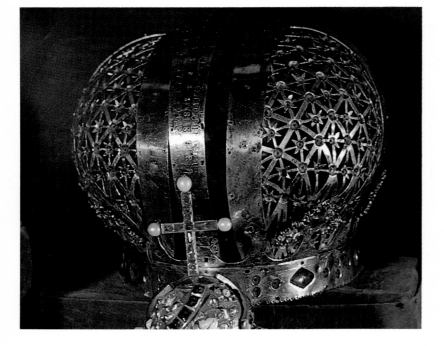

A Lithuanian ex-chambermaid became the first woman to sit alone upon the Russian Throne. She was Peter the Great's gregarious, rollicking widow who, after his death in 1725, ruled for another two years as Empress Catherine I. During seventy-one years—except for fifty-three widely scattered months when a one-year-old baby boy, an irresponsible minor and another royal idiot passed almost anonymously across the stage—the Throne was dominated by women. Peter's 1721 decree, establishing the sovereign's right to designate his heir, followed by his own sudden death without naming a successor, opened the gates to swarms of elbowing aspirants for the Throne. Most were obscure, opportunistic foreigners who had attached themselves to the various Romanov brides that had been seeded around Germany by empire-building Peter, who now were coming to chip away fragments of the old realm—foreigners who ridiculed the Kremlin's frontier-style heritage handed down from its early Grand Princes and tyrannical old Tzars... history which must have sounded rough indeed to young men trained in the waltz and minuet and the ruffled-collar courts of eighteenth century Europe.

Empress Anna's new crown symbolized a lecherous reign. Its diamonds came from Catherine I's crown. As sovereign, Anna —moronic Ivan V's daughter—established a court five times costlier than Peter the Great's. The ruby on her crown belonged to the last Romanov male Peter II, Peter the Great's grandson. Smallpox ended his 15-year life on his wedding day. Anna's time on the Throne (1730-1740) was filled with peasant persecutions, famine and her wars. An infant, one-year-old Ivan VI, succeeded her. His Regency almost immediately fell before Elizabeth, the daughter of Peter the Great. She ruled from 1741 to 1761, founded Moscow university, also added French theater, literature and ideas to the St. Petersburg court. She chose her dull nephew Peter III as heir and married him to Sophie of Anhalt-Zerbst, renowned as Catherine the Great.

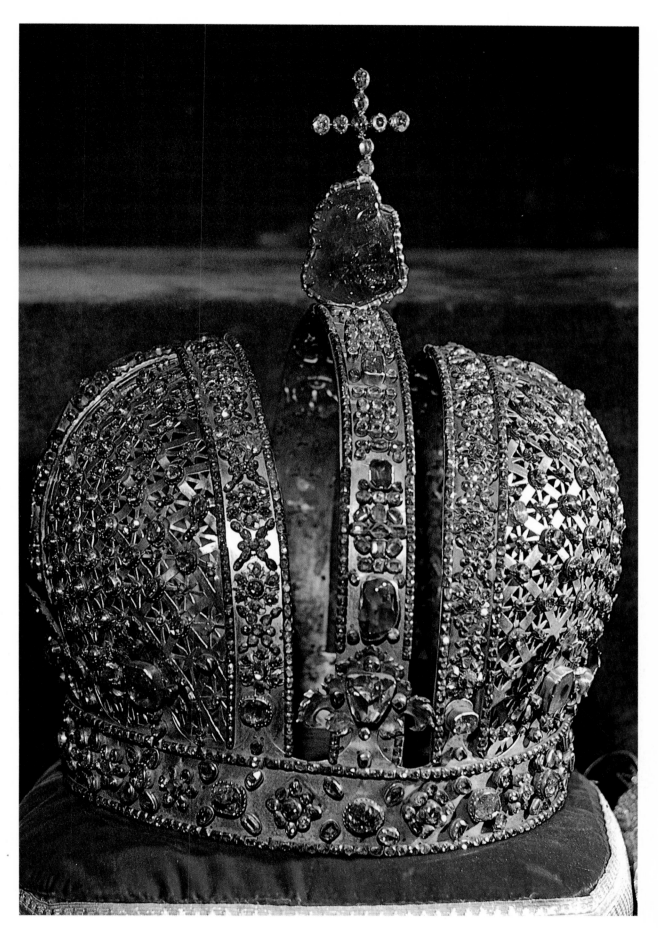

"I MUST REIGN OR PERISH!"

Catherine II, Russia's fourth Empress, permitted nothing to come between herself and her militant motto, not even her husband, Peter III, whom she dethroned six months after he had inherited the Crown.

She was a Russian Empress who was not Russian but the German princess-daughter of a field marshal in the Prussian army. Her mother had served for years as political agent for King Frederick the Great. Gay, idealistic, multilingual, already familiar with most of Europe; a self-assigned student of the Catholic, Lutheran, Calvanistic and Orthodox faiths—sixteen years old—enroute to Russia with three dresses bought from the allowance advanced by her fiancé's family; she was Sophie, the bride-select of insipid, licentious, slovenly Peter III, heir apparent to the Russian Throne—from whom she was to tolerate every indignity for eighteen years...before killing him.

She was Sophie of Anhalt-Zerbst, making the almost endless eastern journey to St. Petersburg for the first fitting of her silver-embroidered, fairy-waisted new dress which future generations would preserve and cherish as the wedding gown of...

CATHERINE
THE GREAT

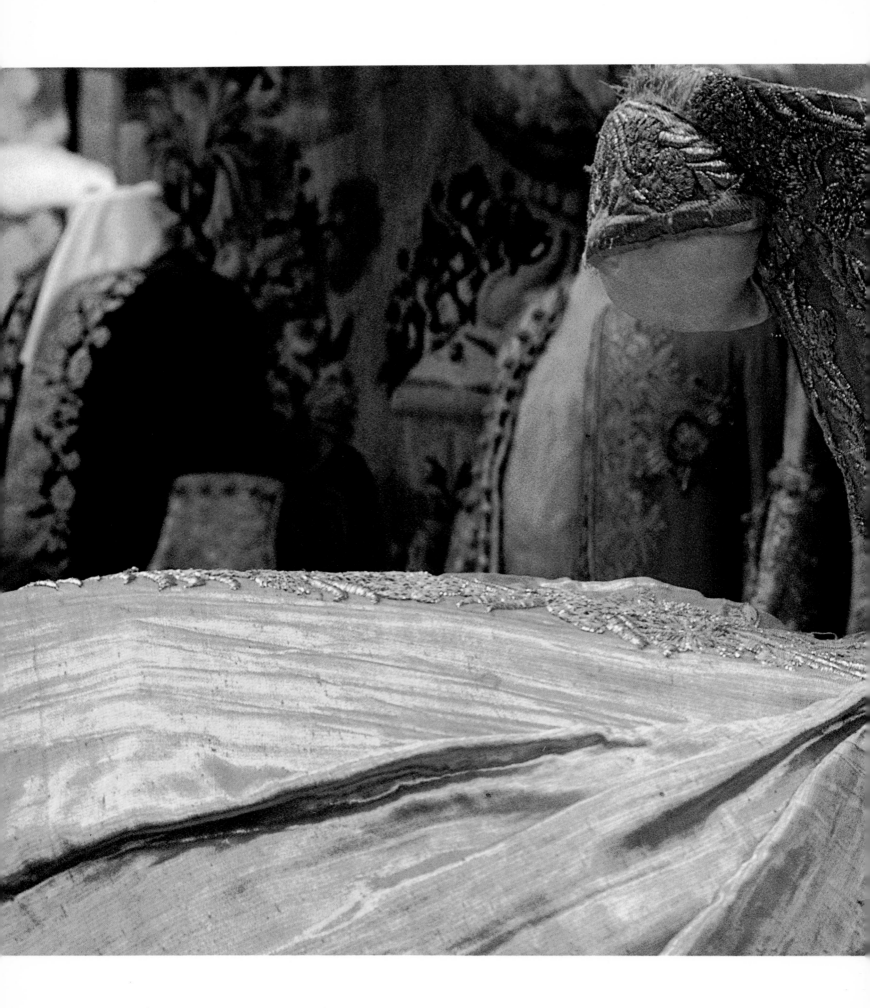

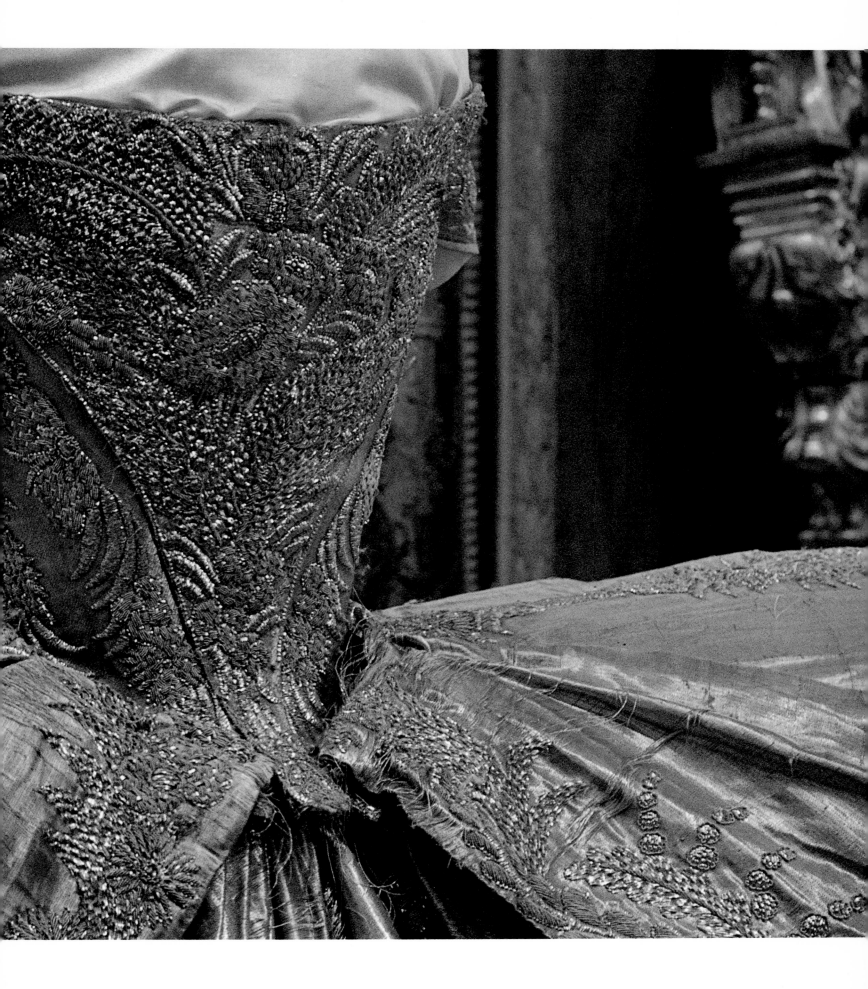

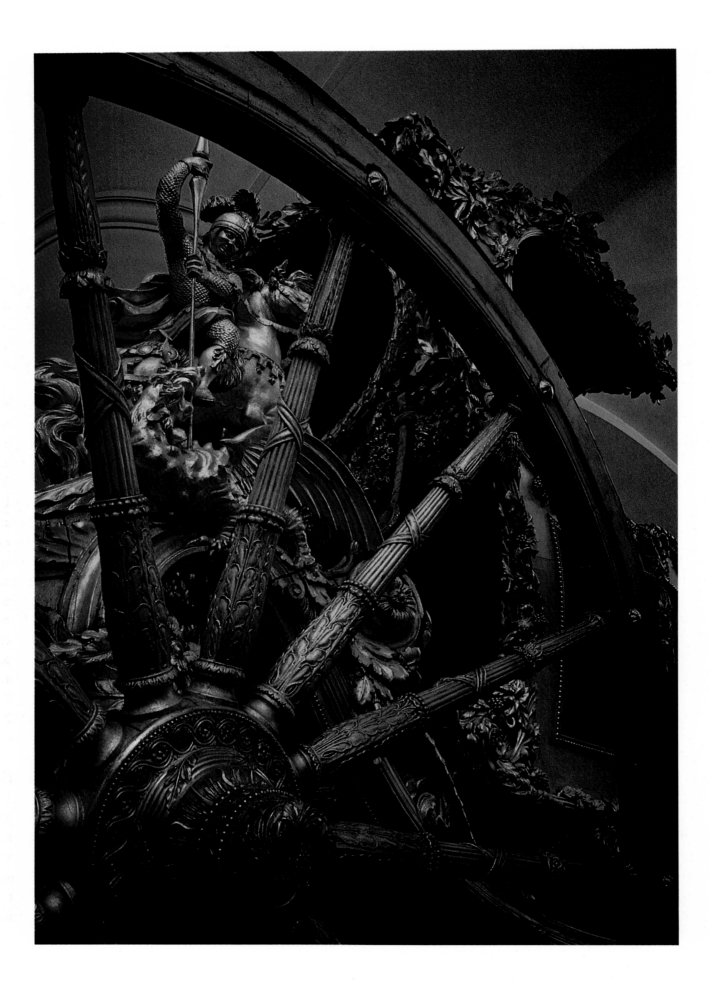

CATHERINE'S FIRST LOVE

"THERE GOES THE LAST DROP OF GERMAN BLOOD, I HOPE!" With that bitter remark Catherine the Great dismissed the doctor who had been bleeding her for some inconsequential ailment. It was a wish that clearly revealed Catherine's lifelong feeling of insecurity upon the Throne to which she had no hereditary or legal claim and which she held only by her wits and sheer strength of character. She could do everything...master the language...support the Church...conquer historic enemies...dedicate her life to the land—but she never could be a Russian Romanov, which haunted her until the very end.

For all of her affectations of being the irreproachable *Russian* Empress, Catherine the Great's entire intellectual existence orbited around contact and correspondence with foreign philosophers, writers, scientists, artists and statesmen. The kings of France, Poland, Prussia and Sweden, together with the Austrian Emperor, were frequently involved in lengthy communications with her, even during the years when their countries were at war. Voltaire was a friend with whom she shared almost every event in her life. The encyclopaedist Grimm sought her opinions as an equal. She was the authoress of numerous French-inspired dramas, satires and poems, and "Grandmother's A B C" stories of Russian history for children.

In one year Catherine the Great donated a million rubles toward the purchase of major collections of Italian and Flemish art. She was the first person in the country to be inoculated against smallpox, calming the apprehensions of her superstitious people by her example—and for his service fee giving an Englishman, a Dr. Dimsdale, 10,000 pounds sterling, with a 500 pound yearly bonus and the title of baron. She founded the Russian Academy, which undertook as one of its tasks the compilation and publication of a six volume dictionary containing 43,257 words. She invited foreigners, mostly Germans, to settle on the unpopulated lands bordering the Volga, then freed them from all taxes for thirty years. She championed religious tolerance. Early in her reign she sponsored a vast assembly of men from every station in Russian life—nobleman to serf—and gave them instructions to outline a "New Code" which would suggest the form of the new life coming within the Empire. Catherine's most memorable contribution was the section starting with: "The nation is not made for the sovereign but the sovereign for the nation." However such voyages into romantic idealism were soon only memories of her adventuresome youth.

More than twenty years later, at about the time that she received from her court favorite a magnificently carved, golden English runabout—with St. George heroically slaying the dragon just above the wheels—Europe was stunned by news of the French Revolution, the fall of the Bastille and the execution of Louis XVI. Not only was Louis dead, but so was the alliance of Russia, France and Austria against England and Prussia, toward which she had been negotiating diligently. Overnight, everything French was outlawed at the St. Petersburg Court. Voltaire's statue was thrown with the trash. Catherine expelled the French ambassador, broke off diplomatic relations with Paris, prohibited French ships from entering Russian ports and categorically refused to recognize the new Constitution or the French Republic. The estrangement with her first love was complete.

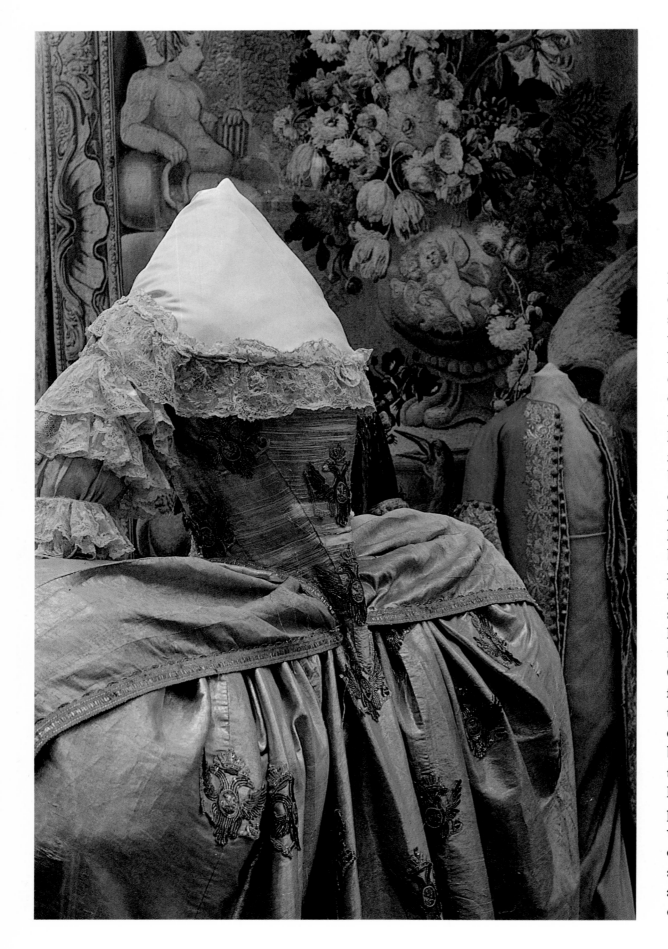

Empress Catherine's coronation dress was a sensation in 1762 when she mounted Russia's Throne. Today it reflects some of the French styles which she brought to her Court but reveals nothing of the story behind her coup that overthrew Peter III, her husband, or that he died in prison on being visited by the new Empress' friends six days after they swore allegiance, in her name alone, to the Imperial Russian Crown. On being informed of Peter's untimely end she waited twenty-four hours before announcing it to his country—then later gave titles and pensions to the men who were witnesses of the murder, an assassination without an inquest or anyone ever punished.

COACHES FOR THE KREMLIN

NO COURT OF EUROPE COULD BOAST of more extravagantly ornate carriages in which to fete their monarchs than those of Imperial Russia during the age of Catherine the Great. Master wagon makers, wood carvers, jewelers and painters lavished years of their lives upon coaches for the Kremlin which would be seen on jubilee occasions like the Empress' Coronation Day. Under each generation of rulers the collection grew until carriages of more than three centuries were mellowing grandly amidst the lurid, oft-told tales of Boris Godunov, and memories of the Empresses Anna and Elizabeth and Catherine who haughtily sat in them when they rode through the rough streets of St. Petersburg and Moscow surveying their submissive subjects.

Europe's best talent painted the panels of carriages sent to the Russians. François Boucher completely covered a monstruous coach with cherubs for the unmarried Empress, Elizabeth. It was made in Paris in 1757 on the order of Alexei Razumovsky, a rough young Cossack who fired Elizabeth's eye while singing in the palace choir, then became a count. The King of Prussia, Frederick the Great, who spoke of a German girl as a bridal candidate for her eccentric nephew, Peter III, gave her another carriage built in Berlin. It had doors ablaze with iris, camellias and orchids. Frederick had reason for sending the gift: Elizabeth's ascent of the Throne shattered a Russian-Austrian Pact imperiling his Crown. He soon regretted his gift for Russia and Prussia fought again—the Seven Years War ending only when his protégée and Peter III sat upon the Throne. Then she, Catherine the Great, sat alone.

121

EVANGELICAL PASSION

"LIBERTY IS THE SOUL OF ALL THINGS, and all is dead without it." Catherine the Great's eyes shone with evangelical passion, especially when she added the postscript, "I want obedience to law and not slavery."

During Catherine's thirty-four year reign the land mass of the Russian Empire increased by nearly six hundred thousand square miles. In Poland alone—which she casually subdivided with her allies Austria and Prussia—Catherine reaped a million eight hundred thousand people of non-Russian origin. In magnanimous moods she regally flicked a hand and Court favorites became lords of State lands, generosity which immediately enslaved into perpetual serfdom nearly two and a half million free men. Hoping to augment imperial income —which it did by an annual twenty-four million rubles—Catherine doubled the poll tax, blithely ignoring its crushing burden on the peasant. In her final year on the Throne total national income was sixty million rubles, while Court-created expenses—mostly for her wide-flung wars—were over seventy million. Having convinced herself that "war feeds war," Catherine wrote to Voltaire in 1774, "Do not judge, I beg, of our finances by those of other powers of Europe, who are ruined; you would do me an injustice. Although we have had war for three years, we build, and everything proceeds as in peace. For two years no new tax has been created; and if we can again take one or two districts, the cost of war is paid."

A later Russian historian named Tcherbatov disagreed with Catherine's policy when he wrote, "If this woman had lived to a more advanced age, she would have dragged Russia into her tomb." Unlike Peter the Great, who fought in the Baltic for a "window" overlooking Europe, Catherine's greatest dreams of conquest centered around Turkey as the door to the Middle East and all of Asia. She probably felt pride and confidence in her policy of building the Russian Empire by war, especially after early in her reign Russian warships—inspired by a fearless, free-lancing British admiral named John Elphinston—sailed against a vastly superior Turkish fleet in the Aegean and blew it to smithereens. The resulting Treaty of Kuchuk-Kainardji, signed in 1774, gave Russia freedom of passage in all Turkish waters including the Dardanelles, and the right to maintain a merchant marine in the Black Sea; compelled Turkey to give independence to the Crimean Tartars and the Georgians in the Caucasus; demanded the payment of massive treasure as war indemnity and, finally, to recognize Russia's sovereign as "Emperor," the title taken by Peter the Great and acknowledged by all European nations except Turkey which had refused, claiming it as its own. All seemed bright for Catherine's empire but the shoals of darker days loomed dead ahead.

FRIGHTFUL SLAUGHTER

Revolution erupted in 1775, in the middle of Catherine's rule. It was ignited and fanned by a wiry, debonair Cossack, Emelian Pugachev, who—claiming to be Peter III, Catherine's unmurdered husband—issued a manifesto abolishing serfdom, with additional benefits for peasants who killed their landlord masters. The rebellion followed the pattern of class-warfare set by Stenka Razin a century earlier. After initial successes amid frightful slaughter, Pugachev—like Razin—was captured, dragged to Moscow and there quartered alive. His was one of the few cruel punishments pronounced by Catherine, possibly because of the ghosts he resurrected by usurping her murdered husband's name.

Pugachev's captor was his physical opposite...frail...stunted...a student of religion and mathematics—and probably the toughest, most competent soldier in Russia. General Alexander Suvorov fought by a simplified code of combat: "Intuition...Rapidity...Impact". It was his highly mobile, skeletonized army which struck the hardest blows against the Turkish forts around the Black Sea while Admiral Elphinston was raiding in the Aegean. His name brought terror into even the stoutest Turkish heart, for he massacred when he conquered. Suvorov again fought the Turks when they declared war, after Russia had annexed the Crimea, followed by Catherine's triumphant journey down the Dnieper to see the miraculous new villages of happy subjects, which were all faked by her Court favorite—Gregory Potemkin—with stage-sets and coerced serfs. Catherine even sailed under arches displaying the blatant threat to Turkey, "The Road to Byzantium", again the work of Potemkin playing upon her dreams of Asian destiny, which had advanced to the point of educating her grandson Constantine in Greek, in preparation for his role as the "Eastern Emperor".

Suvorov was instrumental in cutting the Turkish army to its knees, once more supporting the Russian navy which this time had enlisted another foreign admiral, American freebooter John Paul Jones. In London, instead of aiding Russia against Turkey as had happened during Elphinston's time, William Pitt tried to thwart Catherine's ambitions in the east by demanding an alliance between England and Prussia but was overruled by a Parliament which felt no compulsion to interfere. Turkish resistance collapsed and Sultan Selim III sued for peace. The Treaty of Jassy, signed in 1792, confirmed all of Russia's earlier conquests and recognized her annexation of the Crimea. Also, perhaps for the final time in history, the vanquished presented his victor with a gift for her horse, of rubies, diamonds, solid gold and one gigantic emerald—to glorify the magnificence of *his* country's name, even in surrender.

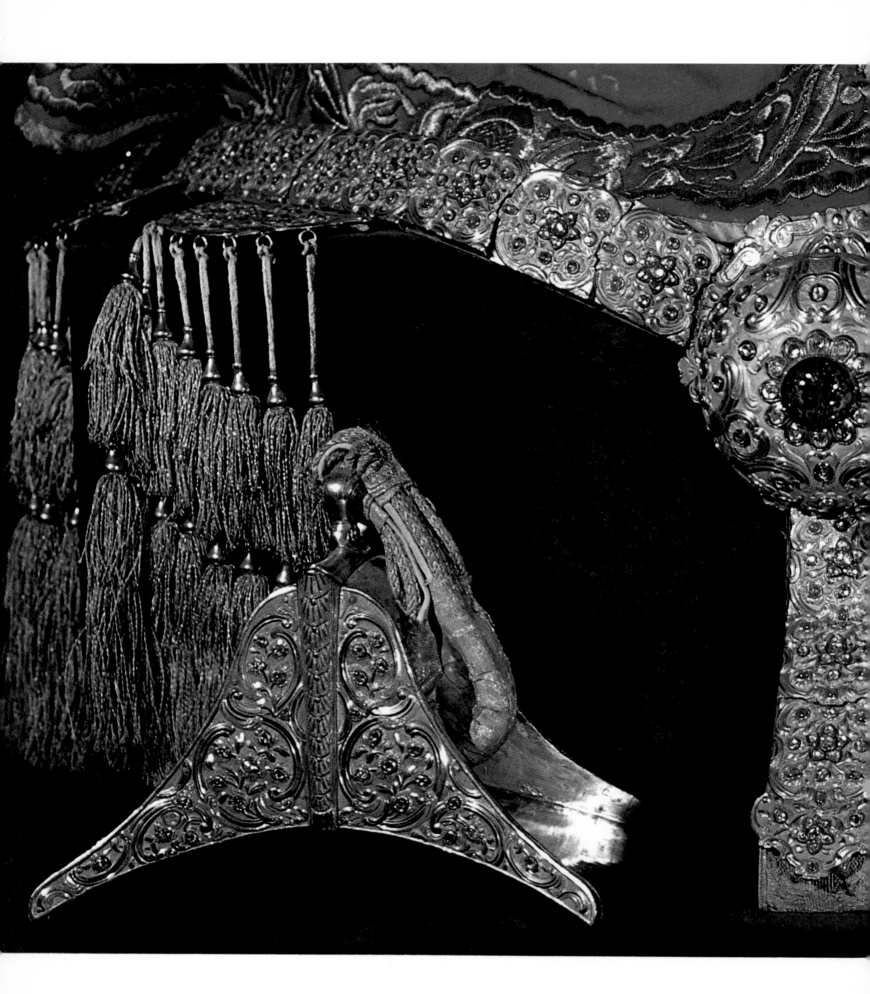

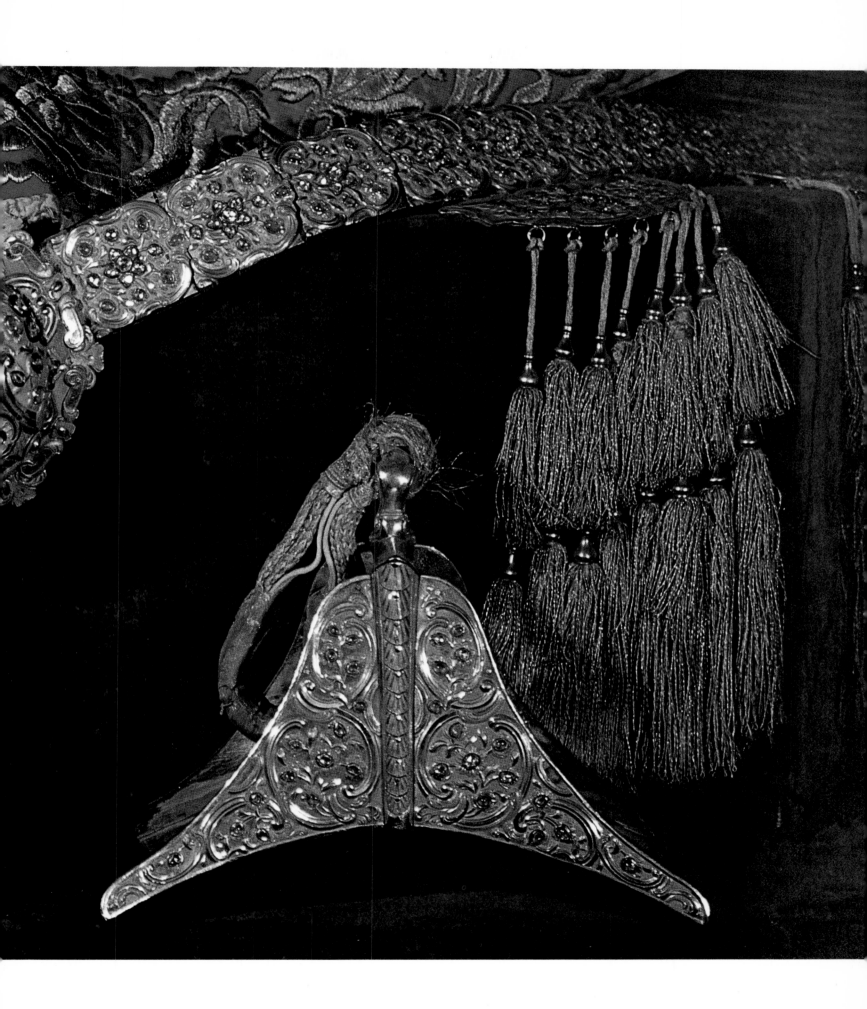

ST. PETERSBURG...THE WINTER PALACE...17 NOVEMBER, 1796
...with a startled gasp, Catherine the Great collapsed and died upon her boudoir floor...

...then Paul, Catherine's son of questionable paternity, ascended Russia's Throne. He was a cantankerous despot who pointed to himself when the Law was mentioned. He filled Siberian prison camps to overflowing and outlawed all European clothes, books and music, yet he was the first sovereign to forbid serfs from working on Sundays for their landlord masters. He was an irrational intriguer who successively fought France, plotted with Napoleon to co-invade India, then broke again with France; a tyrant who converted his new palace into a moated-arsenal but still sank to its floor strangled by a scarf around his throat, the victim of assassination by friends of his own son Alexander, who was an unwitting accomplice.

ST. PETERSBURG...THE WINTER PALACE...23 MARCH, 1801
...almost fainting over the body of his late father, Alexander I was proclaimed Emperor, an Emperor who immediately abolished the use of torture as a police instrument and who promised, then kept his word, not to send one more Crown peasant into serfdom. He also, for the first time among statesmen, in 1804 delegated a special ambassador to London with instructions to propose a unique assembly of world powers: " The peace of Europe can only be preserved by means of a League, formed under the auspices of Russia and England, which should be joined by all second-class States and by all those who really wish to remain at peace.... "

1812

SOLDIERS...WAR IS COMMENCED...Russia swore eternal alliance with France...She now violates her oaths. She declares she will give no explanation of her strange conduct until the French eagles have repassed the Rhine. Russia is led on by a fatality. Her destiny must be fulfilled! Does she believe us degenerated? Are we no longer the soldiers of Austerlitz? She places us between dishonor and war. The choice is not doubtful. We march forward! We pass the Niemen! and will carry the war into the heart of her territory...War will be...glorious to the arms of France.... But the peace which we shall conclude will carry its own guarantee: it will annihilate that proud and overbearing influence which, for fifty years, Russia has exercised over the affairs of Europe.

Headquarters, Wilhowiski, June 22nd, 1812 *Napoleon*

TO OUR ANCIENT CITY AND METROPOLIS OF MOSCOW!

The enemy, with unparalleled perfidy, and with a force equal to his endless ambition, has entered the frontiers of Russia. His design is the ruin of our country....Fully informed of the malignant intentions of the enemy...we do not hesitate to declare to our people the danger in which the Empire is placed....Necessity commands that we should assemble a new force, in the interior, to support that which is now face to face with the enemy....To collect this new army, we address ourselves to the ancient capital of our ancestors, to the city of Moscow. She has always been the sovereign city of all the Russias; and the first, in every case of public danger...to defend the honor of the Empire.... The very existence of our name in the map of nations is menaced....The security of our Holy Church, the safety of the Throne of the Tzars, the independence of the ancient Muscovite Empire, all call aloud, that the object of this appeal may be received by our loyal subjects as a sacred decree!

Camp at Polotzk, July 18th, 1812 *Alexander*

In the midst of a fine night in August, Smolenzk offered to the eyes of the French the spectacle that presents itself to the inhabitants of Naples, during an eruption of Vesuvius.

Smolenzk, August 18th, 1812 *Napoleon*

Smolenzk may be considered as one of the finest cities in Russia, and of the most commanding situation. Had it not been for the circumstances of war, which involved it in flames, and consumed its magazines filled with merchandise, this city would now be regarded as one of the richest sources of our army. But even in its present ruined state, it puts us in possession of a formidable military post, and its remaining buildings afford excellent hospitals for the sick.

Smolenzk, August 19th, 1812 *Napoleon*

For eight years, I found my pleasure in embellishing this country retreat. I lived here in perfect happiness within the bosom of my family; and those around me largely partook of my felicity. But you approach! and the peasantry of this domain, to the number of one thousand seven hundred and twenty human beings, fly far away; and I, put the fire to my house! We abandon all, we consume all, that neither ourselves nor our habitations may be polluted with your presence. Frenchmen, I left to your avidity two of my houses in Moscow, full of furniture and valuables to the amount of half a million of rubles. Here, you will find nothing but ashes.

Moscow countryside, pinned to a gatepost. *Feodor, Count Rastapchin*

SOLDIERS!

Before you is the field which you have so ardently desired! The victory depends upon you. It is necessary to you. It will give you abundance, good winter quarters, and a quick return to your country. Conduct yourselves as when at Austerlitz, at Friedland, at Vitepsk, at Smolenzk, and the latest posterity will cite with pride your conduct on this day. They will say, "He was at that great battle under the walls of Moscow."

Moscow, September 7th, 1812 *Napoleon*

SIRE!

After the hard-fought day...I judged it necessary to quit my position near Borodino. Some of my reasons I have already had the honor of communicating to your Imperial Majesty; and I shall now add another.... Many fell in the conflict; and the wounds and the fatigues of the survivors, though embalmed with the laurels of victory, rendered the hazard of another battle in their weakened situation, and with a reinforced enemy, an enterprise not of courage but of folly. To avoid such a rencontre I changed my position, and turned towards Moscow....To seek a battle under these disadvantages, would have been an useless prodigality of blood, and exposure of my brave troops to the disgrace of an overthrow. The risk, on my part, would have been unpardonable; for, though the reinforced army of Napoleon would now have counted more than double our numbers, yet in defeat there is ever a sense of dishonor as well as inferiority; and, how far would I not lead the Russian soldier from any chance of incurring this appalling feeling! Besides, to be beaten before the walls of Moscow, would expose the city to the lawless entrance of the triumphant enemy; and its riches and its towers would become the strength of Bonaparte!

Foreseeing this, I held a consultation with my ablest Generals. I imparted to them what I anticipated must accrue from the relative state of the two armies; I informed them of the *alternative*, between loyalty to their country and vassalage to the invader, which had been decided on in case of extremity by the noble inhabitants of the ancient city of the Tzars. I offered my opinion on these facts. Some of my Generals dissented from me; but most agreed with my advice, and we determined to allow the enemy to enter Moscow!

Aware of the expediency of this measure, all expedition had been previously made to remove to a place of safety the contents of the arsenal, and the treasures of the city, both public and private. With their property, most of the people departed; and Moscow was left a mere desert of walls and houses, without an inhabitant. Call to mind what the human body is when deserted by the soul! So is Moscow when abandoned by its citizens. The soul of an empire is its people; and wherever they are, there is Moscow, there is the empire of Russia. Hence, I boldly assure your most Gracious Majesty, that the entrance of the French into Moscow is not the conquest of Russia, is not the subjugation of the capital of the Tzars.

I do not deny that the desperate alternative of sacrificing the venerable city of our ancestors, is a wound to all our hearts, is a stroke that must pierce every Russian breast with unutterable regrets; but then it is a city for an empire; the immolation of a part to save the whole.

Already it affords me the means of preserving my entire army. I possess the Tula road; and cover, with the extended line of my troops, the storehouse of our resources, the abundant provinces of the empire, which furnish our armies with their flocks and their harvests. Had I taken any other position, or persisted in maintaining Moscow, I must have abandoned these provinces to the enemy, and the consequences would have been the destruction of my army and the loss of the empire.

Now, I hold an unmolested communications with the armies of Tormozov and Tchitchagov; and am enabled to form a chain of union with my whole force, that empowers me, beginning from the Tula and Kaluga roads, to completely intersect the enemy's line of operations, which stretches from Smolenzk to Moscow. By this advantage I cut off every succor he may have in his rear; and, hope to compel him in the end to quit the capital, and to humble the proud direction of his plans....

For myself, stationed, as I have described, between the enemy and the fertile provinces, and a short distance from Moscow, I watch his movements, and guard the resources of the empire: for, I must repeat, that as long as the army of your Imperial Majesty exists (and it will exist as long as there is a Russian alive to defend his country!) the loss of Moscow is not the loss of the empire! The invader will be forced to evacuate the capital of the Tzars. Its ruins will be repaired, and the glory of the empire brightened by the very attempts that have been made to extinguish its existence.

Gilino, September 7th, 1812

Field Marshal Prince Golenistshev Kutusov
General in Chief
of All the Armies

The Following Declaration is given for the Instruction of all the Troops under my Command.

At the moment in which the enemy entered Moscow, he beheld the destruction of those preposterous hopes by which he had been flattered: he expected to find there Peace and Plenty; and on the contrary he saw himself devoid of every necessary of life; harassed by the length of continued marches; exhausted for want of provisions; wearied and tormented by our parties intercepting his slender succours; losing without the honor of battle thousands of his troops; cut off by our provincial detachments; and no prospect before him but the vengence of an armed nation, threatening annihilation to the whole of his army. In every Russian he beheld a hero equally disdainful and abhorrent of his deceiptful promises: in every state of the empire he met an additional and insurmountable rampart opposed to his strongest efforts. After sustaining incalculable losses by the attacks of our brave troops, he recognized at last the frenzy of his expectations, that the foundations of the empire would be shaken by his occupation of Moscow. Nothing remained for him but a precipitate flight; the resolution was no sooner taken than it was executed; and he fled, abandoning nearly the whole of his sick to the mercy of an enraged people, and leaving Moscow on the 11th of this month, completely evacuated.

 The horrible excesses which he committed while in that city are already well known, and have left an inexhaustible sentiment of vengeance in the depths of every Russian heart; but I have to add, that his impotent rage exercised itself in blowing up part of the Kremlin, where, by a signal interposition of Divine Providence, the sacred Temples and Cathedral have been saved.
Let us then hasten to pursue this impious enemy...
Russian warriors! God is our Leader!

October 19th, 1812 *Field Marshal Prince Golenistshev Kutusov*

SOLDIERS!

That year is gone! That memorable and glorious year, in which you have leveled with the dust, the pride of our insolent Invader! That year is gone, but your heroic deeds remain. Time cannot efface their remembrance: they are present with ourselves—they will live in the memory of posterity—faithful sons of Russia! Sons, upon whom God the Father bestows His paternal blessing.

1813 *Alexander*

"OUR INSOLENT INVADER"

NAPOLEON'S GIFT...Apollo slaying a centaur...one among two thousand plates, arrived for Emperor Alexander just before the Corsican attacked.

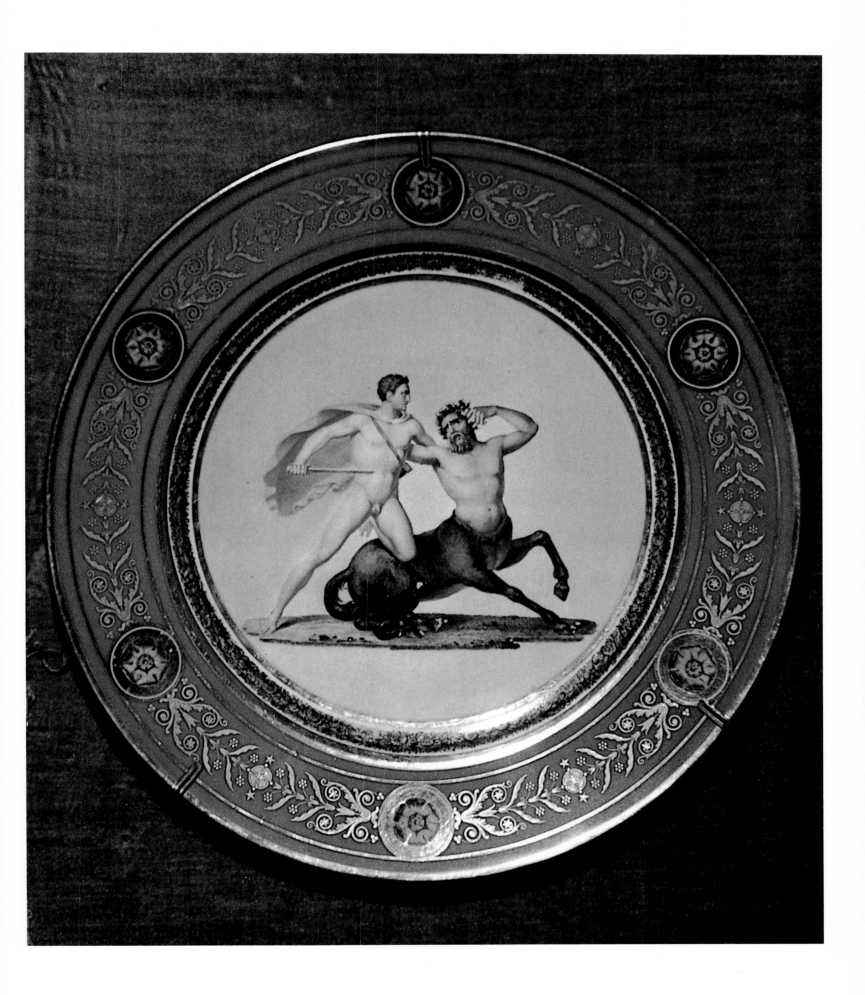

GRAND KREMLIN PALACE

THE GREAT HALL OF ST. GEORGE, the Kremlin's enormous ceremonial room, was built amid the ruin and decay which characterized the ancient site after Napoleon's retreat and generations of neglect, when the capital of the Emperors was in St. Petersburg. Nationalistic pride after the war aroused such concern for the nearly deserted buildings that reparations were finally started in 1839. During the next ten years, on orders of Nicholas I, architects cleared away the debris then built the sprawling Grand Kremlin Palace in which the mightiest hall was named for the Order of St. George, Russia's supreme military honor created by Catherine the Great. Each winner of the Order, regiments and single soldiers, were listed forever upon its walls. There today, the Old Empire and its soldiers gone, rulers of a new regime gather to welcome State guests and to celebrate *their* victories between ivory walls still emblazoned with names of warrior-heroes of the past.

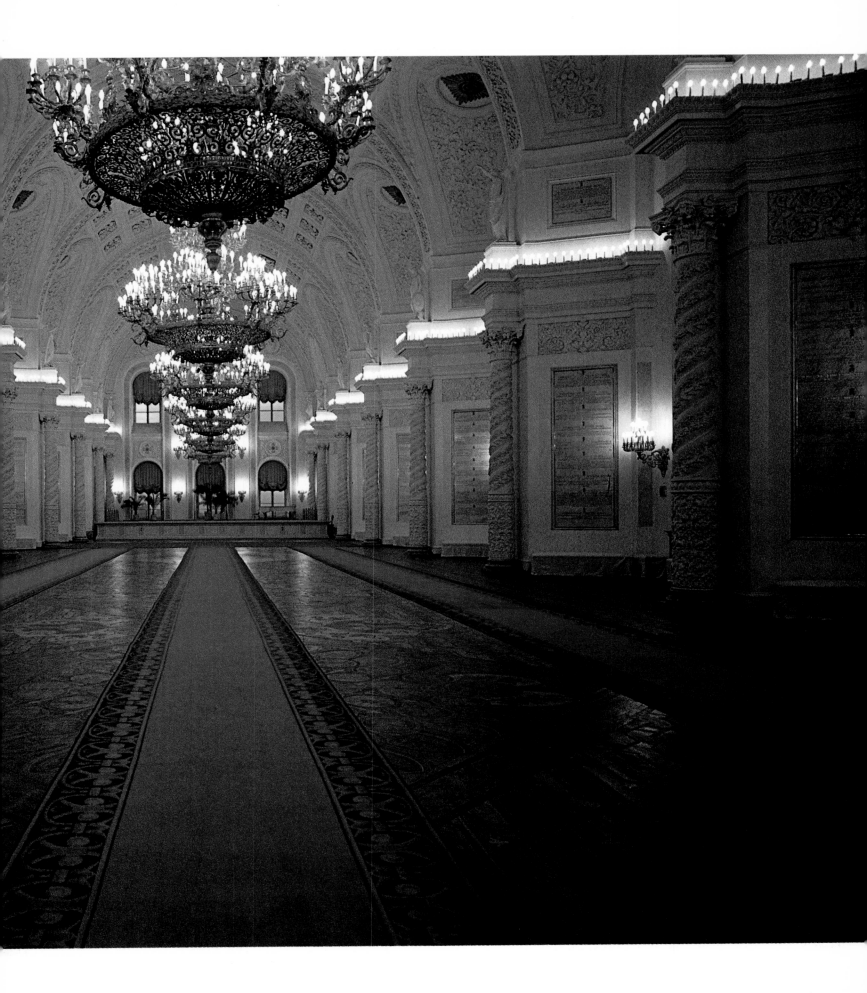

"YOU ARE ABOVE THE LAW"

"I AM EMPEROR, BUT GOOD GOD, AT WHAT A COST!"

Nicholas I had just ordered artillery to fire point-blank into the faces of his beloved army, into a solid square of three thousand Guardsmen shouting allegiance to his older brother, Constantine, whom they thought should have inherited Alexander's Throne. They also had been told by agitators of the country's first secret societies that Constantine believed in abolition of serfdom and in a Constitution. Ironically, Constantine had signed sealed papers of abdication three years earlier, then had abandoned Russia to live with his morganatic bride in Poland. The shooting left the snow of St. Petersburg's Senate Square stained with nearly eighty crumpled figures, Guardsmen and civilians, which crushed the first *political* insurrection to challenge the Romanov dynasty. It was eleven days before Christmas, 1825. For all of Russia's future revolutionaries the dead were enshrined as martyrs in a single word, "Decembrists."

Nicholas was a militant disciplinarian who firmly believed that as Emperor he was God's agent on earth. By ascending the Throne he had become, quite literally, the Father of his country. He harbored no sympathy for opposition to his reign: "I shall be surprised if any of my subjects dare to act counter to my will, once that will has been made known." In speaking with one of the Decembrist conspirators before his execution, a twenty-two-year-old sublieutenant, Bestoujev-Ryumin, the Emperor expressed his paternalistic concern: "You know that I can pardon you, and if I were sure that in the future you would be a faithful servant I would willingly do so." Ryumin's reply must have angered him: "Your Majesty, that's exactly where the trouble lies—that you are above the law; and it has been our aim and object to obtain for your subjects that in the future their fate may depend upon the law, and not upon your momentary whim or impulse!"

For the next thirty years Russia sat rigidly handcuffed and gagged while Nicholas lectured and tried to administer personally all of its needs. Frontiers were closed. Travel abroad was forbidden, as was the employment of foreign teachers, technicians or advisers. Religious tolerance—which had existed since Ivan the Terrible's time when he had said, "In our realm live many members of other Churches, and we leave them to follow out their doctrine: only they must not attempt to spread them abroad amongst our people"—was crushed by a general of the Russian army, the Chief Procurator of the Holy Synod. Napoleon's attack had convinced Nicholas of the evils of the West's designs and that Russia's destiny lay in her role as the leader of the Christian Slavic peoples, many of them under the yoke of Turkey. The Metropolitan, in his silver cassock and pearl-embroidered mitre, led the hierarchy of priests of the Russian Orthodox Church into a willing partnership with the Crown. The Turkish-held Holy Land would become Russian! Thus the politico-religious movement known as Imperial Slavophilism was launched.

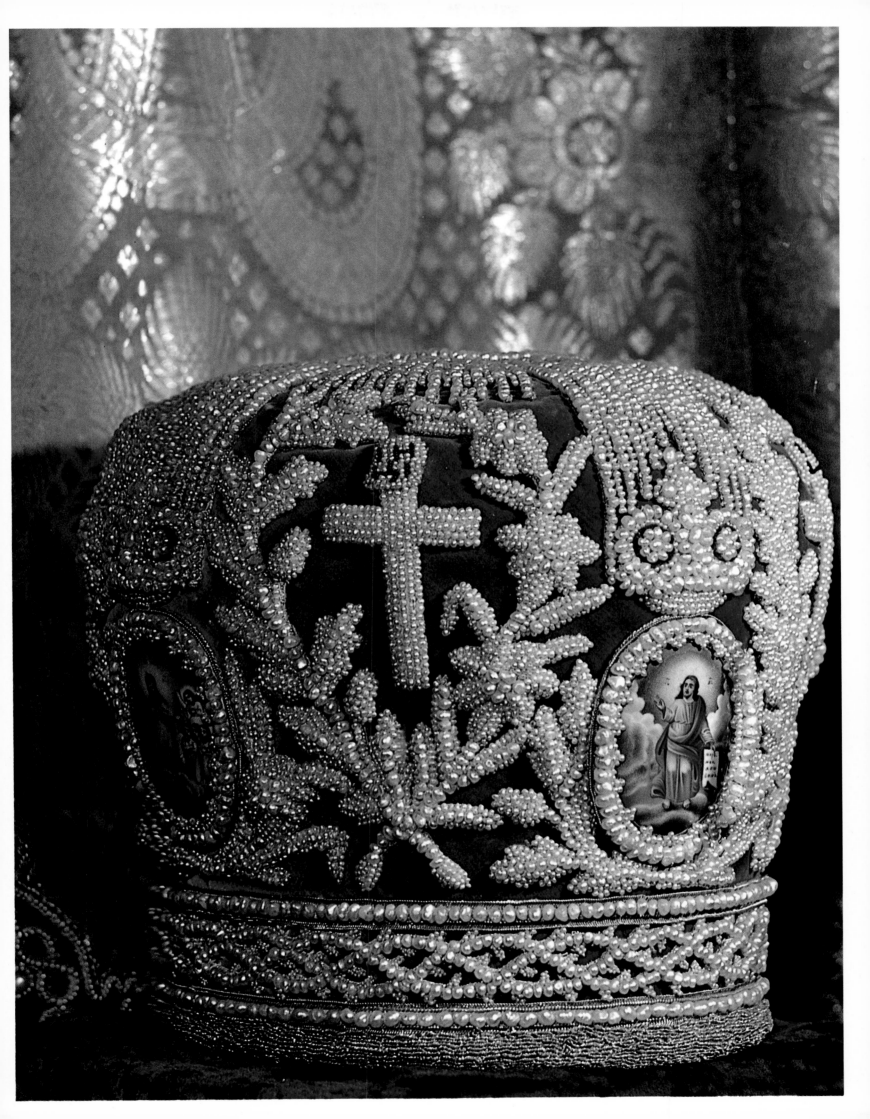

"ODE TO LIBERTY"

Religious zealots, and Nicholas, theorized: "Western religion has chosen the way of reason and logic and so she has gone astray...The Eastern Church alone knows what is the right way for human progress and toward eternal salvation." Then the Throne-appointed Minister of Education spoke: "In the midst of religious and civil institutions rapidly on the decline in Europe, keeping in view the universal spread of subversive ideas and attending the distressing events that were happening at every step, it was necessary to establish the Fatherland on those very stable foundations on which the welfare, the strength, and the life of the nation are generally built; it was necessary to discover such principles as belonged exclusively to Russia and those principles which formed its peculiar characteristics; to gather in one the sacred remainder of its nationality, and there to anchor the hopes of our salvation..." In a nearby, smoke-filled cellar was heard one of Moscow's new philosophers who had escaped the fate of the executed Decembrists, a man named Alexander Herzen: "We and the Slavophils represented a kind of two-faced Janus; only, they looked backward and we forward. At heart we were one, and our hearts throbbed equally for our minor brother, the peasant. But what for them was a recollection of the past was taken by us to be a prophecy for the future." Thus, even then, the fork in the road ahead was clearly marked—one branch leading to the almost total extinction of the Russian Church, and the other to political domination of the world's greatest land mass and its peoples.

Total censorship, enforced by secret police of Nicholas' dreaded "Third Section," should have made Russia an intellectual desert where only the officially nourished could survive—men like Teacher Pogodin of the University of Moscow, who enthused: "Providence guides the history of every nation, but this is particularly true of Russia! No other history contains so many marvels....How great is Russia! How large is her population! How may nationalities it comprises! How immense are her national resources! Finally, is there anything the Russian state could not do? A word—and a whole empire ceases to exist, a word— and another disappears from the face of the earth!" At the same time a young poet named Pushkin, who had written an "Ode to Liberty" and been banished to Bessarabia, returned to the capital. There, with the Emperor as his personal censor, he wrote in rapid succession "Boris Godunov," "Eugene Onegin," "The Bronze Horseman" and sheaves of other poems, plays and prose. Glinka composed the first Russian opera, "The Life of the Tzar."

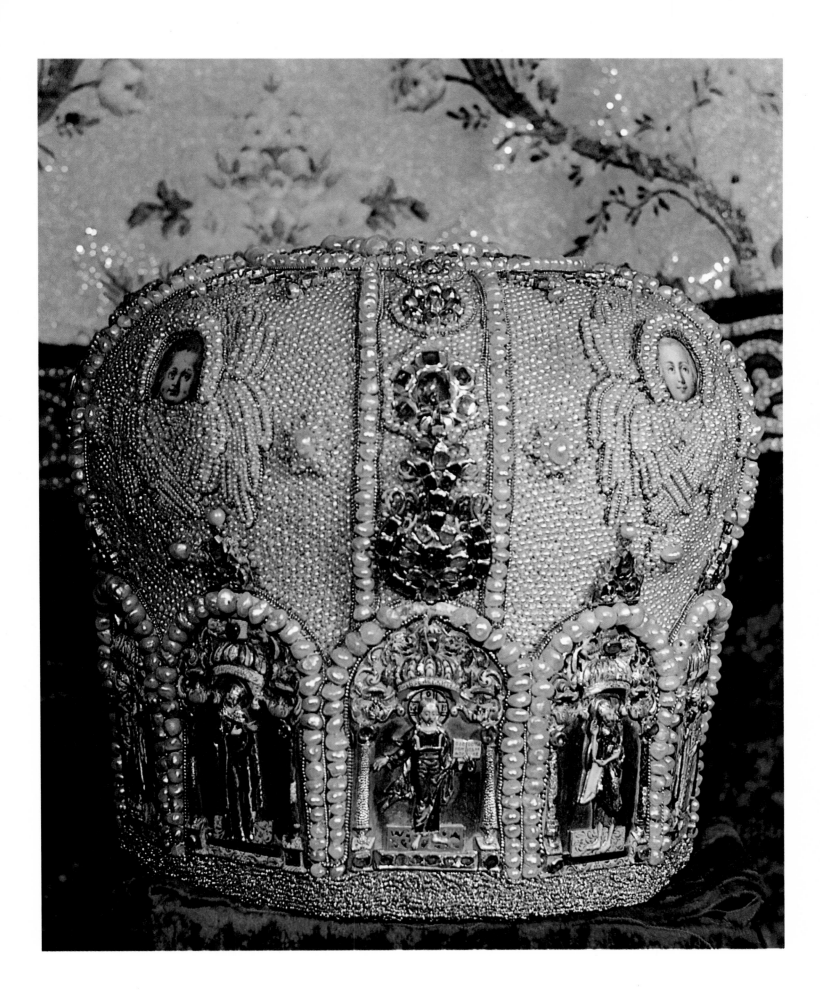

"DEAD SOULS"

Gogol penned his monumental denunciation of serfdom, "Dead Souls." Lermontov recited his poems. Dostoyevski, Tourgeniev and Leo Tolstoy were newcomers finding their media—and an officer of the Guards, Peter Chaadaev, wrote caustically until one of his works was unaccountably printed, after which the Moscow *Telescope's* editor was exiled, the paper suspended, the censor sacked and Chaadaev decreed insane: "Cast a glance over all the centuries we have lived, over all the territory we occupy, and you will not find a single memory that would arrest you, not a single monument that would bring out the past vividly, powerfully, concretely. We live in a state of indifference towards everything, with a narrow horizon, with no past or future.... We have contributed not a single thought to the sum total of the ideas of mankind; we have not assisted in perfecting human understanding and we have distorted what we have borrowed from it. During our entire existence as a society we have done nothing for the common good of man; not one useful thought has been born on our arid soil. Led by a malevolent fate, we have borrowed the first seeds of our moral and spiritual enlightenment from decadent, generally despised Byzantium."

Nicholas' ruthlessly narrow, autocratic world exploded due to his concept of Russia's future being linked inseparably with his dream of Slavophilism. He and his puppet priests within the Holy Synod convinced themselves that Turkey's Christian minority in Palestine would arise to Russia's colors if the Sultan were attacked, especially since revolution was in the air throughout Europe. Louis-Philippe had fallen in France, Metternich finally had been routed from Vienna, Hungary had broken the shackles of the Hapsburgs, Belgium was free of Holland—only Queen Victoria was secure on her throne in faraway England. It seemed a most opportune time to destroy Turkey. It was 1 November, 1853.

Nicholas attacked. So did England and France—on the side of Turkey. No Turkish Christians arose to welcome or join the Russian crusaders. Sebastopol, Russia's most powerful naval base in the Black Sea, fell after a heroic stand against impossible odds. Half a million men were casualties on both sides, one of them the intolerant Emperor of All the Russias, Nicholas I—of a cold. The Crimean War dragged on into the spring of 1856 then finally was terminated by the Treaty of Paris. Nicholas' Russia was a bankrupt wreck, Catherine the Great's hard-won naval bases in the Black Sea were wiped out, considerable southern lands were lost and the Christians in Jerusalem continued living under the Sultan just as before. The grieving Metropolitan of All the Russias sadly donned his gem-embroidered mitre and silver robes to pray for the souls of those multitudes of men who would never come home.

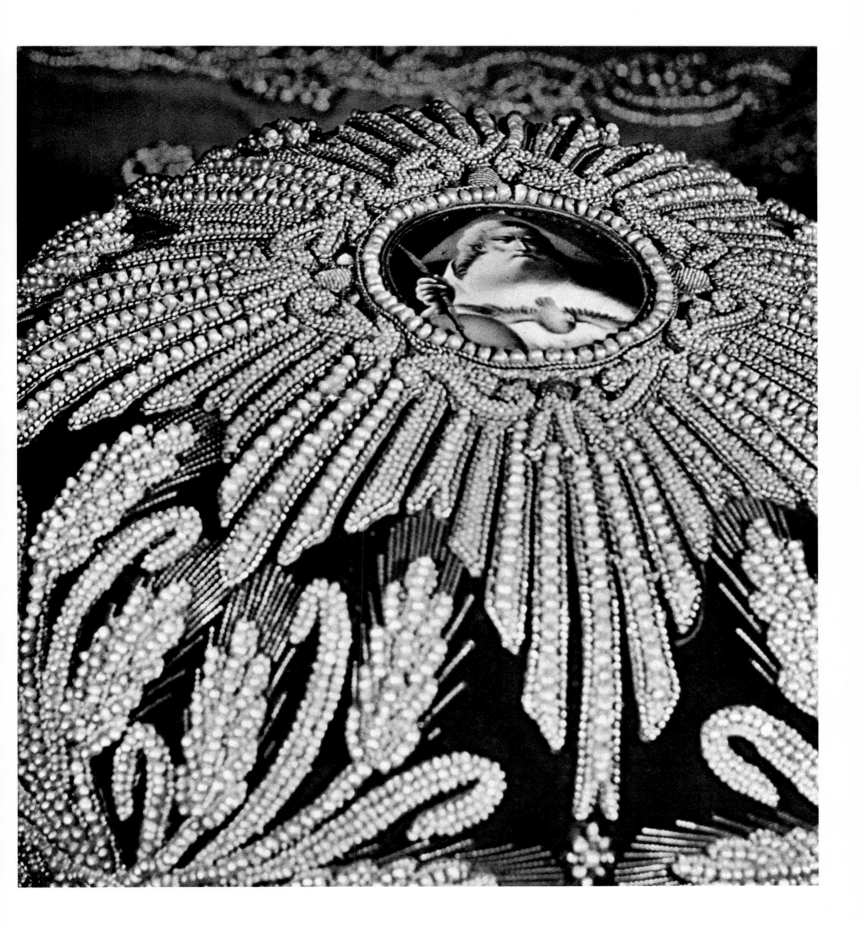

THE
ROMANOV REQUIEM

A GILDED EASTER EGG, with miniature portraits of every Tzar, Emperor and Empress on its shell, was the high light of the 300th anniversary of the Romanov dynasty's reign over Russia—and one of the last Imperial treasures to be placed beside the Kremlin Crowns. Inside the egg, master jewelers of Fabergé had fitted two golden-enamel spheres showing the Romanov Empire as it was in 1613, when the dynasty began, and as it was in 1913 at the close of three centuries in power. Mikhail, Alexei, Feodor, Ivan V, Peter the Great, Catherine I, Anna, Elizabeth and Catherine the Great—they and all of the others were there, including the final three... Alexander II, who was murdered after abolishing serfdom, after the hatred had burst and it already was too late... Alexander III, the giant who could straighten a horseshoe with his bare hands, who believed in remedying Russia's ills the same way... Nicholas II, shy, delicate, fatalistic, who blandly ignored forebodings of disaster when nearly two thousand celebrants were fatally crushed on his coronation day; who accurately appraised his own inability to harness the enraged creature tethered so insecurely to his Throne; who, because of his frantic wife's mystic convictions, entrusted their incurably ill son to uncouth Rasputin, an awesome clairvoyant soon to have Church and Court submissive to his whims while meek Nicholas fought a World War in Europe, then revolution right at home, which was probably more than his failing spirit could bear... so that when he looked at his family—clinging together in a remote Siberian village—then at the assassins pushing them against the wall, perhaps his fatalism took him by the hand to view peacefully that last terrible day simply as the end.

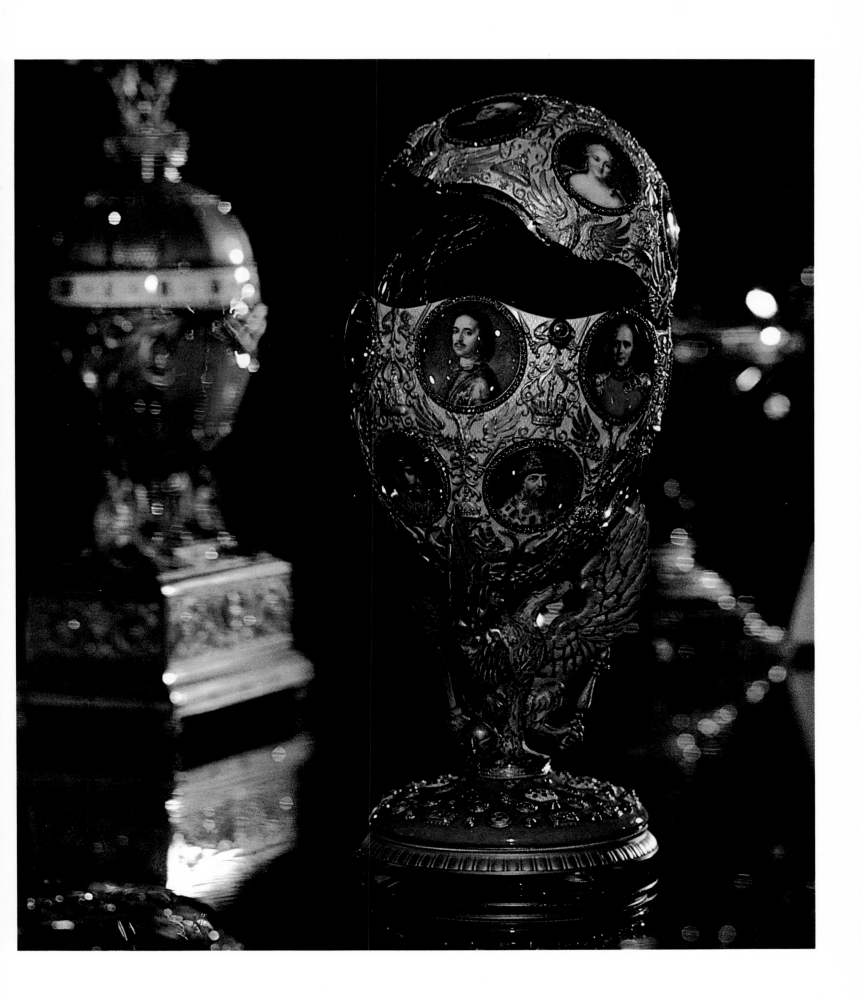

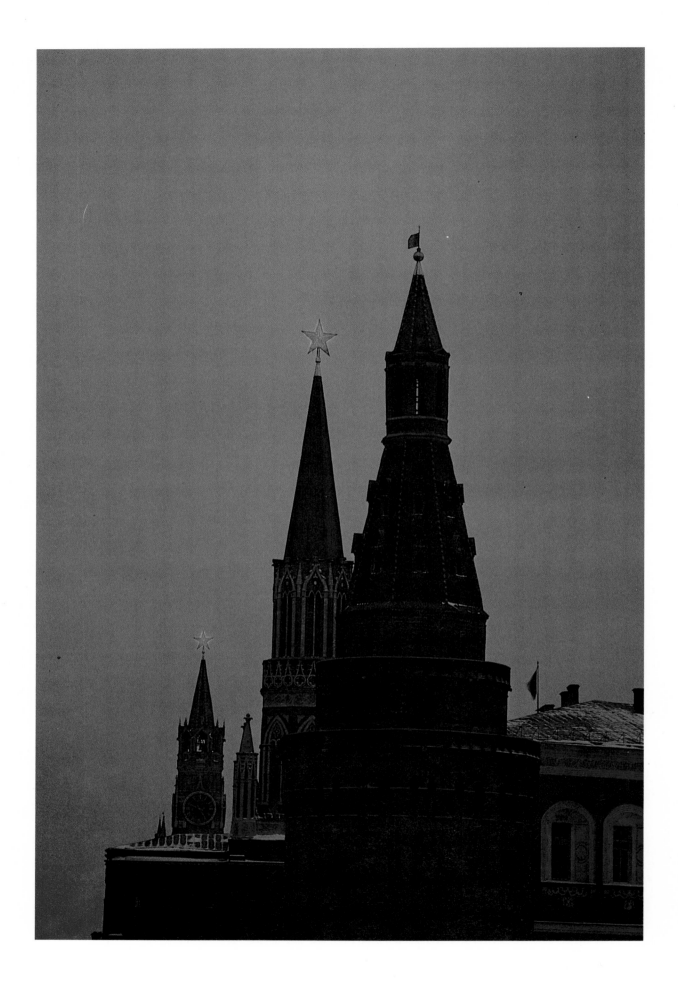

1917
THE REVOLUTION

The Great Hall of the Russian Supreme Soviet was a pair of chapels dedicated to old heroes Alexander and St. Andrew. Today, the two chapels have been combined to form one severe desk-filled chamber where all members gather when they are sitting for sessions. This chamber connects directly to the Great Hall of St. George in which the most formal Kremlin functions are performed. Both halls are in the enormous xixth century Grand Kremlin Palace. The statue of Lenin, who was chairman of the Bolsheviks when they won control of Russia during the October Revolution of 1917, is seen today within its niche behind the rostrum of the Hall.

"FROM EVERYONE ACCORDING TO HIS ABILITY,

AND TO EVERYONE ACCORDING TO HIS NEED."

RED STARS ATOP THE KREMLIN...the statue of a bearded man in a business suit...a bronze shield embossed with tools of the factory and farm—these austere symbols, and a slogan adopted in 1917, remain the only monuments raised by the Communists to commemorate their October Revolution. There are no monuments to the other Russian revolution of 1917, even though it was *the* revolution that deposed the Romanov Emperors.

Nicholas II tried desperately but pathetically failed to provide leadership for his country's arms during the first World War, a war effort which clearly revealed the depth of decay in the Romanov dynasty. Palace intrigue and administrative corruption sabotaged every move. His army suffered losses of over seven million men, men who had been drafted from the far horizons of Russia's black earth without the faintest idea of any issue involved. Unbeknown to themselves, they were the black earth in which final rebellion was to flourish.

On 23 February, 1917, in Petrograd—the new, de-Germanized name for St. Petersburg—police fired upon women rioting for bread. Within ten days all factory workers were out on strike; home guards units and the police themselves were in the streets with the strikers; the first Soviet (Council) of Workers' and Soldiers' Deputies was in session; a Provisional Government had been formed that refused to recognize Nicholas II as Emperor; Nicholas had abdicated; his brother, Grand Prince Mikhail, had declined the Crown unless approved by a Constituent Assembly; and a message had been decoded from an agent in contact with the Kaiser's General Staff confirming that a sealed railway car would soon be safely crossing Germany carrying a special passenger for Petrograd. Vladimir Ilyich Ulyanov...Lenin, was coming back.

Russia was free! After an eternity of waiting it was almost too easy. On 27 April, the first President of the Provisional Government expressed the exhilaration of fellow idealists: " The great Russian Revolution is truly marvelous in its majestic, undisturbed progress. The soul of the Russian people has proved to be, by its very nature, the universal democratic soul. It is ready not only to merge with the democracy of the entire world, but to take its place ahead of it and to lead it along the path of human progress inspired by the great principles of freedom, equality, and brotherhood." His voice was lost against the tornado arising from the steppes and swamps where Russia's army still faced the Germans, for on 3 April, from a palace balcony of the capital's prima ballerina, Lenin had shouted *his* policy: " End the war All land to the peasants. "

Lenin's political faction, the Bolshevik (Majority), was the most influential of all the revolutionary groups milling around Petrograd after the overthrow of the Romanov Emperors, although, despite their grandiose party name, they were the subminority. Meticulously organized, fanatically devoted to their cause, experts in propaganda, they were the only group dedicated to a common dream: absolute control of Russia. The hastily convened, idyllic Provisional Government was an unwieldy mass of romantic rebels with few leaders, little practical governmental experience and no clearly defined immediate goal other than to endorse

CITIZENS FROM ALL THE LAND

universal suffrage for boys and girls when they reached eighteen, and to issue a restatement of the moral obligation of Russia to stay in the war on the side of the Allies—Allies on the western front who were watching with anguish each move which seemed to make inevitable Russia's abandonment of the war. Their fears were well founded. To the consternation of even fellow Bolsheviks Lenin was openly preaching fraternization and peace at any price to the army at the front. He was desperately racing with time. He had to block every possibility of organized army intervention before launching *his* coup. Rumors...pamphlets...frontline "inspectors" all did their work—"The land is being divided...it's the time to be home!"

In July, after goading by the Allies, the Provisional Government mounted a final drive on Russia's southwestern front. It rolled along for a few days, then was blasted to shreds. The soldiers routed. Those who survived kept going until they were home. The army was a shambles of confusion. The Bolsheviks struck for total power in late October. All earlier opposition evaporated except for last-ditch rhetorical barrages fired by ministers of the expiring Provisional Government. Lenin, who had been driven underground in Finland because of his suspected pro-German role in the midsummer military debacle, reappeared to participate in the attack being planned by two veteran revolutionaries, Leon Trotsky and Joseph Stalin.

It came in the night of 24 October. Just before midnight of the 25th, success was assured when defenders of the Provisional Government's headquarters in the Emperors' old Winter Palace surrendered and walked out—a battalion of women. The ministers of Russia's first free government were then rounded up and marched into a nearby dungeon. Other Bolsheviks in Moscow kept pouring artillery fire upon three thousand military school cadets barricaded within the Kremlin. The historic place changed hands twice, then fell. Lenin immediately transferred the capital of Russia back to its traditional site, where the ceremonial halls of St. Andrew and Alexander in the Grand Kremlin Palace were transformed into the sacrosanct meeting chamber of the Supreme Soviet. The second phase of the Revolution was finished. October was gone and it was November. On every November 7th in later years—which was 25 October in the discarded Old Russian calendar—multitudes of *citizens* from all the land would crowd into Moscow's Red Square to celebrate the date by walking slowly past the dull red sarcophagus of Lenin and Stalin, who led the coup that was the Revolution that changed the name of their ancient land to the Soviet Union, and with it the destinies of everyone else sharing life on earth today.

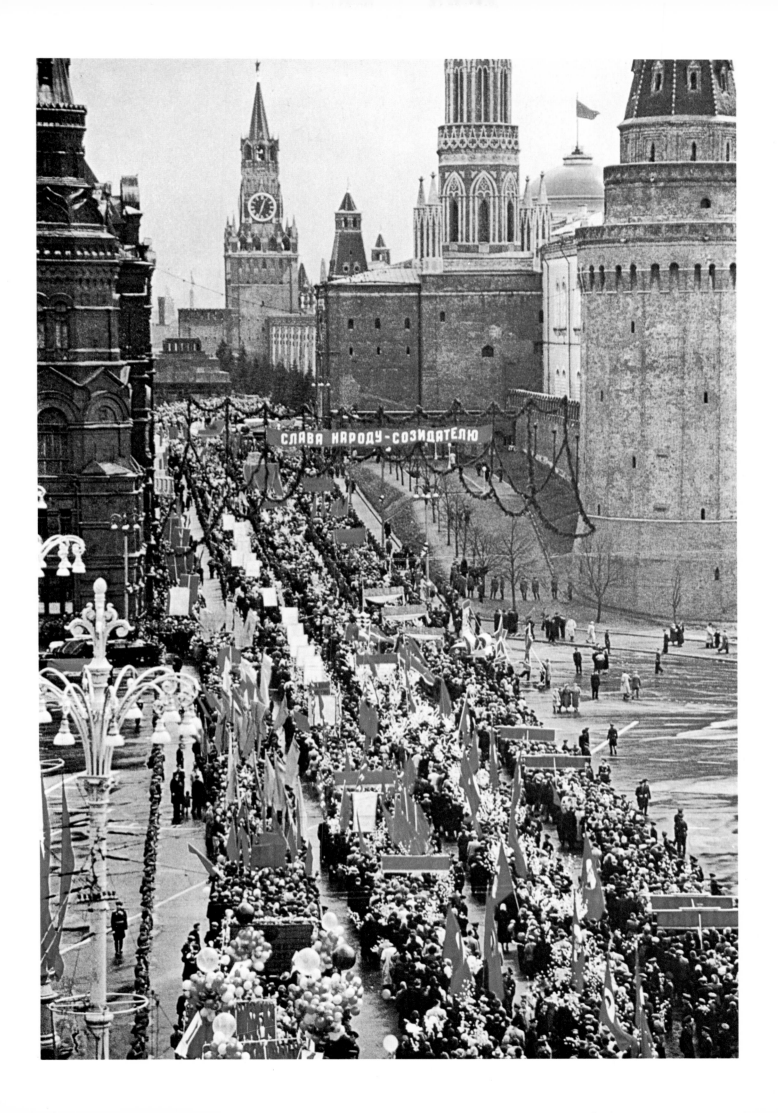

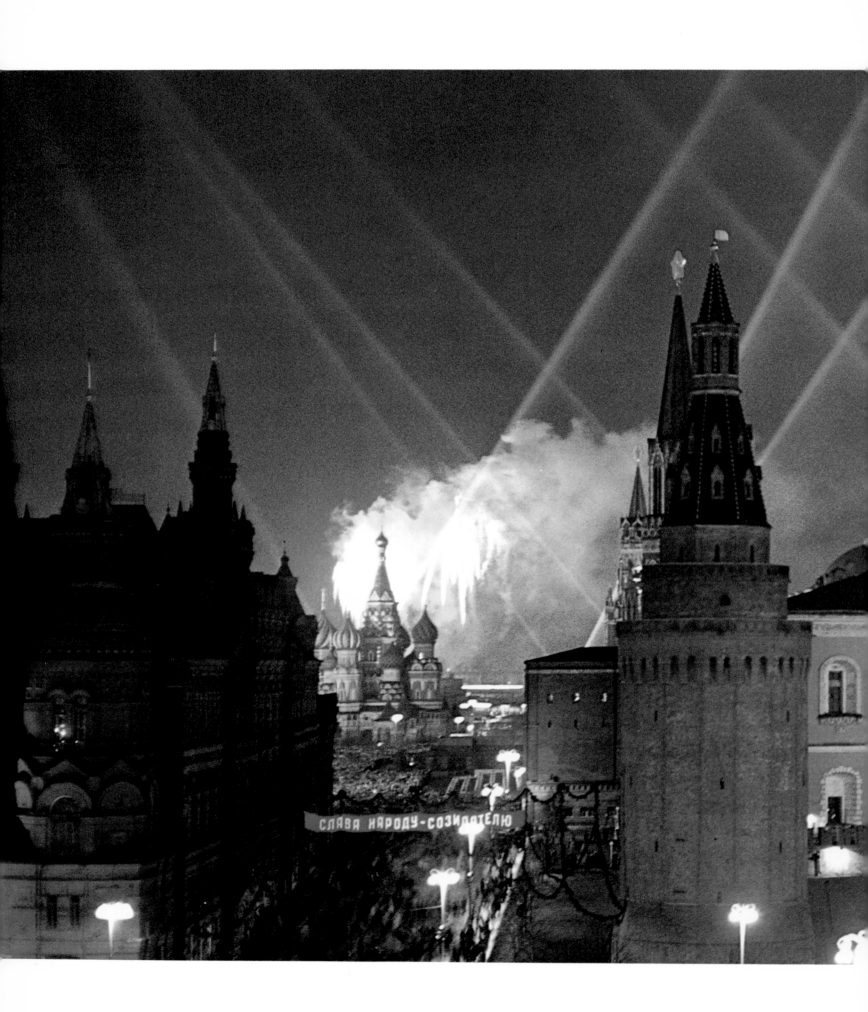

ДОСТУП В МАВЗОЛЕЙ
В.И. ЛЕНИНА и И.В. СТАЛИНА
ПРОИЗВОДИТСЯ:
по вторникам, средам,
четвергам и субботам
с 13 до 16 часов.
по воскресеньям с 12 до 17 часов.

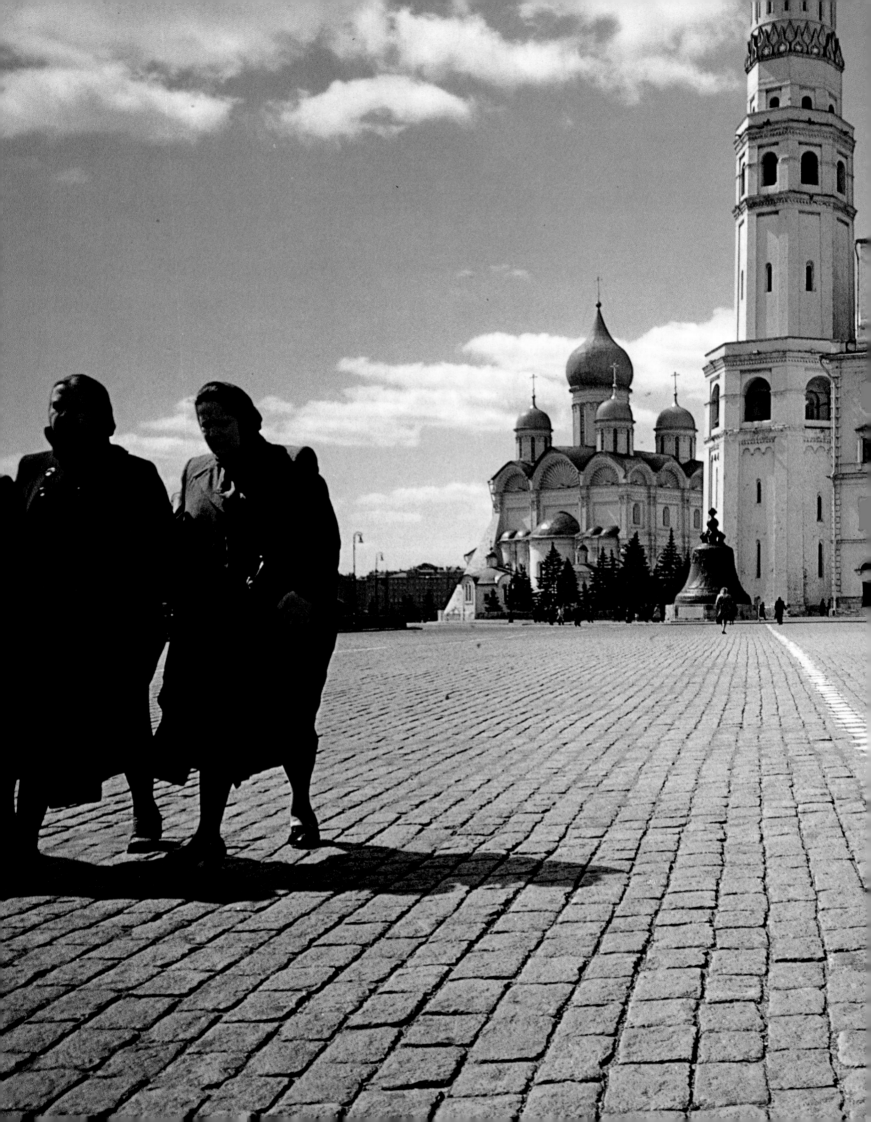

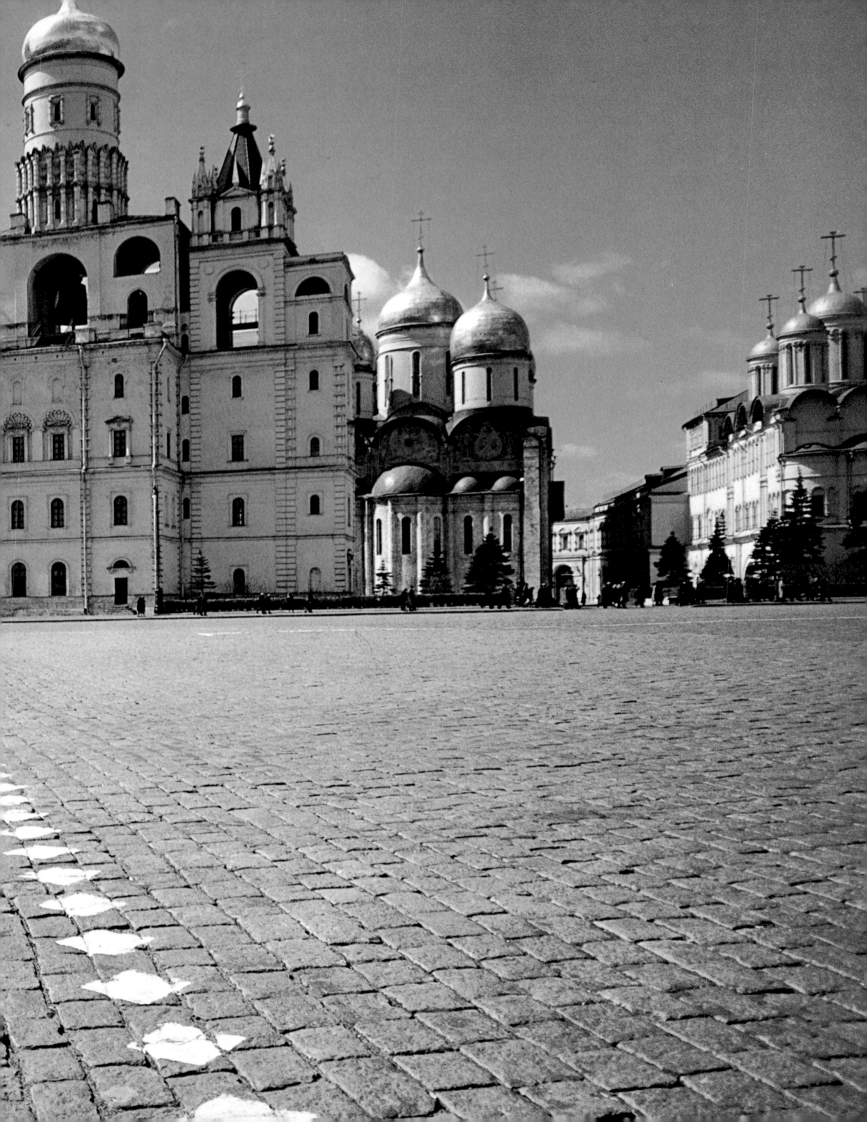

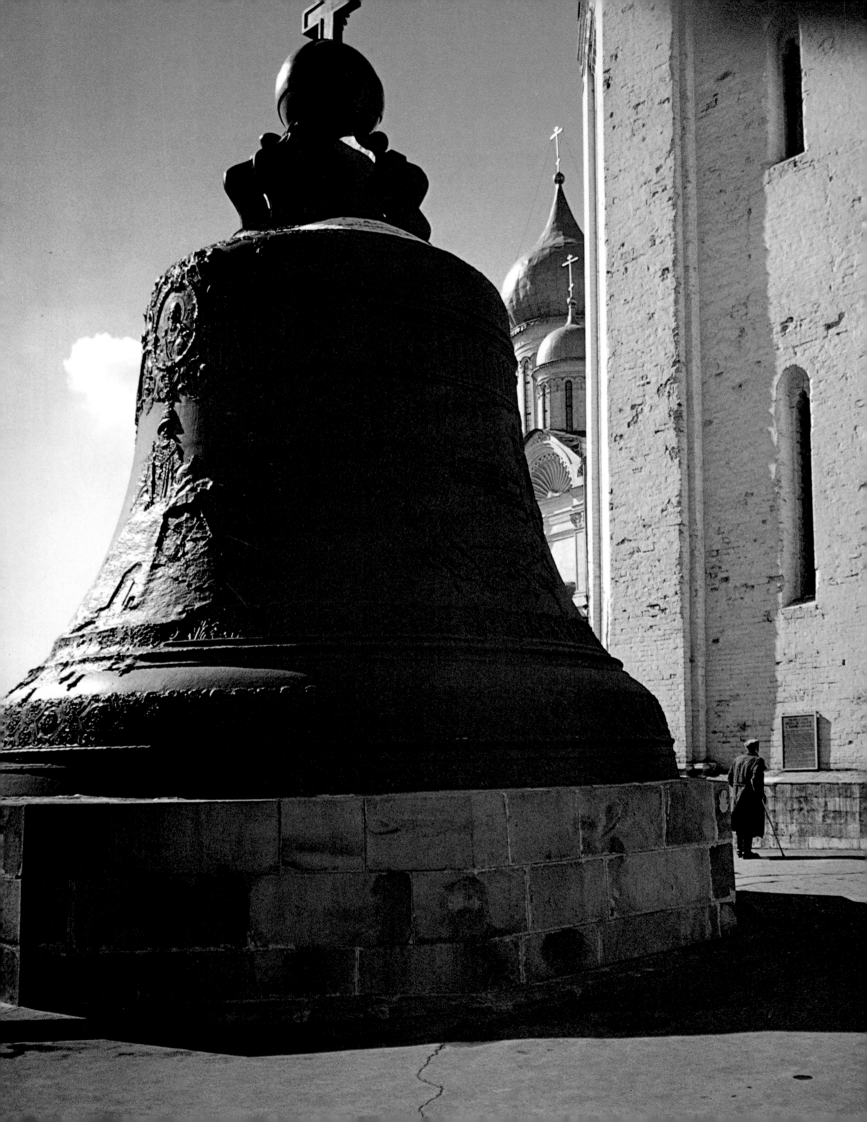

KING

OF THE

BELLS

TWO HUNDRED TONS OF SILENCE are all that remain of what was to have been the biggest, most clarion-voiced bell in the world—a monument to flamboyant Tzarist times. Now it is just an enormous, other-world oddity to the crippled veteran of more recent times who comes as a tourist to the Kremlin to share quietly in the celebrations of his country's Revolution Day. The giant bell was a dream of Tzar Alexei Mikhailovich during the XVIIth century Jewel Age of the Romanov dynasty. It materialized in the reign of Empress Anna. She commanded it cast by Russia's master bell maker who worked steadily from 1733 to 1735, when it was ready for its tower on the Kremlin's Cathedral Square. Two years later, on 29 May, 1737, an unchecked fire engulfed the tower. The still unhung bell sank into a pool of water and cracked. Efforts to repair it were useless for an eleven-ton fragment had shattered from its lip. Today it rests where it broke, near Archangel Cathedral and the white brick tower of Ivan the Great. Still clearly visible on the sides of the bell are the bronze portraits of Tzar Alexei and Empress Anna—around whose head runs a halo of words: "The kindest, holiest, best Tzarina, I, Anna, ordered this bell."

THE SAVIOUR'S TOWER...
St. Basil's spires...a lone militiaman on stolid feet
all cast lengthening shadows across Red Square,
awaiting the drifting snows of another winter's storms.

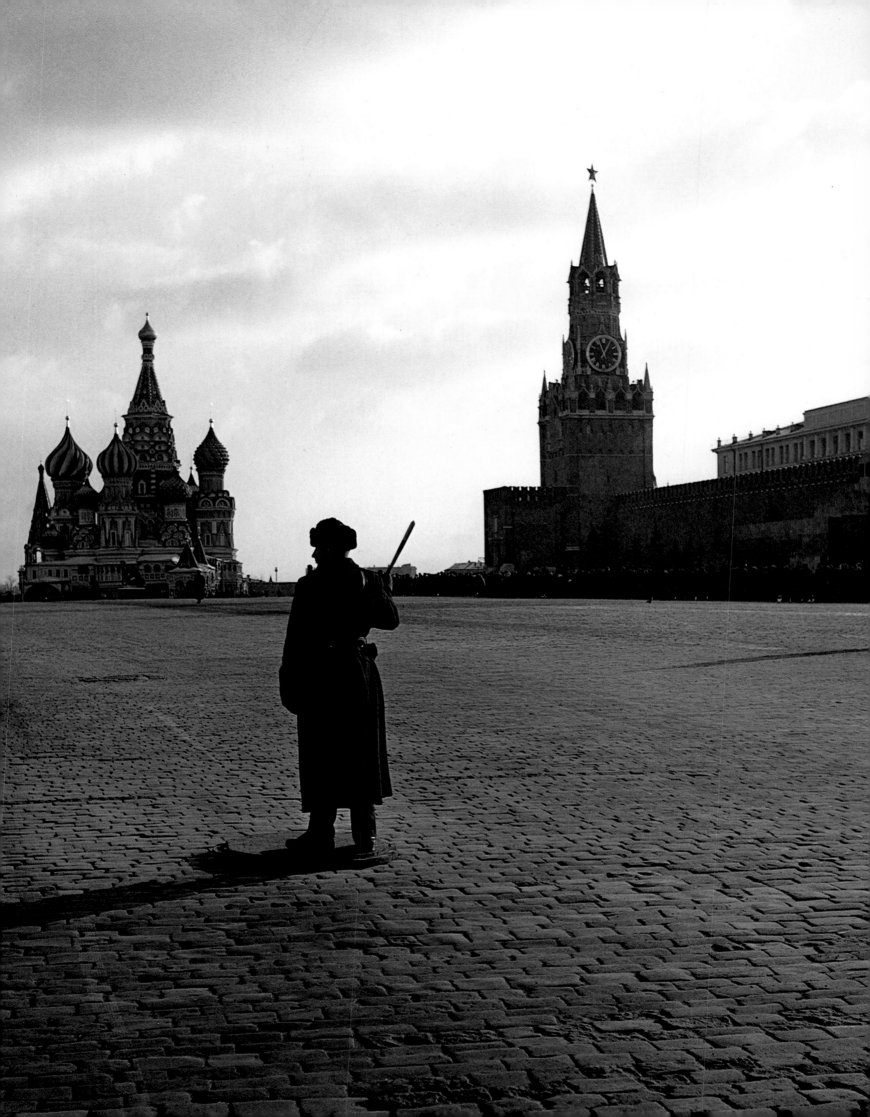

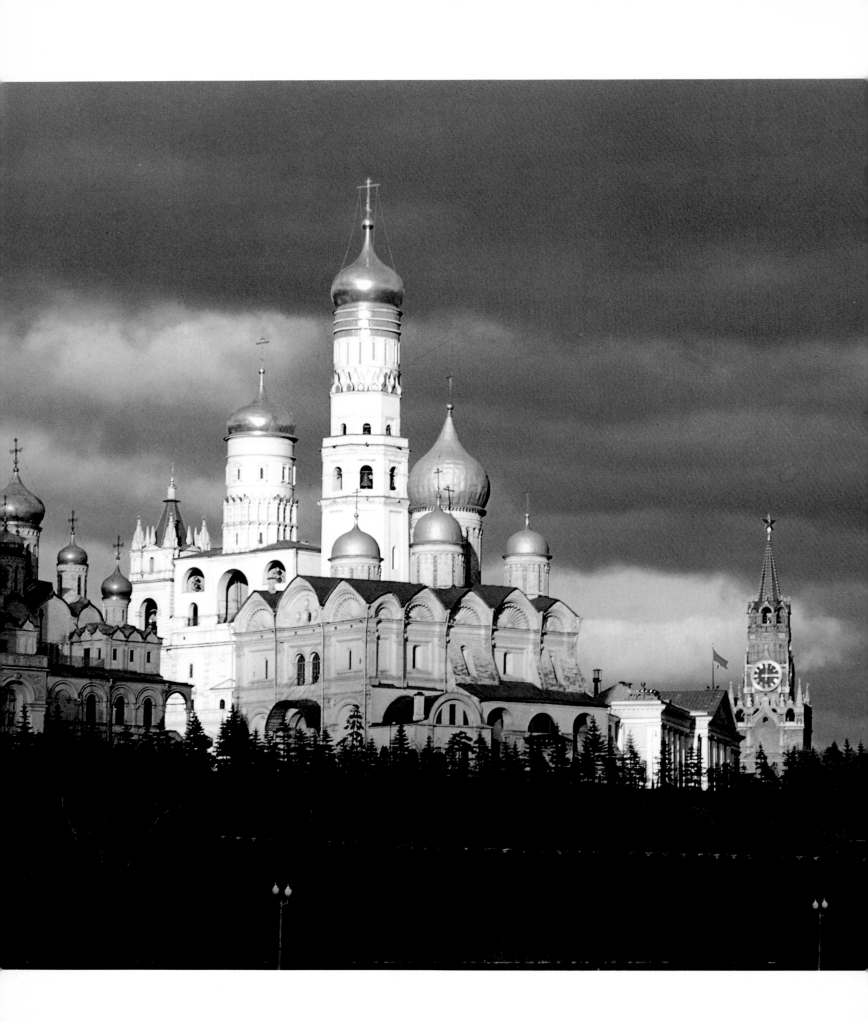

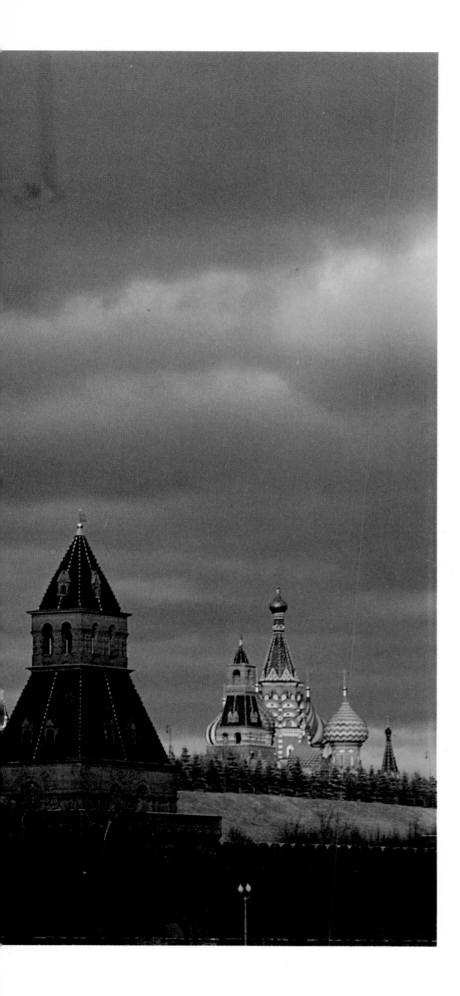

A PLACE OF LEGENDS

of princes, tzars, emperors
of modern revolutionary kings
of fables and facts and frenzied fighting
of heroes, villains, martyrs
of lust and ambition
of eager youth and saintly dreams
of much violence, and some love
of purity, and abysmal sin
of songs and poems
and of treasures
which tell stories
of a land so vast
they really never end....

RESEARCH SUPPLEMENT

Additional historical and technical data to augment the more
romantic lore of the Kremlin Treasures

PAGE 17

The first reference to Moscow was made in the Russian Chronicles of 1147, where it was mentioned only as a wooden stockade settlement at the junction of the Moskva and Neglinnaya rivers (the latter a tributary stream). After repeated Mongol burnings the wooden walls were replaced with white sandstone in 1367. At the same time the perimeter was extended 220 ft. beyond the original fortifications. In 1491–1492, Ivan the Great ordered his chief architect, Milanese Pietro Solario, to build the Kremlin's west wall with its Saviour's Tower (left), St. Nicholas' Tower (center), and Corner Arsenal Tower (right) which protected fresh-water springs and reservoirs. Brick was used for these battlements, for the first time in Russia—a direct influence of the Italian Renaissance. At that time the Neglinnaya river ran before the Corner Arsenal Tower. A moat, 31 to 42 ft. deep and 100 to 120 ft. wide, ran before the Saviour's Tower wall. Drawbridges spanned the moat. Rubbish and roads have long since covered moat and stream. During 1625 English architect-watchmaker Christopher Galloway added a steeple and clock to the 238-ft. high Saviour's Tower. The original clock was destroyed by fire in 1654. Mid-xixth century planners added more tower steeples and the Historical Museum, 1874–1883 (extreme left tower in foreground), which was an effort to copy the Kremlin's style.

PAGES 18–19

Krasnaya Ploshchad has two literal translations, either Red or Beautiful Square. The translation as Red Square came into existence because of its actual color, not because of—and long before—any political connotation attached to it. Three imposing structures dominate Red Square today:

1. The clock tower of the Saviour in the center of the western Kremlin wall. The Saviour's Tower also guards the main entrance into the Kremlin.

2. The mausoleum of Lenin and Stalin, which was constructed in the 1930's of red Ukranian granite and black labradorite. Stalin's body was entombed, alongside that of Lenin, in the air-conditioned vault following his death in 1953. The truncated, pyramidal silhouette of the tomb has been suggested as reflecting the form of tribal chieftains' burial mounds of central Asia. There is a platform atop the mausoleum from which the leaders of the Soviet Union today address and review military and civilian parades during national holidays.

3. Vasili Blazhenni (The Cathedral of St. Basil the Blessed). It has also been known as Pokrovskii Sobor, (The Cathedral of The Intercession of the Virgin). This cathedral was ordered built by Tzar Ivan IV to commemorate his youthful victories over the Horde of the Crimean Tartars at Kazan (1552) and Astrakhan (1556). The construction was assigned to two Russian architects, Postnik and Barma, who finished their work in time for the cathedral's consecration in 1560. It was named for St. Basil, a mendicant of the xvth century, who was a favorite of Ivan IV. There are eight cupolas, covering eight separate churches, clustered around a central belfry. Each church was dedicated to the saint on whose feast day each of eight decisive victories over the Tartars was won. In 1588 another church was added to the complex as a repository for the body of Vasili Blazhenni himself. Early records state that the cathedral was originally whitewashed. The multihued tiles were additions of the xviith century. Although located outside the actual Kremlin walls, the Cathedral of St. Basil has always been considered an integral part of the fortress . . . and a source of pride, literature and emotion for all Russians.

Note: The west side of Red Square is partially flanked by the 275-yard-long GUM's state department store, which was built in the mid-1880's as a glass-roofed commercial arcade.

PAGE 20

The Kremlin's walls today are little changed from what they were for hundreds of years except, of course, that the original timber stockades of the xiith century are long gone, as are the white sandstone walls of the xvth century, Dmitri Donskoi's time. The red brick walls, raised by xvth and xviith century Italian architects, have been repaired and replaced over the centuries—especially following Napoleon's demolition of some of them—yet the design and contour of the majority of the Kremlin's defenses remain the same. The walls form a perimeter of approximately one and a half miles, and average between 12 and 16 ft. thick. Nineteen towers of various shapes and sizes occupy strategic positions in the walls. Battle stations were built at three different levels within the towers and walls, from which archers and (later) cannoneers and riflemen could fire. Along the side (this photograph) facing the nearby Moskva river the wall curves to follow the natural bend of the waterway. At this point the top of the wall is nearly 65 ft. above river level. According to ancient manuscripts, a portion of the river's flow was once diverted through aqueducts beneath the Kremlin to be used in times of siege.

PAGE 21

Moscow's greatest landmark is the bell tower of Ivan the Great, which stands 270 ft. above the Kremlin and surrounding city. It also is the exact center of the Kremlin. The belfry sits on a stone foundation which probably goes down to water level and is made of whitewashed bricks, with iron tierods. The lower portion of the Tower is octagonal, and the upper section cylindrical. A golden cross and dome crown the structure.

The belfry, or Tower of Ivan the Great, was built during the reign of Tzar Boris Godunov, in 1600. An inscription in enormous golden Slavonic letters runs around the column just under the dome, and reads: "By grace of the Holy Trinity and by the order of the Tzar and Grand Prince, Boris Feodorovich, Autocrat of All Russia and his Orthodox son, Feodor Borisovich, Tzarevich of All Russia, this temple was finished and gilded in the second year of their reign." Thirty-three bells

hang in the Tower, including four called "Holiday," "Roaring," "Sunday," and "Weekday."

Ivan the Great's Tower is one of three which are joined today into a single structure. The second and oldest (1532–1543) is called the Bono Tower, which also is crowned by a golden dome and cross. The Bell of Moscow hangs here (it was the first to be rung on any festive, or emergency, occasion). Adjacent to the Bono Tower is the Tower of Patriarch Philaret which was built by the first Romanov Tzar, Mikhail Feodorovich, who was Philaret's son. Raised in 1624, it is crowned by a golden cross atop a miniature Kremlin steeple. The treasure of the Patriarchal Sacristy was originally housed here before being removed to the Armorer's Chamber of the Kremlin during Soviet times. Napoleon's artillerymen shelled this entire bell tower structure just before they evacuated the Kremlin (which had been abandoned intact without a shot fired by Russia's General in Chief, Kutusov) and began their retreat toward France. Ivan the Great's Tower suffered the most damage—it was split from top to bottom and knocked out of vertical. It has since been totally repaired but still is off-vertical . . . so much so that Russians of modern times call it the tower of "Ivan Slightly Tipsy."

PAGES 24–25

Sobornaya Ploshchad (Cathedral Square) of the Moscow Kremlin, as seen today, is mostly the work of Italian architects and engineers of the late xvth and early xvith centuries who came to Russia during the reign of Ivan the Great (1462–1505). The Square itself is in almost the exact center of the Kremlin compound . . . which is in the center of Moscow. During earlier centuries other cathedrals, churches and palaces filled the same area—the debris of which at one time raised the Square six feet above today's level.

The most important and imposing cathedral on the Square is that with five golden cupolas and crosses, Uspenskii Sobor (The Cathedral of the Assumption, center left), built in 1479 by an Italian, Ridolfo Aristotetle Fioravanti of Bologna. Although built by an Italian, the cathedral reflects many basic Russian concepts of church design. Before Fioravanti was permitted to start work in Moscow, he was obliged to tour other Russian cities such as Vladimir, Rostov, Iaroslavl' and Novgorod to see the cathedrals in those areas. The Fathers of the Orthodox Church, zealously protecting their concept of being the only adherents of the True Faith, had no intention of worshipping before the altar of a cathedral which ignored classical Russian traditions and design. Fioravanti must have been a magnificent diplomat, among his other attributes, for he managed to create a cathedral unlike anything seen in Italy—at the same time suggesting the general appearances of churches seen during his travels, which—to his probable concern—were all different.

The second largest cathedral on the Square is that of Arkhangel'skii Sobor (Cathedral of the Archangel, at right), which was built in 1505 by Alevisio Novyi of Milan. Originally, a xiith century wooden cathedral stood on this site. It was replaced by one of stone in 1333, to enshrine the burial place of the Princes of Moscow. All of the Princes, Grand Princes and Tzars of Russia up to Peter the Great lie buried here (excluding Boris Godunov, who is buried in a monastery a short distance from Moscow). Like the other cathedrals on the Square, the Archangel is open as a national monument. No services are held in any of them.

The third, and much smaller, cathedral on the Square is that of Blagoveshchenskii Sobor (the Cathedral of the Annunciation). Only the steps are visible, at the extreme left. It was built between 1482 and 1490 by Pskov architects influenced by Fioravanti. The Tower of Patriarch Philaret (1624), Bono Tower

(1532–1543), and the Tower of Ivan the Great (1600) are united in one structure (center right). The Senate Building (center) was built between 1776 and 1787. Today it houses the offices of the Supreme Soviet.

PAGE 27

The heraldic crest of Imperial Russia is seen today embroidered upon the back of "The Tzars' Chair" in the Cathedral of the Assumption, in Moscow. This particular crest dates from the era of the Romanov Emperors of the xixth century.

Grand Prince Ivan III (1462–1505) was the first Russian sovereign to adopt the double-headed black eagle as his royal standard and heraldic crest. He took it from Byzantium (which collapsed when Constantinople fell to the Turks in 1453) after his marriage in 1472 to Zoe Paleologus, niece of Constantine, the last Byzantine Emperor. The motif of the Byzantine eagle remained the cross of every Russian dynasty until the overthrow of the Romanovs in the 1917 Revolution.

In its earliest form the eagle was drawn rather simply. It became more ornate with the passage of centuries under the gaudier tastes of the Russian rulers. (See page 82. Here the bas-relief carving of the crest shows a late xvith century version of the eagle. On page 66, the Ivory Throne of Ivan III presents an eagle with straight wing and tail feathers. Legend attributes this Ivory Throne to Ivan III but there is no documentary proof that the ivory panels were carved at that time.)

The Romanov crest incorporates a multitude of symbols—all of them based upon legends—which trace Russian history back to the country's earliest recorded times. The St. George and the Dragon, on the breast of the eagle, was the heraldic crest of the city of Moscow during Tzarist times. Earlier, it had been the crest of Kiev. The Princes of that Crimean city took it with them when they fled north, as their lands and homes were devastated and overrun by the Mongol invaders of the xiiith century. The crest was perhaps brought to Moscow by Prince Yuri Dolguruki (1120–1157) who, tradition claims, was the founder of the city. Even though St. George was the patron saint of Moscow, it was not until the beginning of the xviiith century that any city's heraldic crest was added to the design of the Imperial eagle.

On the wings of the Romanov eagle are seen crests of other historic Russian cities, and also Siberia. At the top of the right wing is the crest of Astrakhan: a crown and sabre. Below it is the crest of Siberia: a crown, and two griffins holding spears and an archer's bow between them. In the center of the wing another St. George and Dragon repeats the one in the center of the eagle's breast—possibly to distinguish the commoners' city from the Imperial Kremlin city of the Tzars. At the bottom edge of the wing is the crest of Vladimir: a lion unsheathing a sword. At the top of the left wing is the crest of Kazan: a flame-winged dragon wearing a crown. This dragon is Ziland himself, who lived in Kazan and prowled along the Volga long before Man was on earth. Below Kazan is the crest of Chernigov: a single-headed eagle. In the center of the wing is the crest of Muscovy: the double-headed eagle of Byzantium. At the bottom is a crest of a saint and a lion holding great arrows between them. It is not certain but it may be the crest of the ancient city of Novgorod, which was a Republic until its destruction by Ivan the Terrible in January, 1570. Unspeakable horrors befell its inhabitants for the five weeks that Ivan stalked their city; then, assembling the seventeen remaining adult males, the Tzar reportedly addressed them thus: "Men of Novgorod who are left alive, pray God for our religious sovereign power, for victory over all visible and invisible foes."

Around the neck of the Romanov eagle is the chain of the Order of St. Andrew, the highest decoration of Imperial Russia. It was

the symbol of the Empire itself and, traditionally, could be given only to members of the Tzars' families. However, on the rarest of occasions, it was known to have been awarded to non-titled individuals whose deeds involved acts of valor for the State.

The Crown-Sceptre-Orb, held and worn by the Imperial eagle, were the symbols of absolute power held only by the Tzar. Grand Prince Ivan III was the first Russian ruler to adopt the title of "Tzar," which he did soon after his second marriage, in 1472. It was not until the reign of his grandson, Ivan IV—the Terrible—(1533–1584) that any Russian sovereign *officially* assumed the title of Tzar. At the age of seventeen, in 1547, Ivan IV ordered a formal coronation at which the Metropolitan Macarius of the Russian Orthodox Church bestowed upon him the historic title of "Tzar of All the Russians."

PAGE 28

Great excitement swept through Moscow art circles one day in 1946, when an icon of St. George was cleaned. Under five layers of inferior St. Georges this work of a XIIth century master was discovered. It is a superb example of iconography of its century and reveals many of the new influences which were shaping Russian life of that early day.

The first pagan Russian ruler to become a Christian was Vladimir I who, from his fortress in Kiev, had been making war against frontier Greek colonies. He conquered one called Kherson, then sent word to the reigning dual Greek Emperors, Basil I and Constantine VIII, that he proposed to level other nearby colonies unless they permitted his marriage to their sister, Princess Anne. Anne became his wife. Vladimir embraced Christianity just before the ceremony. The year was 989. Vladimir I had been preceded into Christianity by his grandmother Olga, the shrewd Scandinavian princess-wife of his grandfather Igor, son of Oleg—who had been the original conqueror of Kiev and had made it his realm. After Igor's death Olga ran things so well as to be still recorded as one of the wisest, most resourceful individuals in Russian history. She also must have had a fine sense of humor. After seeing her son Svyatoslav installed as Prince of Kiev, she dropped into Constantinople to visit the Greek Emperor, Constantine Porphyrogenitus, who apparently gave her a marvelous reception, at the same time introducing her to church rituals. She was immediately converted to Christianity, asking Constantine to be her godfather. When he suggested that he would like to have her as a more intimate member of the family—and proposed marriage—she headed for Kiev and home, with gentle remonstrances that as a good Christian he could hardly abuse the law which forbad godfathers from marrying their goddaughters. Both were middle-aged. The year was 957, a year when the Eastern Church of Constantinople was nearly ready to break forever from the Western (Catholic) Church. The division came in 1053.

In the same period that Byzantium was gaining religious independence from Rome, it also was becoming the greatest trading center in the eastern Mediterranean, with commercial (and religious) routes running everywhere throughout all Europe, the Middle East, Asia and Russia. Icons were among the most treasured articles aboard the merchant caravans and trading ships departing Constantinople. In Russia, pagan wanderers and isolated fortress communities were just beginning the search for a new faith to replace the recognized inadequacies of idolatry. Greek traders and returning Russian adventurers introduced icons which very quickly found universal acceptance in the dark forests, on the endless steppes, and along the banks of the rivers Dnieper, Volga and Don.

The panel of St. George, in the Cathedral of the Assumption, is one of the best-preserved examples of early Russian iconography which clearly reflects its Mediterranean origin. The name of the master who painted it has long been lost. St. George is shown wearing a *kolchuga*, a type of primitive chain-mail. Beneath his *kolchuga* he also is wearing a *toga*, in the Roman tradition. The *toga* is weighted with gold—befitting a saint. His head is crowned with golden curls—symbolic of immortality. Angels of the same epoch in Christian art were also given golden curls. The Madonna, the mortal Mother of Jesus, was usually depicted with severe braids of dark hair which were generally semi-concealed by a golden or dark blue veil.

PAGE 29

A partial view of the interior of the Cathedral of the Assumption, built by Fioravanti of Bologna in 1479. Four massive columns (two seen here) support the quintuple-domed roof. XVIIth century frescoes cover the columns from top to bottom, the subjects being full-length figures of saints of Orthodoxy and legendary heroes of Russia. These frescoes were revealed in 1947 when the Cathedral's interior was extensively cleaned of massive layers of paint and plaster. Frescoes from the XVIIth to XIXth centuries cover the walls and other two columns. There is not an inch of undecorated wall surface in the Cathedral, and the same is true of the ceilings. Icons completely sheath the iconostasis (altar screen) which separates the sanctuary from the main body of the Cathedral (at the left of the Cathedral in this photograph). There are five tiers of icons on the iconostasis, the first of which depicts Jesus, Mary, John the Baptist, the Archangel Mikhail and others, each as individual, full-length panel figures. Each of the remaining tiers illustrates a different religious theme. Other icons entirely encircle the remaining three walls of the Cathedral just above eye level. Below these icons are the crypts of all the Metropolitans and Patriarchs of the Russian Orthodox Church (foreground and along right wall).

The crypt-shrine of one of Russia's heroes stands in one corner of the Cathedral (extreme right), behind a gilded bronze mausoleum with a golden canopy. He was Patriarch Hermogen, who defied the Polish invaders of 1606–1612, during Russia's historic "Time of Troubles." Despite all threats Hermogen refused to support the candidacy of a Pole for the Throne of the Tzars (which was unoccupied by a Russian because of war, natural death, murder and abdication). Facing a multitude in Red Square, he denounced the Polish commanders to their faces with these words: "Blessed be those who come to save the Moscow sovereignty; and you, traitors, be accursed." It was his final public act. He was immediately imprisoned and died—either strangled or starved. He was 86 years old. In an opposite corner of the Cathedral there is preserved a masterpiece of Russian woodcarving from medieval times (center). It is the Throne of Ivan the Terrible, which later served as the Coronation Throne of every Tzar—the ascension of each being consecrated in Assumption Cathedral. During Napoleon's occupation of Moscow in 1812, squadrons of cavalry were billeted and stabled here. When they retreated they removed from the iconostasis 500 pounds of gold and five tons of silver. Most of this treasure was abandoned along the wintery way, where Cossacks found it and returned it to the Cathedral.

PAGE 30

In 1553 Richard Chancellor, an English captain of the sailing ship "Eldorado Bonaventura," made a landfall at a desolate spot on the Arctic White Sea coast. Thirty years later the place

became known as Archangel. Chancellor had been commissioned by a group called "The Fellowship of English Merchants for Discovery of New Trades" to try to find a northern passage to China and India. He "discovered" Russia instead, which event aroused nearly as much interest in England as though he had found another America. Ivan the Terrible was in the Kremlin. Ivan received Chancellor warmly with banquets and audiences, and the Throne Room was filled wall-to-wall with tables and cupboards sagging under the weight of gold and silver plate, and great silver barrels for wine—which required twelve gallons apiece before they overflowed. Ivan also gave Chancellor's Company commercial rights which he himself described as "heavier than tribute" (apparently seeing very clearly the advantages of having a powerful ally outflanking his old enemies, Lithuania, Poland and Sweden). Two years later, during Chancellor's second visit, he sent an envoy to England with gifts. Chancellor's ship went down off the coast of Scotland and he was drowned. The envoy was dragged from the sea by the Scots—who kept the gifts but sent the Russian on to London. Ivan's ardor for the English cooled noticeably when they refused to break off trade with Poland—in fact, he later sent Queen Elizabeth a rather spirited letter, much in keeping with his temperament, in which he chastised her for being the pawn of commercial interests, and ended his note with the observation that he should have known better than to have expected much more from "a common wench." Quickly shifting tactics, he then startled the court of Elizabeth by asking for the hand of her lady-in-waiting, Mary Hastings. Lady Mary stayed home.

Pietro Solario (who built the Kremlin's west wall and three major towers), together with another Italian architect, Marco Ruffo (referred to usually as Marco Friasin) designed and built the Granovitaya Palata (Palace of Facets; 1487–1491). It was the first Kremlin palace to be built all of stone (the stone and brick Cathedral of the Assumption preceding it by a dozen years). Solario and Friasin placed the palace on Cathedral Square between the Assumption and Annunciation edifices. The name Palace of Facets originated from the prismatic appearance of its outer walls, which resembled the surface of a facet-cut gem. Its outstanding architectural feature is the single, central, majestically arched stanchion which supports the entire vaulted ceiling of the Throne Room. The Tzars sat here while receiving foreign emissaries; thus it became the room of the Kremlin most famed abroad. The fresco illuminations found there today are XIXth century versions of those painted during the era of Boris Godunov, in the late XVIth century.

PAGE 31

Ivan the Great, at the end of his life, commissioned Alevisio Novyi (who had built the Archangel Cathedral) to start work on his own private palace adjacent to and connected with the new Granovitaya Palata (Palace of Facets, which was an official State structure). The foundations of Ivan's first palace probably still exist and help to support the Palace which today is known as the Teremnoi Dvorets (Garret or Attic). Ivan's Garrett Palace was finished in 1508, three years after his death . . . only to burn and be rebuilt during and after the Moscow fires of 1547 and 1571. It was almost totally destroyed during the Polish invasion of 1606-1612. The first two Tzars of the Romanov dynasty, Mikhail Feodorovich and Alexei Mikhailovich (1613-1676), lavished great attention on the Terem Palace, fashioning it into the series of frescoed salons and private chambers still found in the Kremlin. Curiously, most of the workmen who accomplished this ornate restoration came from Poland, on orders of Tzar Alexei himself.

PAGE 32

The Golden Room of the Teremnoi Dvorets (Garret Palace). The boyars—aristocrats who constituted the landed class—having obtained their grants and positions as princely favors, by military support of the Throne, by sheer wealth, or as governmental tenures, assembled and waited here before being granted audiences with the Tzar, who sat upon his Rose Throne in the adjoining room. Both rooms, as well as the other private quarters of the Tzar (bedroom and private chapel) are on the third floor of the Terem, overlooking Cathedral Square of the Kremlin. Tzar Alexei Mikhailovich, in the middle of the XVIIth century, covered the walls and ceilings of these rooms with leather, upon which religious themes and arabesque designs were gilded. The ceiling arches were inlaid with gold and silver. Each door arch was carved with designs of extremely complex floral bas-reliefs, as were the moldings enframing each lantern niche. At one time (late XVIIth century) these chambers were reportedly covered wall to wall, ceiling to floor, with magnificent Persian and Flemish rugs and tapestries—with others even draped from the ceiling. Unfortunately, these have all disappeared or perished.

PAGE 35

The Tzar's bedroom in the Terem Palace. This chamber connects directly to the Throne Room and, like the Throne and Golden Rooms, is also dependent upon mica-paned windows for most of its light. The bed is probably a replica of the XVIIth century four-poster in which the Tzars slept. The Tzars' chapel adjoins the bedroom. All of these Terem Palace chambers were heated individually by massive, ornately tiled stoves which were part of the wall and room designs.

PAGES 37–43

Blagoveshchenskii Sobor (Annunciation Cathedral) is the smallest of the three cathedrals in the Kremlin, being little more than a magnificent chapel which was used by the Tzars and their families. Ivan the Great ordered it built during the period when he undertook the vast project of "modernizing" the Kremlin following his marriage to Byzantine-born Zoe Paleologus. Construction of the Annunciation Cathedral was supervised by architects from the city of Pskov, which was renowned for its carved-stone churches. They undoubtedly were influenced by the presence of Ivan the Great's chief architect, Fioravanti, who only recently had finished the Kremlin's principal Cathedral of the Assumption. The merging of Russian and Italian talents resulted in the most beautiful, and most intimate, religious structure in the Kremlin . . . possibly in all of Russia. Low-vaulted arcades encircled three sides of the chapel. These were covered with frescoes executed by one of Moscow's best artists, Feodosi, who in 1508 finished the Last Judgment, Paradise, and Hell (page 42). After extensive damage in the 1547 Moscow fire, other low corridors were added around the three arcades of the cathedral. They were decorated with frescoes of the Holy Trinity (page 40: detail) and of Jesus entering Jerusalem (page 41: detail). The painters are unknown. The iconostasis (sanctuary screen) of Blagoveshchenskii Sobor was covered with icons (icon meaning "image," usually painted on a wooden panel and in itself considered sacred) painted by two of the great masters of Russian art, Theophanos the Greek and Andrei Rublev. Theophanos (1330?-1405?) was a Byzantine who moved to Russia sometime in the middle of the XIVth century, settling in

the cultural capital of the country, Novgorod. There, and in him, the fusion of Russian-Byzantine expression in iconography and in frescoes reached its peak. Theophanos was soon recognized as the finest artist in the land. He was revolutionary, too, in that he painted quickly and without making any preliminary sketches. He rapidly acquired a circle of young Russian pupils, the most brilliant being a monk, Andrei Rublev (1360?–1425?). Theophanos was summoned to Moscow in 1395 to fresco the interior of the Church of the Nativity. In 1399 he frescoed the interior of the original Archangel's Cathedral. Both works later perished. On each commission he was assisted by his pupils. In 1405 he was asked to paint the major icons of the original Annunciation Cathedral. The Russian Chronicles here record the name of Andrei Rublev for the first time. When Ivan the Great rebuilt Annunciation Cathedral he ordered all icons by Theophanos and Rublev transferred to the new iconostasis. These panels were damaged during the 1547 Moscow fire but were expertly repaired. During successive centuries the icons disappeared under massive retouching efforts, sometimes done by amateur painter-priests. They were rediscovered in the 1920's, still hanging in Annunciation Cathedral.

Genesis: Chapter 18, verse 1, 7, 8. St. Mark: Chapter 11, verse 11, 12, 13. Isaiah: Chapter 18, verse 5, 6, 7.

PAGE 45

The Oruzheinaya Palata (Armorer's Chamber) of the Kremlin was the very heart of all artistic projects undertaken by the Tzars and Emperors of Russia since the time of Ivan the Terrible, who founded the workshops. When most of Moscow and much of the Kremlin were destroyed by fire in 1547, Ivan commanded the finest talents in Russia to assist in the rebuilding. At the same time he hired foreign craftsmen by the dozens, commissioning all of them to devote their fullest efforts to producing art objects for the Throne. Their work was coordinated under the roof of a State workshop, the original Armorer's Chamber—for weapons also were embellished there with gold and precious stones. Each successive Tzar supported the shops, for it became a matter of pride to surpass the creations of earlier reigns. Special departments were inaugurated where only icons were painted, armor designed, robes embroidered, gems polished and Gospels illuminated and covered with glowing enamels.

Incalculable losses were suffered during the Polish invasions early in the xviith century. Of seven known crowns only two survived, the Cap of Monomakh and Cap of Kazan. The French under Napoleon also took vast amounts of Church decorations which could not be removed to safety before the city was abandoned. During the first half of the xixth century the present Armorer's Chamber was built to house the surviving treasures. It is upon the wrought-iron inner doors of this vaulted building that the Tzarist eagles still stand guard. Behind other doors are collections of thrones, crowns, icon covers, Church vestments, Tzarist and Imperial robes, State gifts, mitres, weapons, jeweled saddles and precious table service. Another alcoved room contains the world's finest collection of crown carriages. Still another overflows with a unique abundance of silver ceremonial objects; the section devoted to English work—gifts from their kings and queens—is in itself the most complete in existence.

Two years after the death of Joseph Stalin (1953), almost the entire Kremlin, including the treasure rooms of the Armorer's Chamber, was unlocked for visitors. Art experts of the western world had imagined most of the Tzarist and Imperial treasures lost during the Russian Revolution of 1917. With the fortress opened to the public it was soon seen that the words of the first Soviet Minister of Education were not exaggerated when he stated, "Workers in the museum ate only brown bread, but preserved diamonds."

PAGE 47

No more ancient icon is known in Russia than that of the Miraculous Virgin of Vladimir. Records of its actual origin are lost but it is believed to have been painted in Constantinople at the end of the xith century, after which it was brought to Kiev, at that time the capital of Russia. Although much of it has been restored many times, the faces of the Madonna and Child are the original work and ideally typical of the "tenderness" school of iconography which portrayed the two figures cheek-to-cheek, with the Madonna looking directly at the viewer and the Child looking up at His Mother. Both expressions reflect the peak effort of an artist trying to capture humanism in his work during a period when religious painting was generally as rigidly frozen to convention as were the church mosaics which dictated artists' style. As such it has no equal among other Russian or Byzantine icons.

During the course of centuries, most of them swept by wars in which the Vladimir icon was often at the center, the majority of the precious covers which ensheathed the holy image have disappeared, although three, of the xiiith, xvth and xviith centuries, still can be seen in the Kremlin. After the October Revolution of 1917, when the Kremlin was closed to the public, the icon was taken to the State Historical Museum (page 17). In the 1930's it was moved again to the Tretiakov Museum in Moscow, where it remains to this day. Because of its direct association with Kremlin history for over five centuries, and because its three surviving covers still may be seen in the Armorer's Chamber, it seemed only fitting to include the great icon among the other treasures of which it was a part for so long.

PAGE 48

In June, 1822, a peasant plowing near the old town of Riazan unearthed eleven medallions of delicate gold filigree on which garnets and enamel depicted figures of saints and of the Virgin. These eleven medallions became known as the Riazan Treasure. It was one of the rare discoveries of art from Russia's earliest Christian era, for it is believed that they were made at the beginning of the xiith century. The medallions are fragments of three or four *barmi* (necklaces or collars) worn by the aristocrats of that epoch. A *barma* was stitched to the cloak of the aristocrat above the cloth so that it formed an ornate choker or breastplate. The *barmi* in the Riazan Treasure trove probably belonged to a prince of that long-forgotten time and are of particular interest because they establish the origin of the massive collar ornaments worn by later Grand Princes, Tzars and Metropolitans (pages 52–53).

Although the enamel figures have been restored in recent times, they conform to the artist's original color scheme for the ornaments—pale lilac, dove grey and old rose. The enamel was placed as a powder between extremely thin gold ribbons which outlined the figures being portrayed. Each was then fired. Centuries of burial in the moist Russian earth failed to destroy their original beauty. That they definitely are of Russian, not Byzantine, workmanship is attested by the nature of the filigree itself, the handling of the gold ribbons outlining the figures and the presence of alternating Russian and Greek characters designating the names of St. Irena (left), St. Barbara (right) and the Virgin (center).

The helmet of Yaroslav, a Russian prince of the early XIIIth century, traces the history of the land back to the beginning of recorded times. It was found under a tree trunk in 1808, near the town of Yurev Polsky, in the district of Vladimir. Emperor Alexander I ordered the president of the Imperial Academy of Art to investigate its origin, and also that of the crumpled fragments of chain-mail found with it. Careful cleaning revealed an inscription encircling the medallion of the Archangel Mikhail on the front of the helmet: "Great Archangel of God, Mikhail, help your slave, Feodor." Feodor was the Christian name of one of the three sons of Vsevolod, Grand Prince of Vladimir at the end of the XIIth century.

The president of the Academy discovered that there had been the battle of Lipetske, in 1216, between the three sons of Vselvolod: Yaroslav, Yuri and Constantine. Yaroslav and Yuri sided together against Constantine but to no avail. Constantine's forces put them to rout. While running, Yaroslav tossed helmet and chain-mail aside. The Russian Chronicles of that period report: "Yuri ran to Vladimir town in only his shirt." Apparently Yaroslav was similarly clad. In 1234, under his new name of Feodor, he won a victory over the Teutonic Knights, thus immortalizing his name among future generations. Of even deeper significance, Yaroslav-Feodor was the father of one of Russia's truly monumental heroes, who dealt invading Swedes a shattering blow in 1240 on the river Neva and thus became known as Alexander Nevsky.

Yaroslav's helmet was made of iron shaped over a wooden core. Silver medallions with simply chased figures of Christ, the Archangel Mikhail, St. George, St. Basil and St. Feodor were nailed through the iron and wood. Centuries of exposure destroyed the wooden core and most of the iron base but left the silver medallions, helmet-tip and face-guard almost intact.

The Cap of Monomakh is the most important headpiece among the Russian Crown Jewels. Only after being crowned with it could a sovereign ascend the Throne. Legends associate it with the name of Grand Prince Vladimir Monomakh, ruler of Kievan Russia between 1113–1125 and the father of Yuri Dolguruki, who founded Moscow in 1147. Actual records show that the Cap definitely was used in 1498 when Grand Prince Ivan III (Ivan the Great, 1462–1505) crowned his grandson Dmitri as Tzar and heir to the Throne, even though he later changed his mind and permitted his son Vasili III to inherit the Crown. Every subsequent Tzar through Peter the Great used the Cap to formalize ascension of the Russian Throne. After Peter changed his title from Tzar to Emperor (1721), all succeeding sovereigns had the Cap carried in their coronation processions to symbolize their inheritance of power. Catherine I, Peter the Great's widow, inaugurated this custom. It survived to the end of the Romanov dynasty, in 1917.

Even though the legends and history of Monomakh's Cap extend back to the XIIth century, most historians and art experts question an origin earlier than the beginning of the XIIIth century for the lower portion of the Cap. Russian records refer to the two portions as "apples," upper and lower. The lower is definitely far more ancient than the upper, which probably dates from the XVIth century. The gold filigree of both apples reflects Byzantine filigree work of the Xth or XIth centuries, which were the centuries of High Renaissance for Constantinople. The lower apple is constructed of eight sections in which are set alternating designs of emeralds and rubies, each solitaire being framed by pearls. Enormous rubies and pearls

crown the upper apple and cross. Total weight of the gold, precious stones and pearls is exactly two pounds. Sable furs encircle the rim of the Cap, just as in the days when it was placed upon the heads of Ivan the Terrible and the other Grand Princes, Tzars and Emperors.

Devastating civil wars swept Russia during the first twenty years of the XIVth century while princes of rising cities fought for supremacy, even though the land itself was held in vassalage by the Tartar Horde. The major conflict centered around Prince Mikhail of Tver, a nephew of Alexander Nevsky, and Prince Yuri of Moscow, Nevsky's grandson. Both journeyed to the Khan of the Golden Horde seeking from the Tartars the cherished title of Grand Prince, under which they would serve Tartar interests (tax collecting and the drafting of recruits for the military ranks of the Horde) while at the same time extending their own power over fellow Russians. Bribery and intrigue in the court of the Horde finally favored Mikhail, who returned as Grand Prince of Vladimir, the capital of the land. He reigned from 1304 to 1318, a fact that Yuri fought and never recognized. However, it was the Church, not the sword, which finally tipped the balance in favor of Yuri, and with it the fate of Moscow as Russia's principal city.

Following the ravages of Mongol invasions during the last half of the XIIIth century, when much of southern Russia was laid waste by Genghiz Khan's heirs, the Orthodox Church moved the see of its Metropolitanate from Kiev to Vladimir in the north. Maxim, the Metropolitan of Vladimir, simultaneously assumed the titular rank of Metropolitan of All Russia, the first in the history of the land. Maxim died in 1304. The Patriarch of Constantinople, Orthodoxy's supreme voice, blessed Metropolitan Peter and appointed him to the Russian see at Vladimir. Grand Prince Mikhail of Vladimir had tried, after Maxim's death, to engineer a priest of his own selection into the vacancy but failed. Peter arrived in Vladimir in 1310 ready to assume office but instead faced charges of incompetency instigated by Mikhail. A Church trial ensued at which time Peter drew total support from Prince Yuri of Moscow. Peter won his case despite Mikhail's manipulations behind scenes. No sooner were the charges dismissed than Peter departed Vladimir for Moscow, where he established the unofficial residency of his Metropolitanate. He died there the same year, 1325, and was buried in the Kremlin's Assumption Cathedral. His successor, Theognostus, gave official sanction to the move to Moscow, where the Metropolinate later became a Patriarchate under Job, in 1588, and where it remains to this day.

A footnote to the feud between Mikhail and Yuri throws relentless light upon Russia's XIVth century princely courts. After Mikhail became Grand Prince of Vladimir, Yuri moved to the court of the Golden Horde, where he married the Khan's sister and was appointed the new Grand Prince of Vladimir. Mikhail, returning to the court of the Horde to plead his case, was murdered instead. In 1324 Yuri, journeying to the Horde to pay homage to the Khan, was killed by Dmitri, Mikhail's son. The Khan took exception to such a blatant assassination so near his own tents. Dmitri was executed. Dmitri's brother, Alexander, became Grand Prince of Vladimir, while Yuri's brother, Ivan I, became Prince of Moscow. All might have remained as it was except than an entourage from the Khan was wiped out in the city of Tver, which was under the jurisdiction of Alexander of Vladimir. Ivan I volunteered to lead a punitive Tartar army against Tver, for which service the Khan bestowed upon him the title of Grand Prince of Vladimir while permitting him to retain

his title, Prince of Moscow . The year was 1328, a most important date in Russian history, for it marked the moment of union of two major cities under one reign. As the centuries passed, Moscow overshadowed Vladimir until the former capital was nothing more than a quiet country town, while Moscow became the citadel of the Tzars and the heart of future empire.

Metropolitan Peter's cassock of the Thousand Silver Crosses (page 52) dates from 1322, when it was mentioned in the Russian Chronicles: "In 1322 there must be made a saccos for Pytor, the Miracle-maker." The blue undercloth was probably woven in Constantinople, while the encircled silver crosses in its vertical stripes were unquestionably embroidered in Moscow. The golden medallions on the collar, with their figures of Christ, angels, apostles and saints, were directly derived from the *barmi* worn by earlier priests and aristocrats as had been unearthed in the Riazan Treasure trove (page 48). Within a century the evolution of the cross motif on Church vestments had advanced to the point where it encompassed some really great achievements in medieval art (pages 56–61). The cassock of Metropolitan Peter is the oldest Church vestment preserved in the Kremlin. It is in such perfect condition that it could be worn today.

PAGE 53

Metropolitan Alexei's cassock of the Golden Cross, with its simple but powerful design of the Cross itself, together with the ornate richness of its collar, clearly underscored the rising status and wealth of the Church. Alexei was Metropolitan of Moscow and All Russia for twenty-four years (1354–1378), many of them years when he practically ruled the Kremlin during the childhood of Grand Prince Dmitri—the same Dmitri who was to rout the Tartars in 1380 (at the battle of Kulikovo on the river Don, which gave him the surname Donskoi and added his name to the growing roster of Russian heroes). As with the cassock of Metropolitan Peter (page 52), the cloth of Alexei's cassock came from Constantinople, but the gold thread embroidery was done by Russian women in 1364. The golden collar with enameled crosses, birds and flowers was also made by Russian artists and showed striking similarities to the *barmi* medallions of the Riazan Treasure (page 48). Tiny seed pearls, which first appeared very modestly on the collar fringes of Metropolitan Peter's cassock, were used in greater abundance on the collar of Alexei's cassock—both cassocks being only austere prototypes of other cassocks to appear during the lifetime of Metropolitan Photius in the xvth century.

PAGES 56–57

Two of the most powerful influences on medieval Russian iconography were the almost unbelievably lavish cassocks of Metropolitan Photius, who dominated the Church for twenty-three years (1408–1431). Each cassock was heavily embroidered with gold, silver and pastel colored threads depicting scenes from the life of Christ. Thousands of pearls were added to one robe as outlines for every figure and design, especially a cross within which is the Cross, Jesus, Mary, St. John and two Roman soldiers. Circular medallions around the cross frame the figures of the Prophets Isaiah, Jeremiah, Mikhail and Saphony. Adjacent panels of embroidery portray the Flight to Egypt, the Last Supper, Entombment, Ascension and Transfiguration—the entire story of Jesus. Prayers stitched in Greek and old Slavonic characters border the pearl-edged Gospel scenes.
Nothing like this cassock had ever been seen before. It broke almost completely with the classic Byzantine style of rendering holy figures, where emotion and action had been reduced to a static minimum. The figures were conceived by an artist capable

of portraying a wide range of movement and feeling, whether in profile, full-face or three-quarter profile, with the Roman soldier at the right of Christ embodying an additional sense of arrested motion. The figure of Christ Himself (with that of Christ on Photius' second cassock of gold and silver, pages 60–61) stands alone in Russian art and, in many ways, even though made of difficult-to-work thread, is equal to the painted figures by Giotto (1276–1337), whose frescoes at Padua marked a turning point for Western art only a few generations earlier. It is known that there was constant movement between Russia and the world of Byzantium during these same years but whether there was appreciable contact with despised Catholic Italy is open to question. Whatever their source of inspiration, these two embroidered cassocks of Photius must certainly be considered as supreme examples of the embroiderer's craft and, when better known by the Western world, may well be rated as two of the really great masterpieces of all religious art.

St. Luke: Chapter 23, verse 44.

PAGES 60–61

The Resurrection of Jesus (detail) reverts to the more conventional Byzantine manner of expressing this last moment of Christ on earth. The figures of the saints and apostles surrounding Him are wonderfully executed works of embroidery on such a confined surface area (these color plates of Photius' cassocks are reproduced slightly larger than actual size). As in the panel of the Crucifixion (page 60) the blending of gold, silver and pastel threads places the workmanship of this embroidery and the action of the scroll-unfurling saints (in the four corners of the cross) in a class by themselves among the acknowledged magnificence of other Russian Orthodox Church vestments.

St. Luke: Chapter 23, verse 34; Chapter 24, verses 51 and 52.

PAGES 64–65

"In the year 6949 [1441] this Cloth was made after the order of the most revered archbishop of Novgorod, Euthyme." Thus reads the embroidered inscription around the edge of the *plashchanitsa* (church shroud) renowned as the Cloth of Christ. Prior to the xviith century, according to Church records, this *plashchanitsa* was preserved in the Assumption Cathedral, where it was displayed only between Good Friday and Easter Sunday. Each of the congregation kissed it in passing, for it represented the crucified Saviour. Archdeacon Paul of Aleppo, who visited Moscow during the reign of Tzar Alexei Mikhailovich, wrote after seeing it in 1645: "They carried out 'The Cloth' embroidered in silk, exactly as though painted in colors." In subsequent years the Cloth disappeared, only to be found after the 1917 Revolution in the tiny village of Puchege. Today, it is in the Armorer's Chamber of the Kremlin, where it is sheltered behind the two great cassocks of Photius—the three of them constituting a treasure cache in themselves among the surrounding Crown Jewels.
Extreme distortion distinguishes the portrayal of Christ's body on the Cloth, although the accompanying figures are of normal proportions. The Virgin Mother holds His head, while St. John the Baptist is at His feet. Choirs of angels cluster at both ends of the bier as others swoop down from Heaven, passing the sun (left) and the moon (right). Two angels stand before the sepulchre fanning a candle flame representing the eternal life of Christ, symbolizing the belief that He was the Light of the World (as also is found in the xvth century Flemish painting of "Giovanni Arnofilni and his Wife," by Jan Van Eyck). It is in-

teresting to note that the distortion used to satisfy the artist's emotional expression predated the birth of El Greco (1542–1614) by a century and the canvases of Paul Gauguin (1848–1903) by four and a half centuries. The Cloth is approximately two meters (almost seven feet) long and is embroidered on a background of silk. Although almost unknown to the outside world, those experts who have seen the Cloth of Christ value it as one of the superlative examples of embroidery in existence—and one of the rarest.

St. Mark: Chapter 15, verses 46 and 47.

PAGE 66

One of the great mysteries of the Kremlin is the origin of the famous Ivory Throne carried in the coronations of the Tzars and Emperors. It is attributed, by legend, to the 1472 marriage of the Ivan the Great and Zoe Paleologus, niece of Constantine, the last Emperor of Byzantium before it fell to the Turks. Total examination by Kremlin art experts, however, has failed to reveal any purely Byzantine work on any part of the throne. Instead, there are indications of Italian and even German craftsmanship. The style resembles armchairs brought to Russia from the West, being high and formed in harsh right angles with only the leg ends protruding. The entire throne is covered with approximately one hundred fifty carved ivory plates that are pinned to the inner wood of the chair. The scenes are in various styles and portray subjects ranging from mythology and history to everyday life, in addition to which there are heraldic emblems and purely ornamental arabesque scrolls. Scenes from the life of King David cover the throne just below the seat. Under the heraldic Tzarist eagle and the unicorn on the back rest are panels depicting a city under siege by the Tzar's troops. Other Tzarist eagles terminate the arm rests. The sceptre is nearly covered with floral carving. It, too, ends in an ivory Tzarist eagle.

Tzar Alexei Mikhailovich used the throne during his coronation in 1645, when it was carried in the procession from Assumption Cathedral into the Archangel's Cathedral. For the occasion it was covered with velvet. For the 1856 coronation of Emperor Alexander II the gilded silver double-headed eagle was added to the back rest of the throne, then the entire chair was covered with a green silk which ended in silver, gold and emerald tassels. A velvet cushion covering the seat also was tasseled with emeralds. The oldest ivory panels of the throne are the mythological creatures on the back rest; yet no one knows precisely where they were carved, nor when. Most legends associate Ivan the Great with the Ivory Throne, after which it became connected with the reign of Ivan the Terrible. Some of the classic paintings and statues of the tyrant depict him leaning forward, glowering down upon his subjects from this chair. Regardless of myths and uncertain history one thing *is* certain: the Ivory Throne is one of the most extraordinary examples of medieval carving extant today, and the mystery surrounding its glacial severity blends very well with the chilling stories of the men who reportedly reigned upon it.

PAGE 68

The Tabernacle (or Jerusalem) of Ivan the Great (1462–1505), of heavily patinated silver, was carried in Cathedral processions and, according to some sources, was a repository for Eucharistic wafers used in the Church service. Unlike the Roman Catholic Church, there are no statues in the Orthodox Church; thus these deeply chased figures on the Tabernacles assumed special significance for the Believers, whose only other outlet for image veneration was the two-dimensional icon. The form of the Tabernacle was taken from the design of a one-cupola church, with an angel in each arch above the heads of Jesus, His Mother, John the Baptist and the other Disciples Mark, Matthew, Luke, Peter, Jacob, Andrew and Simon, seen on various sides of this Tabernacle of Ivan the Great. Between the head of Jesus and the alcoves of angels runs a frieze inscription ordered by the donor of the Tabernacle: "In the year of 1486 was made this Jerusalem. It was ordered by godlike, Christ-loving, kind Grand Prince Ivan Vasilievich, Monarch of All Russ, in the 24th year of his reign, for the Cathedral of the Assumption, to put on the coffin of Miracle-maker Peter, in Moscow." Ivan the Great—offering a tribute to the memory of Moscow's first Metropolitan, Peter (1310–1325). By the XVIIIth century Tabernacles were no longer used in Russian Orthodoxy.

PAGE 69

Ivan the Great's Book of Gospels was given to the Assumption Cathedral in 1499, at a time when the Grand Prince was "modernizing" the Kremlin on request of his Byzantine-born, Vatican-educated wife. The beautiful but relatively austere gold filigree surrounding the gold-and-enamel central bas-relief panel of the Crucifixion is in harmony with Ivan's additions to the Kremlin itself. Other plain gold figures of St. Mark, Matthew, Luke and John balanced each corner of the Gospel cover. Within a few generations such simplicity would completely disappear under an avalanche of elaborately worked gold and floods of luminous gems.

PAGE 70

The reign of Ivan the Terrible (1533–1584) was characterized by conflict at home and abroad. While conducting a reign of terror within Russia, Ivan sent armies marching against his neighbors on every frontier. His worst defeats were from Poland; his greatest successes were against the Crimean Tartars, in 1552 and 1556, at Kazan and Astrakhan. Ivan himself led the campaign and final assault of Kazan, probably wearing helmet and chain-mail similar to the steel-and-gold helmet and mail seen in the Kremlin today (this photo). The gold frieze of flowers running around the rim of the helmet was made separately from the helmet itself, then fastened to it later. Between the floral arabesques are the words "Helmet of Khan Mohammed made in Yarken." The armorer modestly failed to mention himself, which was not the usual practice in that age, when metalsmiths signed their works just like painters of a later era. During combat the gold face protector was dropped into position with its tip nearly touching the warrior's chin. The papier-mâché mannequin wearing the helmet and mail is one of many in the Kremlin Armorer's Chamber, where are preserved the weapons and battlegear of every rank of Russian soldier, from lowest quilt-padded infantryman to gold-and-steel protected generals and Tzars—starting with the soldiers of the XVth century.

One of Ivan the Terrible's most famous generals was Prince Andrei Kurbsky, whose place in history rests not upon his combat record but his exchange of letters with the Tzar. (He led a force of either forty or fifteen thousand Russians which was destroyed by a force of either four thousand or fifteen hundred Poles—depending upon the sources consulted—after which he fled to asylum in Poland.) Kurbsky took upon himself the mission of being Ivan the Terrible's conscience. He sent notes to the Kremlin via messengers while he stayed in Poland composing more attacks, most of them like the following: "Tzar formerly glorified by God! Tzar who formerly shone like the torch of Orthodoxy, but who, for our sins, art now revealed to us in quite

a different aspect, with a soiled and leprous conscience, such as we could not find even among barbarian infidels, I wish notwithstanding to say a few words to you . . ."

PAGE 74

No sight in Russia is more spectacular than one's first glimpse of St. Basil's Cathedral in Red Square. Although not situated within the Kremlin walls, its historic and emotional connection with the Kremlin and Tzarist history has been so direct that it must be considered as an integral part of the fortress. It was built in Red Square, between 1553 and 1560, on orders of Ivan the Terrible, to commemorate his victories over the Tartars at Kazan (1552) and Astrakhan (1556). The structure actually comprises eight separate stone-and-brick churches (originally built of wood) dedicated to the saints on whose feast days occurred the major victories in the two campaigns. Later, in 1588, a ninth cupolaed church was added to house the shrine dedicated to Ivan's favorite mendicant, Basil the Blessed. The Cathedral was white until painted its famous multi-colors in the xvIIth century.

Two Russian architects, Barma and Posnik Iakovlev, built the structure, according to the records. According to legend it was built by an Italian architect (although no such church exists in Italy which is similar) who was asked by Ivan, after finishing the job, whether he could duplicate or surpass his latest handiwork. The legend reports that the Italian, probably sensing a new commission, admitted that he could achieve even greater results if given the opportunity—whereupon Ivan ordered him seized and blinded, or beheaded, depending upon which version of the myth is consulted.

PAGE 75

The Crown of Kazan actually should be called the Cap of Kazan for, like the Cap of Monomakh, its design incorporates the sable rim and peaked dome which distinguished the *chapka*—cap or hat—of medieval Russian rulers. Jewelers who made the later *korona*—crown—discarded the sable rim and redesigned the peak into an arched dome (as in the Crown of Empress Anna, page 111). Thus the royal headgear of Monomakh, Kazan, Mikhail Romanov, Ivan V and Peter the Great were all caps, and those of Catherine I and Anna crowns.

Ivan the Terrible ordered his goldsmiths and jewelers to make the Cap of Kazan to commemorate his 1552 victory over the Tartars on the Volga. Originally, there was a mammoth ruby on its peak, but it was removed and put on the peak of a cap for moronic Ivan V in 1682–1689 (still among the Kremlin treasures but not included in this volume), which was a nearduplicate of the Diamond Cap (Crown) of Peter the Great (page 108). The enormous canary yellow topaz seen today on the Cap of Kazan was placed there in 1627 during the reign of the first Romanov Tzar, Mikhail. The eight golden leaf spires of the Kazan Cap, together with the central jewel-tipped spire, reflect almost perfectly the design of St. Basil's Cathedral with which it shared the honor of commemorating the conquests of Ivan. The Tzar's jewelers' use of filigreed gold, pure Persian turquoise and eastern rubies fulfilled their intention of producing a cap of exotic oriental characteristics. Many Kremlin visitors today find this Cap of Kazan the most beautiful crown in the entire treasury.

PAGES 76–77

The middle years of the xvth century were times of crisis for the Russian Orthodox Church. The root of the trouble went back to

1053, when the Eastern Orthodox Church, under the Emperor and Patriarch of Constantinople, had broken with the Western Roman Catholic Church, under the Pope in Rome. Wars between Christianity and Islam confused matters even worse, especially when Western Church Crusaders moved into Eastern Church Constantinople as their base of operations against the Moslem-held Holy Land. Starting with Byzantine Emperor Michael Paleologus, in 1261, efforts were made to reunite the two Christian Churches, efforts which in Orthodox Russia seemed nearly akin to advocating union with accursed Islam itself. The Metropolitan of Moscow and All Russia was an appointee of the Byzantine Patriarch, himself completely subordinate to the Byzantine Emperor; thus all machinations on the part of the Emperor toward reunion with Rome only cast deeper suspicion over any Metropolitan arriving from Constantinople.

In 1436 Moscow's Grand Prince Vasili II (1425–1462), Ivan the Great's father, hopefully offered his own candidate, Jonah, for Metropolitan. Disregarding the suggestion, Constantinople sent a Greek or Bulgarian priest named Isidor as Metropolitan. Isidor left Moscow almost immediately to attend the 1438–1439 Church Council of Ferrara-Florence, where he was a leading force in preaching reunion with Rome. He returned to Moscow in 1441 where, in his first service in the Kremlin's Assumption Cathedral, he officially announced the reunion of Orthodox and Catholic Churches. Three days later he was in a dungeon. He stood trial before a court of Russian bishops, was threatened with torture at the stake, but refused to confess any guilt of heresy. Later the same year he escaped from his monasteryprison, certainly with the approval of the Kremlin. The Grand Prince was happy to be rid of him so that he could finally appoint Jonah as the first Russian-born Metropolitan of the Orthodox Church. The year of his appointment was 1448, which also marked the end of Russia's submission to Byzantium in ecclesiastical matters. Five years later, in 1453, Constantinople was overrun by the Moslem Turks, the Emperor killed and the Byzantine Patriarchate suddenly silenced. Moscow took this as a Divine Sign approving the Grand Prince's action in contesting the late Emperor's choice of candidates for the Russian Metropolitanate and as an additional omen signaling Moscow's destiny as the "Third Rome" of the future. Curiously, despite the fall of Byzantium, it was not until the time of Boris Godunov, in 1588, that the Metropolitanate of Russia became a Constantinople-approved Patriarchate—no Tzar before then ever having taken it upon himself to make the supreme Church appointment.

Once the Metropolitan of Moscow became an appointee of the Kremlin the character of the Russian Church underwent a drastic transformation, for the sovereign soon interfered in Church affairs at every level. During earlier times, when Metropolitan Peter had moved from Vladimir to Moscow (1325), the Church was almost an autonomous power within the land with holdings second only to the Crown. During the tenure of Moscow's third Metropolitan, Alexei (1345–1378), the Church even acted as the supreme power during the minority of the child, Grand Prince Dmitri. After the break with Constantinople the Church was often little more than an extra weapon in the hands of an autocratic despot (Ivan the Terrible, 1533–1584) asserting his absolute will over his subjects. Some Kremlin-appointed Metropolitans, like Makarius (1542–1563), who managed to retain Ivan the Terrible's confidence and friendship throughout his entire life, were never in deep conflict with the Throne simply because they agreed to and supported the idea of the Church's subordinate and submissive role to the Kremlin. Others, like Metropolitan Daniel, who opposed the Tzar, fared less well. Daniel was strangled in 1569

by Maliuta-Skuratov, Ivan the Terrible's head of the *oprichnina*. Still others, like Anastasius and Herman, simply quit or were expelled. The archbishop of Novgorod, Leonid, was reportedly sewn in a bearskin and tossed to hunting dogs.

Despite all the frustrations and violence suffered by the Church at the hands of the Grand Princes and Tzars, there is one magnificent heritage from those wild times still in existence today. The jewel-and-embroidery portrait-shrouds of several medieval Metropolitans are still preserved within the Kremlin. These cloths were draped over the Assumption Cathedral's crypt-shrines of the priests on the anniversaries of their name-saints' days. Each was of silk, with gold, silver and pastel thread embroidery, to which were added pearls and precious stones. It is believed that the cloth of Metropolitan Jonah (1448–1461) (page 76, left) was woven during his lifetime. The others of Metropolitan Alexei (pages 76–77) were woven sometime during the xvith century. Other cloths in the Kremlin collection portray Tzarevich Dmitri, the youngest son of Ivan the Terrible, and hero Mikhail Chernigovsky, who refused to pay homage to the Tartars and so was slain. These cloths reveal the pronounced Asian features of many early Russians, and form one of the rarest facets of the Kremlin treasure.

PAGE 80

By the time Ivan the Terrible died (1584), the art of iconography in Russia had undergone many changes since that first day when the Miraculous Virgin of Vladimir (page 47) arrived from Constantinople to set the Russian standard in conformity with that established by Byzantine artists. Only priests or monks were permitted to create the sacred images because the icon was itself holy and worshiped accordingly. However, as centuries passed, local characteristics appeared in the church art of Russia just as soon as the country began producing masters of its own. Andrei Rublev (1360?–1425?) was the first and one of the greatest painters of purely Russian origin. He was trained by the incomparable Theophanos the Greek (1330?–1405?), who had come from Byzantium and settled in Novgorod in the middle of the xivth century, at which time he also established a small school where he apprenticed the finest raw talent in the area. His icons, such as those painted for the Kremlin's Annunciation Cathedral (page 37) in 1405, were masterpieces which are still considered the finest icons produced in Russia during the height of Byzantine influence upon the land. Almost two centuries passed before other painters (such as the unknown artist who created this icon of the Saviour) turned to fellow Russians seeking facial characteristics with which to endow their subjects. While local masters were painting Russianized icons, other local craftsmen—jewelers and metalsmiths—were responding to the demands of Grand Princes, Tzars, wealthy Russian aristocrats and the Church itself (which was second only to the Throne as a landlord) to produce increasingly elaborate means of expressing their devotion to the holy images. Thus was born the icon cover. Within a few generations the work on the covers was viewed as an art in itself, with a vocabulary of its own. *Basma* meant the bas-relief technique of chasing silver or gold for the cover. The complete cover was known as the *oklad*, from the Russian verb "to surround." The halo was the *nimb* (probably from nimbus). The field behind the *nimb* was the *phon*. The breastplate, the *cata*. Some icons were completely dressed, in which case the cloak or cape was known as the *riza*. The donor of a *riza* would sometimes even attach an article of personal jewelry to an icon, as was the case of the icon of the Saviour (this photo) which carries a woman's bracelet fastened to its cover just below the *cata*. It probably was placed there by Princess Nagaya early

in the xviith century, when she presented the icon to the Monastery of Suzdal.

PAGE 81

Among the many lavish relics remaining from Ivan the Terrible's reign—St. Basil's Cathedral, the cap of Kazan (pages 74–75)—few were more richly embellished than the Book of Holy Gospels which he gave in 1571 to the Annunciation Cathedral. Nearly two feet high, it is entirely covered with a silver-and-enamel sheath in which are embedded giant rubies, sapphires and topazes. The Resurrection of Jesus, in heavily chased silver, fills the central medallion of the Gospel, while other medallions of Matthew, Mark, Luke and John fill the corners. No finer enamel was made anywhere than that of the sky-blue background for the silver arabesques covering the field between the medallions. Legend pictures Ivan believing that sapphires and rubies could free him from the hideous dreams which he complained were filling his nights, and that he polished smooth, with nothing but his beseeching fingers, the surfaces of the topaz solitaires set centrally in the margins of the Gospel cover. Any lapidary would report that these stones had been polished as cabochon settings from the first day they were mounted in the cover. The inner pages of the Gospel were illuminated by the best miniature painters working in the Kremlin. Oddly enough, for a man of such extravagances in every other aspect of life, Ivan the Terrible despised diamonds and forbad their use in his State regalia, or in gifts to the Cathedral, because of some superstitious reason known only to himself.

PAGE 82

Queen Elizabeth of England's gift carriage to Tzar Boris Godunov was meant to be delivered at the Kremlin shortly after woodcarvers had finished decorating its massive panels, in 1600, but events in Anglo-Russian affairs took a negative turn, delaying its arrival until 1625—twenty years after Boris was dead. The picture panel under the drivers' floorboard took many liberties with actual facts in Russian life by presenting the Tzar as a Roman-tuniced emperor, drawn in a golden chariot behind three matched greys whose road was lighted by flame-belching, golden torches. Roman grooms in togas held prancing horses. The Tzar's standard, the double-headed eagle of Byzantium, was stretched taut by the wind. Altogether, it was a heroic scene, which Boris, who appreciated the dramatic, would have thoroughly enjoyed.

PAGES 84–85

The bas-relief on the rear of the carriage was more related to contemporary history. It showed the Tzar and his helmeted cavalrymen meeting head-on the Sultan of Turkey and his turbaned cavalrymen in front of the cross-spired Kremlin. The Crescent of Islam flies over the Moslem warriors. Pigeons wheel in the sky above the uproar. The Tzar's lance has pierced the chest of the Sultan's mount, symbolic of the role Russia was expected to play in turning the Mohammedans away from western European cities. The carriage panel was carved at a moment in history when one of the vital, unanswered questions posed to the Christian world was the fate of its peoples before the onslaught of the Koranic armies marching out of the Middle East.

The horses of the Tzar and Sultan are of particular interest. They are saddled with chest cinches of gold and jewels which are almost identical to that given Catherine the Great by Sultan Selim III of Turkey, following his defeat before her armies in 1792 (pages 124–125).

Mikhail Feodorovich, the first Romanov Tzar, ascended the Kremlin Throne in 1613 and remained there until his death in 1645. Coming as he did after the hectic years of the Time of Troubles (1598–1613), the very fact that he survived for thirty-two years was noteworthy in itself, but of far deeper interest artistically was the fact that his reign gave birth to a phenomenon of extravagance in the use of precious stones and metals that was unrivalled by any other period in history—whether of the Pharaohs, Incas, Medici or Aztecs—and the phenomenon lasted for nearly a century. Gold, silver, enamels, diamonds, emeralds, rubies, sapphires, topazes (which then were precious), spinels, zircons and pearls were used in such profusion that they stunned even the most worldy visitors to the Tzars' court, and defied even the most rampant imaginations trying to describe them. Crowns, thrones, Gospel and icon covers, church cassocks and mitres, sceptres, shields, saddles, swords, dinner cups and plates, literally everything and anything that came into the hands of the Tzars or their priests emerged encrusted with gems and rare metals. No one, regardless of training or experience, could estimate their value. Other cultures have handled precious metals and stones with greater artistry and sensitivity, but only in Romanov Russia were jewels with the precious metals used for personal and votive purposes with such unrestrained abandon.

The bow quiver of Tzar Mikhail was made in the Kremlin Armorer's Chamber in 1628. Ten master metalsmiths and jewelers worked on it, headed by the chiefs of the shops, Yefim Telepnov and Vasili Strechnyov. It was sheathed in five pounds of gold, into which was carefully worked the enamel-and-ruby crest of the Tzars, surrounded by a mythological unicorn, lion, griffin and eagle (this photo, center, actual size). Mikhail's jewelers also used the following gems on the quiver: 34 sapphires, weighing 223 carats; 35 rubies, weighing 100 carats; 117 zircons, weighing 74 carats; 135 emeralds, weighing 184 carats and 191 diamonds, weighing 105½ carats. Among the emeralds five weigh forty carats, two weigh ten carats and sixteen weigh sixty carats. Among the sapphires one weighs twenty carats, four weigh thirty-five carats, another four weigh forty carats, seven weigh forty carats and fourteen weigh eighty carats. Of the rubies two weigh thirty carats and four weigh forty. The smaller stones, as well as the great solitaires, were all carefully matched for color and brilliance, perhaps the most difficult and rarest achievement in the handling of gems.

Swords and daggers which reflect the craftsmanship of Persian and Turkish jewelers, metalsmiths, enamelists and armorers are seen beside the great bow quiver of Tzar Mikhail Feodorovich. When the Tzar was on march the quiver was carried by Prince Ivan Vorotinsky, Chief of the Hundred Soldiers, the Tzar's bodyguard. When not on march, the quiver and other jeweled weapons were kept in the arsenal section of the Kremlin Armorer's Chamber, near where they were made. Court favorites and princes owned and wore regalia nearly equal to that of the Tzar and, like the Tzar, made every effort to display their wealth. Each vied with the other in presenting gifts to the Kremlin Cathedrals and to the Tzar himself, for one's name and fate often hinged directly on the opulence of his offering.

When Kremlin jewelers, under Yefim Telepnyov, designed the Cap (Crown) of Tzar Mikhail Feodorovich in 1627, they pro-

duced a bauble weighing five pounds—five pounds of gold, emeralds, sapphires, rubies, pearls and sable—intended only as a model for another cap which would have been Mikhail's *real* cap, weighing eleven pounds and made of the same exotic ingredients. For some unrecorded reason the second cap was never produced. The original, five-pound model has survived as the first Romanov crown. According to the Russian Chronicles it was intended to represent the kingdom of Astrakhan, the Caspian city conquered by Ivan the Terrible in 1556. Its design reflects some of the oriental aspects of the Cap of Kazan (page 75), although its upper portions differ considerably from the earlier headpiece. The Cap of Kazan was made to mirror the silhouette of St. Basil's Cathedral, while the Cap of Mikhail carries a triple-winged crown of sovereignty on its peak, atop which is another sub-miniature crown which supports a vertically suspended emerald of incredible purity and size. As a companion piece for the cap, the jewelers made the Tzar's sceptre of additional emeralds, pearls, rubies and enamel into which they worked floral arabesques and hunting scenes. The tip of the sceptre is at the left of Mikhail's Cap. As was true with Mikhail's bow quiver (page 90), each of the immense sapphires is matched for color and brilliance to its companions on the cap. Sable furs rim the edge of the cap. According to best-informed sources in the Kremlin Armorer's Chamber today, this cap (crown) also served as the cap for Alexei Mikhailovich, second Romanov Tzar.

Gifts of the first two Romanov Tzars (1613–1676) to their Patriarchs today bridge the reigns of Mikhail and his son Alexei. One of Mikhail's most beautiful gifts was a golden mitre encrusted with pearls, emeralds, topazes, zircons and an enamel figure of Christ on the forehead. Made in 1634, it reflects the still almost barbaric tastes of the Russian Tzars who mixed pagan with Byzantine heritages, who still had had very little contact with the more sophisticated tastes of western Europe. Most of Mikhail's treasures were made by a group of wandering metalsmiths and jewelers who came to the Kremlin and there worked under the head of the Armorer's Chamber, Vasili Streshnev, and a priest, Yefim Telepnyov.

Behind Mikhail's mitre is the golden saccos ordered in 1648 by Tzar Alexei Mikhailovich as a gift for Patriarch Joseph. The following entry was made in the Kremlin Inventory: "30 August, 1648; after order of the Monarch, they gave to the Treasury Room Turkish double satin with silver background with images of Christ on Throne made in gold; and above Him a Heruvin [type of angel]. The satin was a gift of the Monarch, Tzar and Grand Prince Alexei Mikhailovich of All the Russias to the Holiest Patriarch on the Holy Day of Christ our Saviour; and the Holiest Patriarch ordered a saccos, and the saccos was made and given to the *riznisa*." (The *riznisa* was the treasury of the Cathedral's sacristy.)

On 18 December 1621, an entry was made in the Inventory of the Kremlin Armorer's Chamber, where all accounts and records were kept concerning the Tzar's treasures: "You must pay the Master [goldsmith] of the Armorer's office, Nikita Davidov, ½ meter of yellow Venetian brocade, worth 11.5 rubles per meter, and 4 meters of dark blue English woolen, worth 13 rubles per meter. This is given to him because he made a Hat for the Tzar and gilded a suit of armor also for the Tzar." The "Hat" referred to was the Hat of Yerikhon, the most profusely decorated helmet among the Kremlin treasures, which legend asso-

ciates with the name of the XIIIth century hero Alexander Nevsky. Even earlier tales link the Hat with the Crusades to the Holy Land. It is from this source that it derives its name, for Yerikhon was a Palestinian town famed for making war helmets of severely conical design. It is believed that Tzar Mikhail, who had a deep appreciation for the arts of the jeweler and metalsmith, ordered Davidov to reembellish this particularly fine Crusader's helmet which was already so rich with lore. Davidov resorted to techniques of inlaying gold upon steel which had originated in Egypt and Greece when artists in those countries adapted even earlier known methods of inlaying precious metals upon bronze. The inlaid weapons made by these early smiths had spread with soldiers who were sent to fight in Syria (Damascus steel), the Caucasus, and in Spain with the Arab armies. The enamelist who made the Archangel St. Mikhail for the face guard employed techniques already highly developed in Russia. Almost concealed by the gold frieze are the Arabic words: "Give joy to Believers by the promise of God. Give help and quick victory." Spaced between the words are the golden crowns of Old Russia's Grand Princes—Kiev, Vladimir and Novgorod.

The helmet appears to be gilded, but that is only an artistic illusion achieved by Davidov's talent, for the entire design was made of infinitesimally fine threads of pure gold. The Arabic characters were chosen as part of the pattern because of their lyric appearance. Contemporary records state that Davidov apparently worked freely, without resorting to preliminary models or designs, while striving always for the complexity of motif admired by the Russian Tzars, at the same time preserving the simplicity of line which the helmet had inherited from its Eastern birthright. The high-peaked shape of the helmet was also practical: it deflected sword blows. With the face guard down, the warrior was reasonably secure from all but lateral attacks, which were not too dangerous. As a mark of rank a flag, plume of feathers, or spike was worn in a small hole in the peak.

A tribute to Davidov's artistry is the fact that the Hat of Yerikhon unostentatiously carried in its design 1.6 pounds of gold; 2 very large pearls, 148 smaller ones; 36 large rubies, 118 small; 5 large emeralds, 2 small; 15 large diamonds with 66 diamond rays; and 2 large zircons, 69 small. When Borodin wrote his opera "Prince Igor" (which tells the story of a Russian Grand Prince's battles with Tartar nomads on the eastern steppes), some of the most vivid moments were composed around the play of sunlight upon the Prince's helmet as he rode to war—a helmet which very well could have been this Hat of Yerikhon.

PAGE 98

The Diamond Throne of Tzar Alexei Mikhailovich (1645–1676) is the most valuable of the Kremlin's surviving five thrones (Ivory Throne, Boris Godunov's Throne, Mikhail Romanov's Throne and the double Throne of Peter the Great and Ivan V. Only the Ivory and Diamond Thrones could be included here because of space limitations). It is encrusted almost solidly with precious stones and pearls. Its name is derived from the 870 diamonds embedded in its surface. The left arm rest alone is set with 85 big diamonds, 32 big rubies, 36 medium and 76 small rubies, plus 32 pearls, 97 seed pearls and innumerable pieces of Persian turquoise (which are not listed in the Inventory). Above the elephants on the front panel of the Throne are seen some of the 71 diamonds and 41 rubies which trim the seat edge. The nine medallions on the panel (three large and six small) contain diamonds and rubies in balancing alternating patterns. The lower edges of the Throne (not shown) are entirely covered with the finest Persian miniature

paintings of wildlife and hunting scenes. The Throne's oriental characteristics result from its being made in Persia on order of the Armenian Trading Company, which organization presented it to Alexei in 1649.

On the back rest of the Throne, between two embroidered angels holding a symbolic crown, a shield was stitched proclaiming in Latin: "Potentissimo et invictissimo Moscovitarum Imperatori Alexio in terris feliter regnanti, hic tronus, sumna arte et industria fabrefactus, sit futuri in coelis et perennis faustum felixque omen. Anno Domini 1659." The words were embroidered in silk. The crown was embroidered with 21 small diamonds and 105 seed pearls, while another 162 seed pearls were embroidered into the border of the quotation. Its elephants were made of gilded silver. The Diamond Throne was last used during the 1883 coronation of Maria Feodorovna, the wife of Alexander III and the mother of Nicholas II, the final Romanov Emperor.

PAGE 99

Alexei Mikhailovich, the second Romanov Tzar, apparently was a patron of foreign jewelers as well as of masters working in his own Armorer's Chamber. His flowerlike Orb of Power was made in Constantinople. The Kremlin Inventory of 1665, Item N° 220, records: "Greek citizen of the town Tzargorod (Constantinople), Ivan Yurjev, in 1662, brought this gold apple to the Great Tzar; as payment he received from the Siberian Treasury different goods, price of which is at least 7917 rubles." The term "apple" was generally used when referring to the globe, sphere or dome of a Crown, Cap or Orb which symbolized the authority of the Tzar over his subjects. The reference to the Siberian Treasury means that Ivan Yurjev was paid in ermines, sables, mink and probably fox furs, all of which were in great demand throughout the Mediterranean and Byzantine worlds.

The upper edge of the Orb is rimmed with a serrated crown in which there are alternating sprays of diamonds and rubies. In the top of the Orb is a much smaller, emerald-green enameled orb, atop which there is a cross. On one side of the cross a huge ruby is surrounded by eight perfectly matched diamonds. On the opposite side of the cross a giant diamond is flanked by eight smaller diamonds. On each sphere, above and below the equator of the Orb, there are alternating rosettes of solitaire sapphires surrounded by rubies and solitaire rubies surrounded by diamonds. Equatorial bands girdling the Orb hold thirty-six matched diamonds and 136 matched rubies. The field of the whole Orb, as on the smaller upper orb, is a uniform emerald-green enamel. The entire Orb stands approximately a foot high and weighs 3.6 pounds. In the opinion of the writer, who has spent a lifetime wandering through the world's museums and art galleries, the Orb of Alexei is the most spectacular single expression of the jeweler's craft to be seen anywhere on earth today.

PAGE 100

While thrones and orbs were being made abroad and shipped to the Kremlin to satisfy the flamboyant tastes of the XVIIth century Romanov Tzars, jewelers and goldsmiths were at work right in the Armorer's Chamber producing royal treasures in such abundance that even contemporary records lost all count. Gospel covers, church robes and mitres, chalices and icon covers commanded the top priorities for gems and artists' time. One such masterpiece was the cover made for a life-size icon of the Madonna, a solid surface of pure gold, rubies, emeralds, diamonds, sapphires and hundreds of perfectly matched pearls which even today have lost none of their lustre or brilliance. In

the Kremlin Inventory it is listed only as an icon cover made toward the end of Alexei Mikhailovich's reign.

PAGE 103

Jewels and gold were used to decorate everything in the households of the Romanov family and their friends, including regal bridles of rubies and turquoise for their horses. Additional equestrian equipment was ordered sent to the Tzars by generals, lesser princes and the wealthy boyars of the land. The Shahs of Persia and the Sultans of Turkey dispatched gift-laden ambassadors to Moscow. Almost all of these gem-covered presents are still preserved in the Armorer's Chamber, where a seemingly unending collection is displayed upon lifelike cavalry horses today. Other saddlegear of silks and feathers accumulated as gifts from the chieftains and khans of central Asia and even China, until the Kremlin treasuries nearly overflowed.

PAGE 104

Tzar Alexei Mikhailovich's reign (1645–1676) inaugurated the first period in Russian history when western states made deliberate efforts to woo the Kremlin rulers with ambassadorial presents. Half a century earlier, Queen Elizabeth had sent gifts of English silver and a carriage to Boris Godunov, gifts still preserved in the Kremlin, where the silver constitutes the finest such collection in existence today (not included in this volume because of space limitations). But Elizabeth's was a lone gesture soon abandoned when Muscovy was torn by the Time of Troubles (1598–1613). By Alexei's time diplomatic offerings to the Tzar were again viewed as worthy vehicles for winning Russian friendship. The silver *lokhan* was a favorite choice when the taste of the Romanovs were under discussion. The Hanseatic city-state of Hamburg sent a scallop-edged *lokhan* on which was chased the classic theme, "The Rape of Europa." Even though executed in silver by German smiths, it might well have been painted by their Flemish contemporary, Peter Paul Rubens (1577–1640), or by Frenchman Pierre Auguste Renoir (1841–1919), two centuries later.

PAGE 105

Few works of the metalsmith's art have ever equalled the Augsburg *lokhan* offered by Queen Christina of Sweden, in 1647, to Alexei Mikhailovich. The Reconciliation of Joseph and Jacob, as the central theme of the great tray, is convincingly executed, yet it is in the group composed around the nervously pawing horse, his attending groom and the four curiosity-driven cavalrymen that the *lokhan* reaches heights of beautiful craftsmanship. Far in the background, faintly etched into the surface of the silver, a peasant shepherd watches over his flocks. Several parts of the *lokhan* (the heads of the women, the child, the horse and the complete figures of the dogs) were cast separately, then later fastened to the surface of the tray. The camel-mounted Arabs are poorly drawn, probably because of the lack of familiarity in Europe with the then rare animals—yet the artist was forced to attempt them by the very nature of the *lokhan*'s theme.

PAGE 106

The years of the third Romanov Tzar, Feodor Alexeievich (1676–1682), left very little that future generations might use to mark his time on the Kremlin Throne. Even a tremendous Gospel cover made of fifty-seven pounds of gold, plus emeralds, rubies, diamonds and superb enamels, although made in his reign, today is just an anonymous addition to the Kremlin treasures. The robe of Jesus has no superior among the other gold and enamel works in the Armorer's Chamber, for in this robe the enamel and precious metals appear to fuse into a single, richly brocaded garment. The slightly flaked area at the right of His hand reveals the manner in which the artist covered the gold base with the sheerest film of enamel. The heart-shaped emerald in His crown is, of course, an extraordinary jewel. These stones probably came from the emerald mines in the Ural mountains, which had been worked since the earliest recorded Russian times. It is most unlikely that any of these gems came from the great Muzo mines of Colombia, which supplied most of the emeralds that so astounded Cortez when he led his *conquistadores* into South America against the Incas.

PAGE 107

Tzar Ivan V had two caps (crowns) but never ruled Russia. He was the idiot son of Alexei Mikhailovich, the young brother of Tzar Feodor Romanov and the stepbrother of Peter I, who soon became known as Peter the Great. Ivan V and Peter I sat together upon a double throne which still is preserved in the Kremlin. Behind the throne can be seen the niche and curtained window through which Sophie, the older sister of the two young Tzars, prompted them while enforcing her decrees as their Regent. This arrangement lasted for seven years (1682–1689), after which Peter ousted his stepsister and ruled Russia himself. It is of particular interest that neither Peter nor Sophie molested defenseless Ivan but permitted him to live quietly until his death in 1696. After Sophie's overthrow she tried to engineer a coup, was totally unsuccessful, and was banished to a convent where she died in 1704. Ivan V's Cap of the Ruby Cross was made in 1684, two years after he ascended the double throne with Peter. As in all earlier caps of Kremlin rulers, sable furs rim the bottom edge and the "apple" shape is again repeated in the golden half-sphere which supports the cross. Rubies, pearls, diamonds and one perfect cornflower-blue sapphire were set against a dome of silver thread which formed the foundation of the cap—the technique of the weaving giving the name *altabas* to the entire headpiece. *Altabas* weaving was probably of Turkish origin, where headgear of silver and gold thread were made for the Sultans.

In 1635, during the reign of the first Romanov Tzar, Mikhail Feodorovich (1613–1645), three crowns were fashioned in the Armorer's Chamber for his daughters, Princesses Irena, Sophia and Anna. In 1636 still another crown was made for Princess Irena. It was the richest of those created for the royal children, for it was set with 109 rubies and 96 diamonds. These crowns, together with that of their mother, Mikhail's Tzarina Yevdokia, were later taken apart and the gems used for other jewelry being made during Tzar Alexei's reign (1645–1676). It is believed that the precious stones seen today in Ivan V's Cap of the Ruby Cross came from the earlier crowns of Mikhail's Tzarina and daughters.

PAGE 108

Two almost identical caps (crowns) were made between 1682 and 1689 for Peter the Great and his stepbrother, Ivan V. Each was of diamonds, among which were sprinkled sapphires and rubies. Each possessed on its peak a mammoth cabochon ruby, above which glittered a diamond cross. Today, both are still guarded within the Kremlin Treasury. The Cap of Peter the Great (this photo) is possibly the more beautiful of the two because of the delicacy of the sapphire globules which seem to float around its edge just above the sable rim. Nearly hidden

beneath the gems is a finely chased silver and gold "apple," the form of which was inherited from all earlier caps of the Tzars. These two caps of Peter the Great and Ivan V were the final such headpieces made in Russia. After Peter's reign the Kremlin was dominated for many generations by women, most of them foreigners, who discarded the ancient style of the caps for the more conventional western crown. Together with the cap, the court also was changed by the women. Russia was never to be the same again.

PAGE 110

Russia's first Empress was Peter the Great's second wife, a Lithuanian girl of uncertain and extremely modest background. She was born sometime around 1683, of peasant Polish or Latvian parents. Orphaned while still just a child, she was reared by a Marienburg Lutheran pastor named Gluck, in whose home she worked as a servant for her subsistence. The Russian army captured Marienburg in 1702 and the young girl soon was enjoying the companionship of Prince Alexander Menshikov, one of Tzar Peter the Great's closest friends. By 1705 she was much closer to Peter than to Menshikov. They were married in 1712. Although she was illiterate she possessed a tremendous natural intelligence, wit and tireless vigor which endeared her to Peter. At a formal ceremony in December, 1721, the Holy Synod and the Senate—on command of Peter—conferred upon the ex-servant-girl the title of Empress Catherine I. Her coronation on 7 May 1724 in St. Petersburg was reportedly one of the most magnificent spectacles ever staged in Russia. Eight months later her husband was dead and she was the sole ruler of the Empire, the first woman to sit alone upon the Russian Throne.
Catherine I's Crown, the first korona of any Russian ruler, was a sphere of chased silver and gold upon which were mounted hundreds of diamonds, together with additional clusters of rubies. Today, only the webbed skeleton of the crown is to be found in the Armorer's Chamber, because shortly after Catherine's death in 1727 it fell into the hands of another woman who was then sitting upon the old Tzarist Throne. Anna, in whose crown the diamonds of Catherine I are now to be seen, was the second Empress of Russia, which she ransacked for ten years (1730–1740), the same way she stripped her predecessor's legacy.

PAGE 111

The last crown of the Romanov dynasty to be seen in the Kremlin is the Diamond Crown of Empress Anna (1730–1740), the daughter of moronic Tzar Ivan V, who was the ghostly co-occupant of the Throne with his stepbrother, Peter the Great. After Peter died the Throne passed to his widow, Catherine I (1725–1727). When she died it went to Peter's grandson, Peter II, because Peter had tortured and killed his own son Alexei (1718). Peter II was only a young boy, so he was given the Throne under a Regency of older advisers. He "ruled" from May, 1727 to January, 1730, when he died on his wedding day. He was fifteen years old. The Throne was offered to Anna, whose reign became one of gross incompetence, waste and excesses of every nature. To embellish her crown she turned to that of Peter the Great's widow, Catherine I, from which she removed all of its diamonds and rubies. She also looted a crown that had been made for her predecessor, Peter II, removing a gigantic ruby which today still balances atop her crown under a cross of diamonds. The ruby had been bought in Peking in 1676, on the order of Tzar Alexei Mikhailovich. It must have been one of his final purchases for his treasury, for he died the

same year. While the ruby was being mounted upon Peter II's crown a cross of diamonds was added to symbolize the kingdom of Poland, which at that time was part of Russia. When Empress Anna scavenged Peter's crown she took the cross along with the ruby, and mounted them both on her own crown. Other rubies and spinels were added to its arches and edges. From the tip of its cross to its lowest rim, this single piece of jewelry is set with 2,536 diamonds.

PAGES 114–115

The wedding gown of Catherine the Great was made in Russia, on a pattern strongly influenced by French fashions. Catherine was sixteen when she married Peter III in 1745, a marriage arranged by Frederick the Great of Prussia and Empress Elizabeth, Peter the Great's daughter who ruled Russia for twenty years (1741–1761). Now, more than two hundred years after the wedding, the heavy silver lamé and satin of the gown are richly patinated with the passage of so many generations, yet the dress appears to be nearly the same as it must have been that day when the high-spirited German girl from Anhalt-Zerbst first entered the St. Petersburg court as an Imperial bride.

PAGE 116

During Catherine the Great's long reign on the Russian Throne (1762–1796) she had many favorites, but few were closer to her than Prince Alexei Orlov, who, almost at the end of her life in 1795, presented her with a jaunty golden runabout for her promenades around St. Petersburg. Made by English wagon masters, the carriage sported above each rear axle a carved-and-gilt figure of St. George slaying his dragon. Eagles swooped down to hang woodenly suspended over the carriage's front wheels. It was ironic that the English craftsmen, and Orlov, chose a legendary act of violence for the carriage decorations: in 1762 Orlov had led a small clique of conspirators, in connivance with Catherine, to oust and then kill her husband, Emperor Peter III.

After the death of Catherine the Great in November, 1796, the Russian Crown passed to her son, Paul I, whose father has been a source of curious speculation among historians. Paul, who apparently felt that he should have inherited the Throne when Peter III was assassinated, was kept in seclusion instead by his mother on an estate near St. Petersburg. He spent his time drilling his private guard and pursuing less militant pleasures around the house. He was forty-three when he finally mounted the Throne. One of his first official acts was to exhume the body of his alleged father, Peter III, which had been buried in a sepulchre under the Alexander Nevsky Monastery. It was then borne in state to the burial place of the Romanov sovereigns in St. Petersburg's fortress of St. Peter and St. Paul. Behind a funeral caisson with Peter III's remains walked an aged courtier carrying the Imperial Crown of Russia—Prince Alexei Orlov, honoring his victim thirty-four years after murdering him.

PAGE 118

Catherine the Great ascended the Romanov Throne in 1762, seventeen years after she had come from her home in Anhalt-Zerbst, Germany, as a sixteen-year-old bride for Peter III. Her coronation gown with its embroidered golden Tzarist eagles, worn at the age of thirty-three when she became Empress, shows that she retained her childlike figure for many years. Later, after decades of unrestrained dissipation and promiscuity, she may have looked back upon the styles and measurements of her coronation and wedding dresses with consid-

erable nostalgia, for when her life ended she was a most unattractive woman, a physical wreck.

PAGE 119

Imperial commissions for the Romanov Court kept the finest carriage masters of Europe busy through the xviiith and xixth centuries. One cloistered room of the Kremlin Armorer's Chamber is filled today with these regal vehicles, which are said to constitute the finest and most complete collection of its kind in the world. The majority came to the Kremlin during those years when women sat upon the Throne, the reason possibly being that the earlier Tzars, as robust, violent men, still adhered to the traditions of their age and country, and rode their own horses. Today's papier-mâché horses in the Kremlin are harnessed to the carriage given in 1746 to Empress Elizabeth by Prussia's Frederick the Great. Its wood carving and panel paintings were executed in Berlin. Behind the carriage of Elizabeth (at the left in this photo) is an English carriage ordered in 1769 by Catherine the Great. At the end of the alcoved room is a French carriage made for Catherine in 1765.

To the right of the chandeliers and carpet is the carriage ordered by the Cossack Count Alexei Razumovsky in Paris in 1757, and given to Empress Elizabeth. It was entirely covered with paintings by François Boucher. It was more picturesque than practical; all of Red Square was needed to turn it completely around. The carriage given to Boris Godunov by England's Queen Elizabeth, in 1600 (the box-like silhouette at extreme right of this photo), is one of the oldest in the Kremlin. Because of its magnificent bas-relief panels (pages 82, 84–85) it is one of the most remarkable. Other carriages of the collection include one on wooden runners for use in the snow, and one for children that was pulled by ponies. Each carriage carried on its roof the carved wood and enamel crown of its owner.

PAGE 120

Cherubs playing on cloud tops watch over the bow and arrows, shield and helmet of Mars, while the god of war is in some other part of Heaven. French master François Boucher painted these side panels for the carriage given in 1757 to Empress Elizabeth by her court favorite, Count Alexei Razumovsky. Each panel apparently was painted separately and later fastened by almost perfectly concealed pins to the carriage doors. Other cherubic scenes cover the front and back of the great coach. It must have been used infrequently, for the paintings have remained untouched by any restorer's hand since the day Boucher watched them dry in Paris. The carriage itself was made by the xviiith century master wagon maker of France, Bournigal.

PAGE 121

The carriage given by Frederick the Great to Empress Elizabeth in 1746 reflected a very strong Prussian trait which still would be noticeable in German vehicles of the xxth century. The door panels of the ornate coach were painted with fragile bouquets of orchids, morning-glories, iris and sprays of other flowers. In present-day Germany, countless automobiles are equipped with dashboard vases in which their owners diligently tend vivid clusters of freshly cut blossoms. Another interesting, more fundamental point of comparison with the French carriage of Bournigal (page 120) is that both vehicles conform to almost identical body lines and the use of rococo ornamentation in their coachwork.

PAGES 124–125

The Sultans of Turkey, at the end of the xviiith century, lost two major wars to Catherine the Great's armies and navy. The first was ended by the Treaty of Kuchuk-Kainardji, in 1774, at which time Sultan Abdul Gamida sent Catherine a richly jeweled set of saddle ornaments for her horse. Almost twenty years later, in 1792, Sultan Selim III of Turkey lost again, signed the Treaty of Jassy, and sent to Catherine another wondrously jeweled set of stirrups, bridles and saddle cinches for her horse. The surrender gift arrived in 1795, just a year before the end of the Empress's life. The xixth century ushered in an entirely different code of combat ethics, with surrenders and victories based more upon national than personal levels; thus this gem-encrusted tribute was among the very last of its kind. With its presentation and acceptance another chapter of history was forever closed.

Two hundred years earlier, in 1600, when England's Queen Elizabeth was ordering her woodcarvers to work on a gift carriage for Boris Godunov (pages 82, 84–85), the same type of saddle gear must have been well known, for each horse in the bas-reliefs is saddled and bridled in the same way. The stirrups were called *papersts*, from the original Turkish design. The chest cinch was called a *rechma*, also from the Turkish. Each side of each *paperst* was a plate of pure gold into which were set 12 rubies and 18 diamonds. Each of four golden, silver-tasseled saddle lapels was set with 12 rubies and 18 diamonds. The *rechma* itself was made of three linked straps of gold into which were set 120 rubies and 240 diamonds. In the center of the *rechma*, surrounded by a halo of 12 perfectly matched diamond solitaires and sprinklings of lesser diamonds and rubies (all of the same purity), was nestled an absolutely round emerald the size of a walnut.

PAGE 131

Heroic Apollo with dagger in hand brings the wild centaur to bay—all on the bottom of a plate which arrived, among nearly 2,000 other pieces, as a gift to Emperor Alexander I from Napoleon. The porcelain was made in Sèvres, a suburb of Paris still famous for its chinaware. The entire set was known as the Olympic Service of Napoleon, no two plates of which showed a repeated motif. Now, nearly a century and a half later, after other wars have swept across Russia since Napoleon's attack in 1812, it is almost amusing to see that this particular plate among all of the other hundreds in the set prophesied the war, and even portrayed Napoleon himself as the godlike victor over shaggy, bestial Russia as the vanquished. The plate was exquisitely painted—but the prophecy backfired.

PAGES 132–133

Each chandelier weighs a ton, the ceiling rises to a point fifty-eight feet above the parquet floor, the walls are sixty-eight feet apart and one end of the room lies two hundred feet away from the other. In every way the Great Hall of St. George the Victorious, in the Grand Kremlin Palace, is an impressive architectural accomplishment. It, like the rest of the Grand Kremlin Palace, was built between 1839 and 1849, when the capital of Russia was St. Petersburg, when inherent pride in the fortress of the Tzars and the birth of *nationalistic* pride following Napoleon's retreat demanded that the war debris be cleared away and something symbolic be built in its place. The Grand Kremlin Palace was the final result. The floor surfaces in the colossal structure cover half a million square feet. At one end there are formal apart-

ments in which national guests stay when visiting the country's leaders. Every New Year (in recent years), children of Moscow are invited to the Great Hall of St. George for a holiday party at which they are entertained by Russia's favorite clowns, ballerinas and musicians. State guests are welcomed here at formal receptions to which are invited the members of the capital's diplomatic corps. There are still other occasions when the Great Hall of St. George is closed to all outsiders. At the opposite end (this photo) from the main doorways, there is another small door which opens into the holiest political chamber in the Soviet Union—the Great Hall of the Supreme Soviet (page 144).

PAGES 135–139

The mitres worn by Metropolitans and Patriarchs of the Russian Orthodox Church have traditionally been among the most lavishly jeweled headpieces worn by any individuals in the world, with many of them rivalling—and some of them surpassing—the crowns of the richest kings and emperors. By the end of the XIXth century the mitres of Russian Metropolitans became so covered with pearls and precious stones that their sheer satin surfaces had completely disappeared (page 137), making those other mitres from the times of the first Romanov Tzars (page 94) seem almost plain by comparison. The beautifully enameled figures of Christ and His Apostles probably came from earlier mitres. Emeralds and rubies were still used for crosses, crowns and floral rosettes, but the major emphasis was on pearls, of which two types were favored by the Kremlin and court jewelers. Small pearls and seed pearls came from the rivers near Feodosi, in the Crimea. These were the pearls that had been used in such profusion by the Grand Princes, Tzars and priests dating back to Moscow's first Metropolitans Peter (1310–1325) and Alexei (1354–1378) (pages 52–53), who had used them on the collars of their cassocks. Later, during the epoch of Metropolitan Photius (1408–1431), the artistic use made of Russia's fresh-water pearls reached heights rarely seen, and never surpassed (pages 56–57).

Fresh-water pearls from Feodosi (originally known as Kapha) acquired the name *kaphimiski*, by which they still are known today. Larger, salt-water pearls came principally from the Persian Gulf—just as they do today—and were called *burmisky*, the origin of which has been lost. One very curious aspect of the later mitres (page 137) was the liberty taken by the artists who painted the enamel heads of the pearl seraphims (six-winged cherubs dedicated to love and purity) seen at the top of several of the headpieces. These rather self-conscious seraphims might easily be mistaken for actual portraits of the children of those Emperors in whose Cathedrals the Metropolitans led their congregations to prayer.

PAGE 141

Each of the Romanov Tzars, Empresses and Emperors for three hundred and four years peer from their tiny frames in the Fabergé Easter Egg. The egg, supported upon the wings of the dynasty's double-headed eagle, stands approximately ten inches high. It was made in Paris in 1913. Below the eagle is a miniature of the medallion-pinned Coronation Shield used in the ascension ceremony of each sovereign. Seen on the upper half of the opened egg are the portraits of Emperor Paul I (1796–1801) and Empress Elizabeth (1741–1761). Almost in the center of the upper edge on the lower half of the egg is the portrait of Tzar-Emperor Peter the Great (1682–1725). To the right, in his scarlet uniform, is Emperor Alexander I (1801–1825). At the bottom of the egg (left) is the first Romanov Tzar, Mikhail Feodorovich (1613–1645). At the bottom center of the

egg is the creator and the chief patron of the Romanov Tzars' Jewel Age, Alexei Mikhailovich (1645–1676). The other Tzars, Emperors and Empresses are enframed around the opposite sides of the egg.

PAGE 142

Legends, which so enshroud Russia's past, have attached themselves to one very conspicious aspect of the Kremlin today. The red stars which perch atop the five highest spires of the fortress's turrets are said to be made of melted rubies—despite the fact that each is ten feet wide, tip to tip. Actually, they are made of a translucent plastic designed to transmit the same intensity of colored glow by sunlight and by artifical light at night. These stars are said to weigh one ton apiece, which speaks well for those long-gone architects who added the spires to Ivan the Great's XVth century Kremlin towers.

PAGE 143

The speaker's stand of the Supreme Soviet, in the Grand Kremlin Palace, reflects the total simplicity of the room and the rejection of the lavishly ornate past by today's leaders of Russia. Members of the Supreme Soviet's Central Committee sit at desks under a statue of Lenin behind the mahogany rostrum. Earphones carry the voice of the speaker addressing the assembled group. Because of the diversity of languages spoken within the fifteen republics of the Soviet Union, simultaneous interpretations of the speeches are heard, as is the practice in the United Nations Assembly in New York City. The shield with its embossed hammer-and-sickle framed in wheat sprays is, of course, the emblem of the Soviet Union. The room in which the Supreme Soviet meets was once a pair of chapels dedicated to Old Russian heroes Alexander and St. Andrew during Romanov times.

PAGE 144

The Great Hall of the Supreme Soviet in the Grand Kremlin Palace is filled with mahogany desks at which sit the thousand-odd members when the Soviet is in session. When foreign diplomats, State guests, or the press are permitted to attend the sessions, the visitors sit in the boxes along the right wall. Delegates to the Supreme Soviet (Council) meet at irregular intervals, and on request of the Supreme Soviet's Central Committee. The entrance to the Supreme Soviet's Great Hall is directly behind the camera, which doorway leads straight into the Great Hall of St. George the Victorious (pages 132–133).

PAGES 147–149

The greatest celebrations in Russia today take place on 7 November, to commemorate the 1917 October Revolution (25 October in the Julian calendar; 7 November in the Gregorian calendar, which was adopted after the Revolution) and May Day. The Moscow Kremlin, to which the government returned from Petrograd following the overthrow of the Romanov Emperors, serves as a backdrop for all festivities on both days. Marchers assemble from factories, schools, military units, sports organizations, hospitals, farms and private homes to funnel into the canyon between the State Historical Museum (left, page 147) with its line of soldiers, and the turreted walls of the Kremlin. They walk across the long-covered streambed of the Neglinnaya River, which protected this flank of the Kremlin during the

Middle Ages. The marchers carry innumerable banners and flags representing their various schools or organizations, plus balloons and sprays of artificial flowers, while passing under another banner welcoming them with the words, "Glory to the People."

Farther along the line of march they pass before the leaders of the Soviet Union, who stand reviewing them from atop the truncated mausoleum of Lenin and Stalin, who led the original 1917 October Revolution. After nightfall of both 7 November and May Day, the sky above the Kremlin and Red Square is ablaze with fireworks, flares, and the million candle power tracery of whole batteries of anti-aircraft searchlights emplaced along the banks of the Moskva River for the occasion. Hundreds of thousands of celebrators surge into Red Square for these special nights. After the fireworks fade and the searchlights switch off, the Muscovites head back into the darkness for home where they undoubtedly anticipate anew the spectacle of their next Revolution Day celebrations. The roof of Moscow's staid old National Hotel served as the shooting platform for this view of the Kremlin and Red Square on Revolution night (pages 148–149).

PAGE 154

The Tzar Kolokol (King of the Bells) rests where it broke after the Kremlin fire of 1737. In 1836 it was hoisted onto its present platform at the base of Ivan the Great's Bell Tower—which is said to mark the center of the Kremlin. The broken bell, with its 11-ton fragment standing nearby, looms as a really astonishing testimonial to the grandiose style in which the rulers of Old Russia ordered their most impractical dreams into reality. Near the King of the Bells there is another equally fantastic creation, the Tzar Puskha (King Cannon). It weighs 38 tons, is 17 feet long, was designed to take a half-ton powder charge and to fire solid iron cannon balls weighing two tons apiece. It was cast in 1737, during the reign of the same Empress Anna who ordered the King of the Bells. Like the King of the Bells which never rang, King Cannon never fired.

PAGE 157

A wooden platform underfoot to keep him warm, one of Red Square's militiamen stands silhouetted between the Kremlin Saviour's Tower and the spires of St. Basil's Cathedral. Only special government cars are allowed to cross Red Square during the four days each week when endless streams of visitors are filing slowly beneath the Kremlin walls and into the double mausoleum-shrine of Lenin and Stalin (extreme right, this photo). It is just past midday on an almost clear but cold afternoon, yet dusk is about to fall. Snow soon will be drifting across Red Square—and Moscow will be deep in another winter.

PAGES 158–159

The heart of the Moscow Kremlin, seen from across the Moskva River. (L-R): Blagoveshchenskii Sobor (Annunciation Cathedral, 1482–1490); Patriarch Philaret's Tower (1624), Bono Tower (1532–1543), Ivan the Great's Bell Tower (1600) and Arkhangel'skii Sobor (Archangel's Cathedral, 1505), all grouped together; the Senate (1776–1787); Spasskaya (The Saviour's Tower, 1491); xvth century defense tower on south side of Kremlin guarding approaches from Moskva River used in the Middle Ages by Tartars; Vasili Blazhenni (Cathedral of St. Basil the Blessed, 1553–1560) and another Kremlin defense tower in its walled perimeter. Late afternoon on a bitterly cold winter's day. Spotlighting sunshine filtered through clouds heralding the season's first snowstorm, to give the pyramided Cathedrals, Towers and Palaces the Babylonian look that belongs to the Kremlin alone.